1400 definitions
450 illustrations

From Antiques to Inflatables—
Clear and Authoritative Definitions
of Every Important Style and Term
Used in Decorating by Interior Designers,
Furniture and Antique Dealers,
Architects and Artists

DECORATING DEFINED

A DICTIONARY OF DECORATION AND DESIGN

by JOSÉ WILSON and ARTHUR LEAMAN, A.I.D.

Simon and Schuster

NEW YORK

First printing

SBN 671-20525-0
Library of Congress Catalog Card Number: 70-101886
Manufactured in the United States of America
Printed by Halliday Lithograph Corporation, Hanover, Mass.
Bound by American Book–Stratford Press, Inc., New York

Sketches accompanying the definitions are by
Cynthia Brants and Judith Fisher.
Photographic credits follow the text to which they refer.

The authors would like to acknowledge the help
given by the editors and staffs of the following
publications, organizations and museums:

Antiques Magazine
The Bettmann Archive, Inc.
British Travel Association
The Brooklyn Museum
Celanese Fibers Marketing Company
Connaissance des Arts
Connoisseur
Consulate General of Japan, New York
The Cooper Union Museum
Country Life
Courtauld Institute of Art, London
House Beautiful
House & Garden
Interior Design
Interiors
McCall's
The Metropolitan Museum of Art
The Museum of the City of New York
The National Trust, London
The Victoria and Albert Museum, London
The Wallace Collection, London

INTRODUCTION

THE LANGUAGE OF DECORATION AND DESIGN has been evolving and growing since the days of those early style-setters, the Egyptians and Greeks. Today it merits a dictionary of its own, to define the many different, often confusing, words and terms the language embraces. Some are foreign words coined in past centuries for a specific piece of furniture such as a *marquise* or a *credenza*. Others come from the professional vocabulary of architects, interior designers and antique dealers—*corbel, sample length, married piece* are examples. Then there are the trademarks of manufacturers *(Indian Head, Naugahyde)* and the technical terms of manufacturing processes *(drop repeat, piece-dyeing)*. In the last few years, new words have been added to the language that reflect technological advances, design innovations, trends in interior design and architecture, such as *silicone finish, floating furniture, Brutal Look.*

To communicate intelligently and intelligibly in this as in any other language, you have to know not only the words but also their precise meaning. You won't get what you want from an interior designer, an antique dealer or a furniture salesman unless you know exactly what you're talking about. Half the fun, in fact, of furnishing a house or redecorating a room is knowing the difference between one style and another, appreciating the subtleties of design, being aware of the components of a certain decorating look or color scheme, or even knowing how to deal with an inherited antique that doesn't fit your way of life—what can you do with a *rafraîchissoir* other than chill wine in it?

Then there are all the words that look as if they should be connected but actually have totally different meanings—*frieze* and *friezé, applique* and *appliqué, chiffonnier* and *chiffonnière.*

In this book we have endeavored to take the mystery—or mystique—out of the working vocabulary of design and decoration and also to relate furniture, furnishings and decorative accessories to both the historical and the contemporary scene, indicating where and how the function of a piece of furniture has been updated, a color or material restyled, a design derived from a classic shape or motif.

Recognizing that pronunciation can be another barrier to comprehension, we have included phonetic pronunciations for words and terms of foreign origin, following the simple Berlitz method.

Lastly, because we are living in a visually oriented age, and design and decoration are most easily recognized and appreciated through the visual image, we have accompanied the definitions, wherever necessary, with detailed sketches and photographs.

JOSÉ WILSON AND ARTHUR LEAMAN

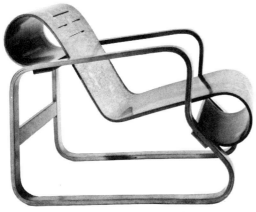

Molded and bent birch plywood lounge chair by **ALVAR AALTO,** c. 1934. Collection, The Museum of Modern Art, New York. Gift of Edgar Kaufmann, Jr.

Aalto, Alvar

Finnish architect and designer noted for his "wood macaroni" chair composed of thin strips of wood, glued and shaped into arms and legs, and the mass-produced body-contoured plywood chair.

Abacus

In classic architecture, the structural element between capital and column. In the Grecian Doric capital, the abacus is a simple rectangular section without a molding. In the Roman Doric, it has a molding around the upper edge. In later architecture, the abacus may be round or octagonal.

Abattant *(ah-ba-TAHNG)*

French term for a fall-front or drop-front panel. A secrétaire à abattant is a desk.

Abstract art

The major art form of the twentieth century—nonrealistic and owing nothing to tradition. In decoration, abstract art not only takes over the large, flat wall spaces of modern houses and apartments, endowing them with vibrant color and pattern, but has also had a formative influence on contemporary design in furniture, ceramics, fabrics, carpets, lighting fixtures, marked by the use of bolder colors, more abstract patterns and less hidebound shapes.

Acacia

A strong, hard, yellowish wood often found in inlay work and banding on the less sophisticated Georgian cabinetwork.

Acanthus

A decorative motif adapted by the Greeks from the acanthus plant. Found in succeeding styles of design, in both bold and restrained versions.

Accent lighting

The projection of a strong beam of light on an object or a specific limited area, in contrast to the more general illumination of overall lighting. Pinpoint and eyeball spots and frame-mounted lights on paintings qualify as accent lighting.

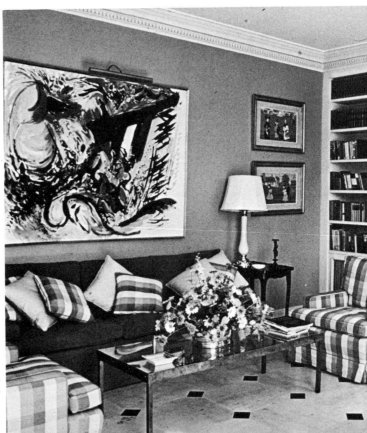

ABSTRACT ART over sofa in a modern living room. Photographer: David Massey.

ACCENT RUG. Courtesy Celanese Corp.

Accent rug

A small rug designed to draw attention by its striking shape, color, texture or pattern, often seen under a coffee table or laid on top of wall-to-wall carpeting.

Accessorize

A verb coined to cover the "finishing off" of a room scheme by the addition of decorative accessories—lamps, pillows, vases, pictures, bibelots.

Acetate

A protean man-made fiber, usually combined with other fibers in both pile and flat fabrics. Among acetate's virtues are its resistance to wrinkling, shrinking and fading, its ability to take dye, and the soft, supple hand it gives to a fabric.

Acroteria

The pedestals at the apex and lower angles of a pediment on which statues, urns or other ornaments were placed in ancient Greece. They were later revived by English architects to support classical statues in Georgian houses.

Acrylic

Generic name for man-made fibers which under the trademarks Acrilan, Creslan and Orlon are made into upholstery and curtain fabrics and carpet. Acrylic fiber has many virtues; it is long-wearing, stain- and soil-resistant, resilient, quick-drying, and will not stretch, sag or shrink. The sheet acrylics (under the trade names Lucite and Plexiglas) are used for furniture, room dividers, windowpanes, lighting fixtures and accessories.

Adam (1760–1800)

A neoclassic style belonging to the late Georgian period of eighteenth-century England, named for John, Robert, James and William Adam, architects who also designed furniture to fit the superb houses they built. The brothers Adam (of whom Robert was the most famous) commissioned leading designers and artists of the day to embellish their furniture and their rooms—Josiah Wedgwood, Angelica Kauffmann, Michelangelo Pergolesi among them. Adam designs, based on Roman, Pompeian and French styles, were characterized by delicacy, restraint and classic simplicity. The brothers favored mahogany and satinwood and motifs that ran the gamut from classical acanthus, pineapple, disks, ovals and floral swags to animal heads and figures. Although Adam furniture has innate charm and undeniable symmetry and beauty, it lacks warmth and comfort and is hardly suited to contemporary living.

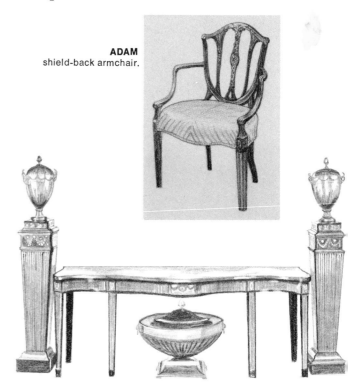

ADAM shield-back armchair.

ADAM serving table, wine cooler, pedestals with knife boxes.

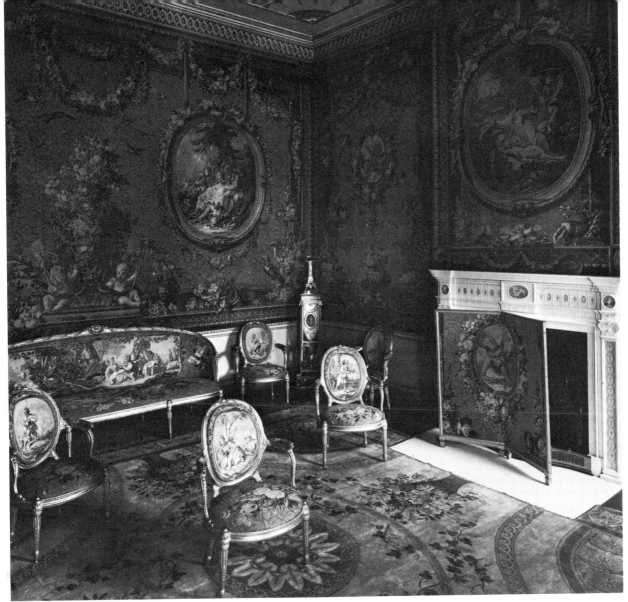

The "en suite" Tapestry Room, Osterly Park, England, designed by **ROBERT ADAM,** c. 1775.
Courtesy Victoria and Albert Museum, London. Crown copyright.

Adam green

A grayed yellow-green associated with the brothers Adam, who favored it as a background color in their decorating of eighteenth-century English houses. Regarded today as an "antique" color, it is considered especially flattering to the wood tones of mahogany and walnut furniture, and still is current for traditional room schemes.

Adaptation

A change or modification in furniture design to conform to current circumstances and conditions. For example, a double or triple dresser in the style of an earlier single commode.

African art

Specifically, the art of Black Africa from the countries south of the Sahara below the Arab belt. Sculpture is the chief art form and wood, ivory, stone, metal and clay the materials. African art, which is linked to tribal values, rites and ceremonies, is stylized, traditional and has changed little over the centuries. At first regarded as purely ethnic and relegated to museums, it is now recognized as art in its own right, worthy of a place on the collector's shelves.

Collection of **AFRICAN ART.**

Agateware

In ceramics, a type of pottery developed in England during the eighteenth century for which colored clays are worked into a marbleized pattern and then given a slightly bluish glaze to simulate the semiprecious stone. In glassware, a nineteenth-century marble or agatelike pattern made by mixing different colored glasses. Reproductions of both kinds of agateware, as well as the originals, are collected today.

A.I.D. (American Institute of Interior Designers)

A professional organization of interior designers founded in 1931. Specific professional standards, education and experience are required for membership. F.A.I.D. designates a Fellow of the American Institute of Interior Designers.

Akari lanterns

Registered name, from the Japanese word for light, for the modern paper lanterns and lamps designed by sculptor Isamu Noguchi.

Alcove

At one time, the comparatively draft-free recess assigned for sleeping quarters. In the eighteenth century a special bed, or *lit d'alcove,* was designed to fit snugly into the space. Today, an alcove is more apt to be treated as a music, study or dining area.

Alfresco *(ahl-FRESS-koh)*

In decorating, the term usually applied to activities and appurtenances connected with an "outdoor room" (terrace, porch, sun deck, patio, lanai) furnished for leisure hours and dining. Alfresco living today seldom implies communion with nature, but a comfortable quota of leisuretime pursuits enjoyed *en plein air.*

Alpujarra *(ahl-poo-HARR-rah)*

A hand-loomed, fringed peasant rug made in Alpujarras, southern Spain since the fifteenth century. The rugs, coarse and heavy, were originally intended to be bedspreads, but are more generally seen now as floor coverings. The bold designs—flowers, grapes, leaves, geometrics, tree of life—are usually woven in two colors, although some have as many as ten. The fringe is woven separately in one of the colors and then is sewn on.

Amberina

Late-nineteenth-century art glass in colors shading from ruby to amber, made by the New England Glass Company. Now both collected and copied.

AKARI LANTERN.

ALPUJARRA rug and bedspread. Courtesy Clavos, New York.

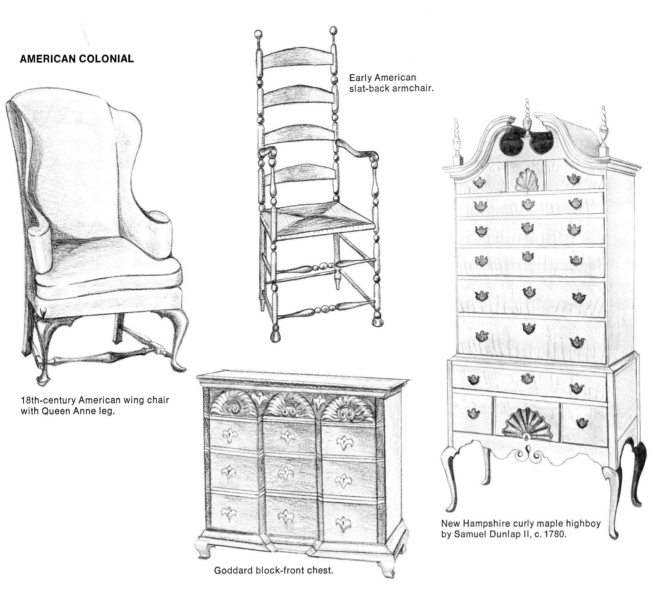

Early American slat-back armchair.

18th-century American wing chair with Queen Anne leg.

Goddard block-front chest.

New Hampshire curly maple highboy by Samuel Dunlap II, c. 1780.

Amboyna

A richly figured wood with a curly grain and warm honey-gold color that found favor with English and French cabinetmakers of the eighteenth and nineteenth centuries as a veneer wood. In furniture, amboyna was often teamed with teak, another native East Indian wood.

American Colonial

Generic term for furniture produced in America before the Revolution. It may be roughly divided into two categories: Early Colonial (1620–1670) and Late Colonial (1700–1790). The early pioneer furniture reflected England's Jacobean and Elizabethan styles, adapted by the New England settlers in crude but serviceable versions, using woods like pine, oak and maple, mostly unfinished and left to acquire color and patina through exposure to use and time. Necessity, rather than fashion, prescribed the types of furniture: unadorned chests and cupboards for storage; simple trestle and gate-leg tables; banister-back and ladder-back chairs and rockers with solid wood, rush or leather seats. German and Swiss colonists produced brightly painted and decorated pieces in what we now call Pennsylvania Dutch style, and in California and the Southwest, the Spanish left their mark in Mission and Ranch styles.

As the colonies prospered in the eighteenth century, more craftsmen arrived from England, bringing with them later, more elegant styles which were promptly copied locally but simplified and changed in proportion and scale to suit New World tastes and living. By 1750, distinct American styles of furniture were being made in walnut and mahogany in Boston, Newport, New York and Philadelphia. American Colonial is by far the most popular style of furniture reproduced today, and original pieces are the most sought after.

Americana

Furniture, objets d'art, books and papers having to do with America, its people and its history.

Anaglypta

Clever contemporary copies of classic architectural details made from liquefied rag stock formed into moldings, columns and ceiling crowns that closely resemble the hand carving or plasterwork of the eighteenth and nineteenth centuries. Lightweight as well as lifelike, anaglypta moldings, which are easily applied with a heavy adhesive to walls and ceilings, around doors and windows, represent an inexpensive way to embellish a plain modern room with traditional flourishes.

Analogous colors

Neighbors on the standard color wheel—blue, blue-green, green, yellow-green, etc.—and partners in the kind of color scheme also known as analogous, generally with the added visual boost of an accent color.

Andirons

Horizontal metal bars placed at either end of the fireplace to support logs, usually in pairs but some-times joined by a rail. Also known as fire dogs. The back of the bar terminates in a low, plain foot, but the upright part at the front can be extremely decorative, displaying scrolls, initials, coats of arms and figures fashioned in brass or, in certain sump-tuous antique andirons, beaten silver.

Angel bed

No celestial resting place but an eighteenth-century French bedstead with a partial canopy attached to the headboard or hung on the wall and with hangings that draw back at either side of the bed head. Also known as a half-canopy bed.

Antimacassar

A small lace, crocheted or embroidered cover that the Victorians draped over the backs of chairs, ostensibly as a protection against the greasy Macassar oil on male locks. Similar covers were also used on the chair arms, just another manifestation of that era's prim predilection for bundling up things.

Antique

U.S. Customs regulations define as antique any-thing made one hundred or more years ago. How-ever, age is no guarantee of worth or value, and the status of an "antique" is more often determined by current attitudes and vogues—witness the recent upsurge of interest in Victorian and Art Nouveau, with a corresponding rise in price.

ANAGLYPTA capitals, fluted pillars and bases. Courtesy W. H. S. Lloyd Co., New York.

ANGEL BED. Photographed at Celanese House.

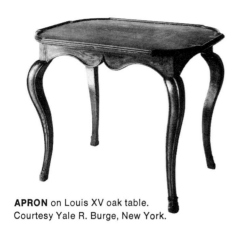

APRON on Louis XV oak table.
Courtesy Yale R. Burge, New York.

Apothecary jars

Pottery jars in which apothecaries kept their stock in trade. Like many objects that were once strictly functional, the antique jars are now collectors' items and are priced accordingly. Among the rarest are the early medieval jars of green glazed pottery and the Lambeth jars of blue-and-white delft earthenware. In the seventeenth and eighteenth centuries, the jars were often ornamented with angels, birds and human figures. The working jars that held drugs are usually about seven or eight inches tall. Larger jars, strictly for decoration, are about sixteen inches tall. The most attractive jars are those made (and currently reproduced) in Spain and Portugal.

Applewood

A fine-grained fruitwood used in France and England during the eighteenth century for furniture, mainly tall case clocks and chairs, and in America today for provincial styles.

Applied decoration

A type of wood or metal decoration, moldings, motifs, etc., applied to the face of furniture with glue or small nails.

Applique (*ah-PLEEK*)

French term for an ornamental accessory attached to a wall—a sconce, candelabrum or bracket.

Appliqué (*ah-plee-KAY*)

In French cabinetwork, applied decoration on furniture, such as bronze doré ornaments on a com-

mode. In needlework, a design cut out in one material and stitched or glued to another (onlay appliqué).

Apron

On furniture, the band of wood (with or without drawer) just under a table top, beneath the seat of a chair, along the base of a cabinet.

Aquarelle

A water color done with a thin layer of transparent colors that allow the tone of the ground surface to show through.

Aquatint

A form of etching that artfully imitates wash tints or a sepia water color.

Arabesque

A centuries-old design motif in which the complex and fantastic patterns are composed of geometrics, entwined floral scrolls, mythological forms and human or animal figures. The patterns—painted, carved or inlaid—are usually enclosed within a rectangle. The arabesque motif can be found in all types of home furnishings, from fabrics to screens.

Arabia

Finland's chief ceramics factory, renowned for the vigorous contemporary designs of its pottery and ovenware, and for original, decorative ceramics by its group of designers and artists which have won international awards.

Arca

This Spanish chest has changed little in design since it was introduced in the Gothic period. An unusual feature of the arca is the lid, which is carved, painted or inlaid on the underside. An inner, plain lid covers the contents of the chest so that the upper lid may be propped against the wall to show off its decoration as if it were a picture.

Arch

A venerable architectural detail borrowed from the past and decoratively reinterpreted in today's flimsier forms, to disguise windows and doors, to shape

screens and wall niches or to panel the doors of furniture. Gothic, Roman and Moorish are the most frequently emulated styles.

Architect's table

Considered a fashionable piece of furniture in the eighteenth century when architecture was held in high esteem, this small worktable or table desk makes practical provision for a drawing board, either in a drawer or as an attachment to the base.

Architectural interest

Term for simulated or real interior architecture, such as beams, moldings, dadoes, paneling, added to a plain room. Many architectural effects today are clever copies of the real thing—structural papers or printed vinyls that simulate wood grain or brick, trompe l'oeil versions of marble, plywood facsimiles of beams and wood paneling.

Architrave

A term from classical architecture that originally referred to one specific division of the entablature, but now is applied to the moldings around door and window openings.

Argand lamp

A type of oil lamp invented by Aimé Argand of Geneva in 1784; it had a cylindrical wick, a greater draft capacity and therefore a brighter flame. Electrified versions are on the market today.

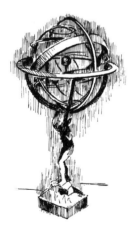

Armillary sphere

An early astronomical instrument, rather like a skeleton of a celestial globe, consisting of a number of rings representing the more important circles of the celestial sphere, mounted on a carved or turned wooden stand. It makes a handsome desk or library accessory.

Armoire (ahr-moh-AHR)

French version of a wardrobe; a piece of furniture traditionally used to store clothes, though the name may be derived from an earlier kind of storage, that of arms or armor. In America, with its plenitude of closets, armoires seldom hold clothes. Instead, they are much more likely to be converted into bars, stereo shelters or china closets.

Armpad

The small padded cushion on the exposed wood arm of a chair, upholstered to match the seat and back. The French manchette.

Arras

Originally, a wall hanging hand-woven at the great tapestry center of Arras, France, in the fourteenth and fifteenth centuries and now, by usage, another word for a tapestry.

Arrow back

A style of American Windsor chair with three or more arrow-shaped spindles in the back, popular during the late nineteenth century.

Art glass

A portmanteau term for the various types of late-nineteenth-century ornamental glassware, beautifully colored and fancifully shaped, that was designed to be looked at rather than used. Favrile, hobnail, peachblow and satin glass are some of the best-known and most collected.

Art Moderne (ahr maw-DERN)

French term for modern or contemporary design. During the 1920's, a term used in the United States to describe the new breed of modern objects. See also Moderne.

Art Nouveau (1890–1910) (ahr noo-VO)

A style of decorative art and architecture launched by Henri van de Velde in Paris in 1895 that spread throughout Europe and America. Art Nouveau, which encouraged free but distorted interpretations of nature and was distinguished by sinuous, flowing lines, encompassed styles derived from the Gothic and the Japanese. Exemplars of the style are van de Velde and Victor Horta in Europe, Louis Comfort Tiffany in the United States. Unusual pieces that went out of fashion in the last generation and were banished to attics and basements are highly prized and copied today, and the style itself is having a successful revival in decorative home furnishings.

Furniture in **ART MODERNE** style. Courtesy Parzinger Originals, Inc., New York.

ART NOUVEAU salon in Musée des Arts Décoratifs, Paris.

Arte povera (*AHR-teh POH-veh-rah*)

Literally, poor man's art. An eighteenth-century Italian decorative deceit for furniture in which the porcelain plaques, bronze mounts and fine woods of court pieces were simulated with paint and découpage.

Artificial flowers

Imitations of nature, sometimes laudable, sometimes lamentable, produced for more than four hundred years. The most successful are those where the deception is more artistic than realistic—the almost lifelike carved wood flowers of Grinling Gibbons; the flamboyantly fake huge paper cabbage roses from Mexico; the prim and patently artificial painted shell bouquets of the eighteenth and nineteenth centuries in their protective glass domes; the stiff nosegays of beaded flowers and the chilly Parian lilies that bloom under glass in cemeteries; the delicate, definitely unreal gossamer silk posies from France. It is only when artifice tries to ape reality that the result is unfelicitous and deplorable—witness the lifeless perfume-impregnated plastic flowers that fill the windows of modern florists' shops.

Ash

A strong, flexible blond hardwood that lends itself to the curving contours of furniture frames—witness its widespread use for Windsor chairs.

Astragal molding

Originally, a small semicircular architectural molding. The term is now generally applied to the small, convex decorative wood molding on the edge of a cabinet or secretary door.

Astrolabe

An ancient astronomical and surveying instrument, now a collectors' item.

Astrolabe clock

A clock that gives not only the time but also the positions of the moon, the sun and the planets.

Asymmetrical balance

In decorating, a term that usually refers to a furniture or picture grouping or an assemblage of art and objects in which the balance does not depend on a central focal point, or pairs, but on the visual balance achieved by groups or masses that are not identical and have no central axis. The opposite of symmetrical balance.

Atrium

The serenely inner-oriented central court, open to the sky, around which the Greeks and Romans built their houses. This room-at-the-core, recently revived by architects as an apt solution to the modern dilemma—how to achieve privacy without

ASYMMETRICAL BALANCE of art and accessories in a room designed by Barbara D'Arcy, A.I.D., of Bloomingdale's, New York.

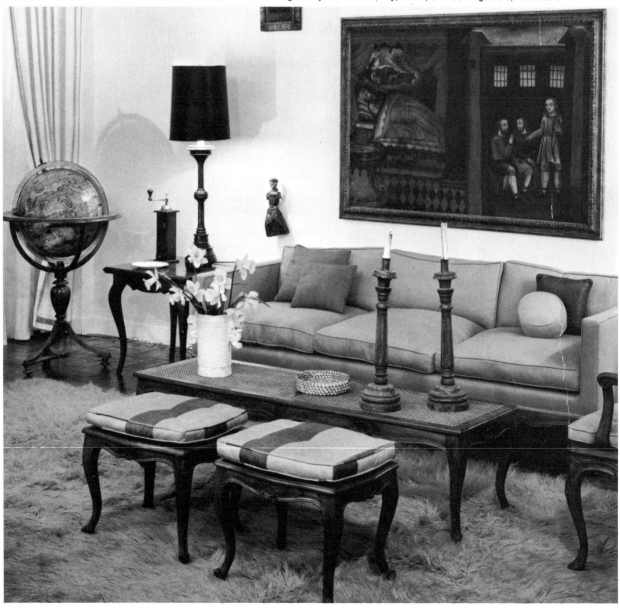

seeming antisocial—now appears roofed or unroofed, according to its purpose and the prevailing climate.

Aubergine (oh-bear-ZHEEN)

The deep rich red-purple of the ripe eggplant, or French *aubergine,* the color of a glaze made from manganese found on Chinese porcelains of the Ming Dynasty. In the last few years, the emergence in decorating of the dark background has re-established aubergine as a fashionable, high-style color for walls, ceilings and carpets.

Aubusson rugs (oh-bew-SOHN)

Carpets and rugs of wool, linen and cotton originally woven in the French tapestry works at Aubusson during the Middle Ages, when the patterns were borrowed from the Orient. In the Gothic period, millefleurs designs took over, but from the Louis XIV period, the patterns conformed to the larger scale and muted colors of other French textiles. The name Aubusson is now given to any rugs with this type of heavy, coarse tapestry weave whether made in Aubusson or not, in both period patterns and contemporary designs.

Audubon, John James

Nineteenth-century artist and ornithologist whose name is synonymous with prints of American birds. The originals are rare and expensive, but through mass production, reproductions of Audubon prints are a common sight.

Austrian shade

Vertically shirred sheer curtain which is pulled up to any point like a shade, but with cords rather than a roller. Austrian shades were very popular a few years ago but, probably because they have become the standard window treatment for hotels and restaurants, the more tailored Roman shade seems to have taken over at home.

Authentic

Neither copy, reproduction nor adaptation, but the genuine article, be it a signed Louis XV table or a nineteenth-century William Morris fabric design.

Authentic reproduction

A line-for-line copy of the original, such as the authorized Williamsburg reproduction line of furniture.

Avant-garde

In decorating, any new or advanced concept or movement, such as the application of op art to interior design, is considered avant-garde.

Axminster

Carpet with a thick, high pile, woven in colorful and intricate patterns, and ranging in width from twenty-seven-inch strip carpeting to eighteen-foot broadloom. The name comes from Axminster, England, where it was originally made.

Azulejos (ah-zoo-LEH-hoss)

Gaily patterned, multicolored tiles from Spain, Mexico and Portugal imported to embellish bathrooms, kitchens, dining-room floors and dadoes in garden rooms. The Moors are credited with introducing these decorative tiles to the Iberian peninsula, where they have been made since the fourteenth century. Although the early tiles were polychrome, as they are today, the name developed from the Spanish *azul* (blue), and was probably adopted in a later century when the tiles were made in the favorite seventeenth-century color combination of blue and white.

AUSTRIAN SHADE in taffeta with gilded pine cornice. The Metropolitan Museum of Art. Gift of the Samuel H. Kress Foundation, 1958.

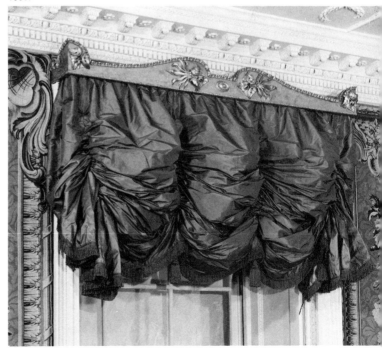

Baccarat (*bah-kah-RAH*)

The crystal of the French kings, this exceptionally beautiful glass has been made in France since the early eighteenth century, and both old and modern pieces are highly prized by collectors. Cutting, pressing and blowing produce the patterns.

Bachelor chest

A narrow chest of drawers designed to house a man's gear, further equipped with a fold-over top or pullout shelf under the top for writing or toiletries. Introduced during the Queen Anne period, it was very much in vogue in the eighteenth century, the age of the dandy, and is frequently reproduced today.

Backgammon board

Board game from the Middle Ages adapted to tables by seventeenth- and eighteenth-century French and English cabinetmakers.

Bahut (*bah-EW*)

In the nomadic Middle Ages, a portable chest for personal belongings and household furnishings. Eventually, it grew legs and developed into a tall, decorative storage cabinet.

Bail handle

A drawer or door pull shaped like a loop or bail on an escutcheon or backplate. The design dates back to the seventeenth century.

Baize

Feltlike plain wool fabric, coarsely woven and usually green, originally made in Baza, Spain, and used since the eighteenth century as a surface for inserts on card and game tables, a lining for drawers.

Baker's rack

Tiered iron or brass stand on which nineteenth-century bakers arranged their wares. These proletarian objects now stand in the most elegant of living rooms and assume a modern role as bars or display shelves for plants, books and accessories.

Balcony

A small, railed platform outside a window or French door. Despite its present domestic position, the balcony was originally a martial device—a protective battlement built out from a fortified building from which stones and boiling liquids were hurled on attackers. Peaceable versions of balconies began to appear on houses in the late fifteenth century, but it was not until the Regency period that improved building methods and a widespread use of wrought and cast iron made balconies really feasible—and fanciful—decorations for the exteriors of small houses, the form in which we know them today.

Baldachin (*bahl-dah-KEHN*)

A freestanding canopy supported on posts or pilasters.

Baldwin, William (Billy)

Interior designer and disciple of Ruby Ross Wood known for his distinctive and charming style in high-style decorating. The Baldwin "signature": a single floral-printed fabric in clear colors used

throughout a room for curtains and upholstery, often with matching wallpaper, played off against a second pattern in carpet and accessories.

Balloon back

Chair back that swells out like an inflated balloon, attributed to Hepplewhite. The design was adopted for rockers and side chairs in nineteenth-century America.

Baluster

A small turned column, usually found as a support for a stair rail, now often a table or lamp base.

Bamboo

Introduced during the eighteenth-century rage for things Chinese, the wood of the bamboo tree has for centuries been turned into furniture.

Bamboo furniture

Eighteenth-century English furniture made not of bamboo but of beech turned to simulate the con-

tours of the bamboo stem and then painted in either the natural yellowish tone or in strong colors. These charming faux bamboo pieces, superb examples of which can be seen in the Royal Pavilion at Brighton, remained popular until the Victorian era, when real bamboo, fashioned into chests, hatracks, washstands and spindly tables, took over with results far less felicitous in style than their painted predecessors.

Bamboo-turned

Wood turning that apes the real thing, a type of decorative bamboozlement found in eighteenth-century furniture in the Chinese taste, including the legs of some Chippendale chairs and tea tables. Also, a type of leg introduced on American Windsor chairs around 1790. *See also* Bamboo furniture.

Banding

A narrow inlay of contrasting woods usually found on table or desk tops or inset around drawers.

BACHELOR CHEST. Courtesy Wood & Hogan, Inc., New York.

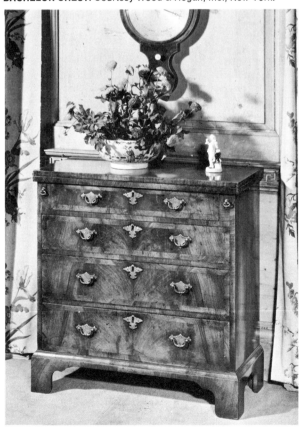

BAKER'S RACK used as a plant stand. Photographer: Richard W. Walker.

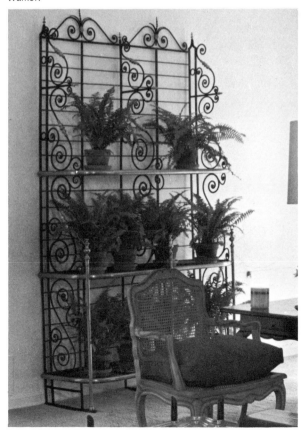

Banister back

A back made up of spindles, half spindles or similar uprights found on seventeenth-century English and American chairs.

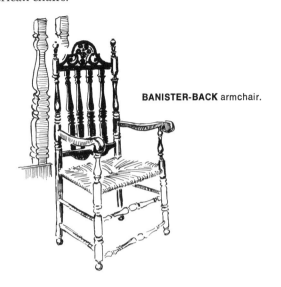

BANISTER-BACK armchair.

Banjo clock

A popular nineteenth-century American wall clock shaped like a banjo, usually with a painted panel in the lower section.

Bank of England chair

A type of English Regency tub chair supposedly designed for the Bank of England. The front of the seat is serpentine, the legs are straight, tapered or cabriole, and the arms continue from the front post in a rising curve to form the back.

Banquette (bahng-KETT)

An upholstered bench, with or without a back.

Barbizon School

Mid-nineteenth-century group of French landscape painters, among them Millet and Corot.

Barcelona chair

The X-frame steel-and-leather chair designed by Ludwig Mies van der Rohe for the Barcelona Exposition in 1929. Officially considered a contemporary classic and, unofficially, a status symbol in furniture, it is still produced by Knoll Associates.

Barn siding

Weathered and grayed planks from old barns that, as a facing for interior walls, became identified with the Country Look. With the natural supply depleted, the texture and patina of barn siding have been imitated in printed wallpapers, plywood sheets and laminated plastic.

Barometer

Starting out strictly as a scientific instrument, the barometer's case developed into a handsome ornament, valued as much for the beauty of its design and wood as for its function. The simple stick, the banjo and the rococo versions of the barometer are the most collected and copied today.

Baroque

A bravura style, blustering and masculine, that swept across Europe from the mid-sixteenth to the early eighteenth centuries. Baroque is distinguished from the cool refinement of the classic styles by the use of overscaled and frozen-motion bold curves, heavy ornamentation, twisted columns, all designed to stimulate the eye in an almost theatrical way.

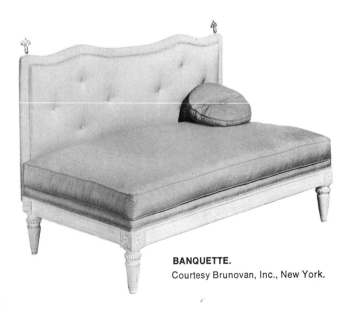

BANQUETTE.
Courtesy Brunovan, Inc., New York.

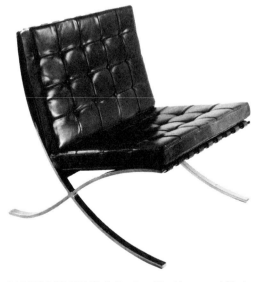

BARCELONA CHAIR. Collection, The Museum of Modern Art, New York. Gift of the manufacturer, Knoll Associates, Inc., U.S.A. Photographer: George Barrows.

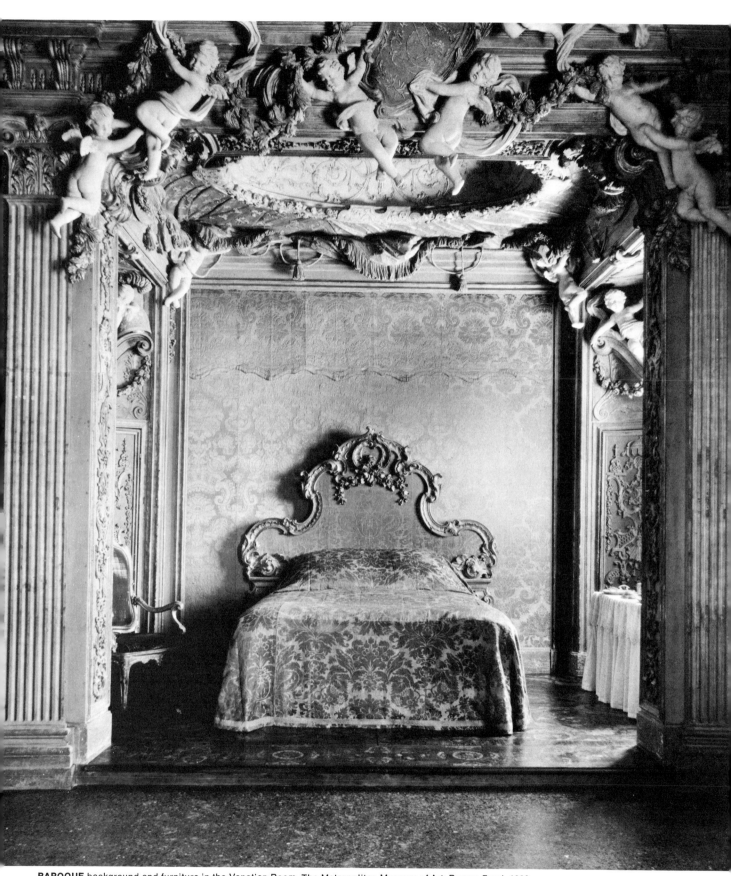

BAROQUE background and furniture in the Venetian Room, The Metropolitan Museum of Art. Rogers Fund, 1906.

Furniture designed by **MILO BAUGHMAN.** Courtesy Thayer Coggin, Inc.

Barrel chair

An upholstered chair, the back of which is shaped like a vertically halved barrel.

Barrett, David, A.I.D.

Interior designer whose talent for combining the sublime and the ridiculous, in the best and most subtle tradition of high camp, has resulted in many highly imaginative and theatrical rooms. His reproductions also reflect this taste for the unusual and *outré* in furnishings.

Bartolozzi, Francesco (1728–1813)

Italian engraver who came to England in 1764 and became famous as the leading exponent of stipple engraving. Bartolozzi engraved from original works by Cipriani, Angelica Kauffmann, Sir Joshua Reynolds and other artists of the day.

Basalt

An inky-black Wedgwood porcelain supposedly named for its resemblance to the dark basaltic rocks of the Giant's Causeway in Northern Ireland. The styles and shapes are classic, in the eighteenth-century Wedgwood manner, usually self-patterned in relief, but occasionally decorated with baked-on colors such as white, terra cotta, etc. Although antique basalt is expensive and hard to find, it is currently reproduced by the Wedgwood factory in many of the classic shapes, and a collection of the pieces, with their sharp outlines and rich color, can be an extremely effective accent in a contemporary room.

Base

The lowest section or support of a column or a piece of furniture, or the block on which a sculpture rests.

Baseboard

Horizontal wood trim around the base of a wall. Depending on the type of interior architecture, it can vary in height from two inches to twelve inches, and may be made up of several moldings, or one flat strip topped with an ogee molding, or be nothing more than a piece of quarter round.

Bas-relief

A type of sculpture in which the design projects only slightly from the background.

Bastard

Terse term for any design of mixed and uncertain origin.

24

Batik

A hand-printed fabric, originally cotton, patterned by a process which involves dipping the cloth into a series of different colored dyes. Parts of the design not to be dyed any specific shade are made dye-resistant by a removable wax coating. Batik originated in the Dutch East Indies and is now imitated in machine prints.

Batiste

Originally, a sheer, fine, plain cotton fabric, often made up into curtains and bed hangings, now simulated in synthetics and often printed with floral designs or woven in stripes.

Batten

Bracing strips of wood, usually two or more, nailed across vertical boards; mostly found on board-and-batten doors.

Baughman, Milo

Designer who brought a new low look to moderately priced contemporary furniture in his designs for Thayer Coggin.

Bauhaus (*BOW-house*)

The famous school of art, architecture and design established in Weimar, Germany, in 1919 by Walter Gropius and others to explore the concept of total creative design that could be applied to all aspects of daily life. The Bauhaus school and its disciples, among them Marcel Breuer, Paul Klee, Wassily Kandinsky and Ludwig Mies van der Rohe, have had a lasting influence on twentieth-century art, architecture, furniture and industrial design.

Bay

Architecturally, the space between columns or pilasters, or, in contemporary houses, an enclosed windowless projection.

Bay window

A window that projects from the wall of the house, forming an interior recess.

Bayadère (*bah-yah-DEHR*)

A horizontally striped, multicolored silk, cotton or rayon fabric, borrowed from costumes worn by Hindu dancers.

Beading

A narrow, semicircular molding with a beadlike design used to ornament a plain surface. Beading is often found around drawers on veneered pieces to prevent the veneer from coming away from the solid wood.

Beadwork

As a companion to (or replacement for) needlework, the art of decorating materials with colored glass beads has been around for many centuries. By the Elizabethan period it was firmly entrenched in England as a form of ornamentation for snuffboxes, stockings and mirror frames. The Victorians were the greatest exponents of beadwork, lavishing it on every conceivable kind of domestic object from chair and stool covers to fireplace screens and artificial flowers—the last-named being the one form we are apt to find it in today.

Beardsley, Aubrey (1872–1898)

English artist and esthete whose sinuous, flowing illustrations for the *Yellow Book* and Oscar Wilde's *Salome* did much to influence the Art Nouveau style of interior decoration. In the recent Art Nouveau revival, Beardsley's designs have been reproduced on fabrics and wallpapers.

AUBREY BEARDSLEY design in fabric by Tressard, New York.

25

Beaton, Cecil

English photographer, author and designer of interiors and theatrical sets, best known for his updated versions of Edwardian and Art Nouveau and high-style interpretations of the Country Look. He is now designing fabrics, carpets, wallpapers and contemporary furniture for American manufacturers.

Beau Brummell

A man's dressing table with a fold-back top, mirror and drawers, named after the eighteenth-century dandy and style setter.

Beauvais (boh-VEH)

French town where the art of tapestry weaving has been practiced spasmodically for at least a thousand years, most successfully and notably between 1736 and 1755 when artist François Boucher designed a superb series of tapestries on such currently fashionable themes as the "Loves of the Gods" and the "History of Psyche."

Bed steps

A set of low steps designed in the eighteenth century to boost the sleeper into the high beds of the time. Often the steps were multipurpose pieces of furniture, and concealed certain nighttime necessities such as the *pot de chambre*. Bed steps are now relegated to the living room and serve, in pairs, as end tables flanking a sofa or, singly, an end table between two chairs.

BED STEPS converted to end table. Courtesy Yale R. Burge, New York.

Beech

A pale, silver-flecked wood that was favored by seventeenth- and eighteenth-century furniture makers, especially for painted, lacquered or gilded pieces and the polished frames of Louis XV and XVI chairs. Today, mainly employed for bentwood chair backs and furniture frames.

Beehive chair

A rush chair woven in the shape of a beehive—the seventeenth- and eighteenth-century predecessor of the similarly shaped wicker chairs of today.

Belleek

Creamy porcelain with a pearly glaze from Fermanagh, Ireland, often decorated with a shell motif.

Bellpull

Early form of intercom. A long, thin strip of fabric, usually embroidered with petit point, that was attached to a lever connected to a call bell below-stairs and summoned the butler from his pantry or the parlormaid from the kitchen. Now a strictly decorative household item.

Belter

Victorian furniture made in New York after 1840 by John H. Belter and highly prized now for its excellent craftsmanship, fine carving and superb use of rosewood, walnut and oak.

Belvedere

From the Italian *bel vedere* (beautiful view) came this word for an outdoor pavilion or gazebo commanding a panorama of the surrounding countryside. The belvedere originated in Renaissance Italy, when it was a kind of open top story on a building.

Bennett, Ward

Avant-garde designer of interiors, and contemporary furniture in steel, marble, glass and leather.

Bennington

Nineteenth-century pottery, both glazed and unglazed, made in Bennington, Vermont. The most familiar and widely collected is the mottled brown ware.

Bentwood ✔

Wood softened by steam, afterward molded into shapely yet strong and inexpensive furniture—a nineteenth-century process which foreshadowed the twentieth-century laminates. Classic examples are the Windsor chair, with its bow back and arms, and the chairs and rockers of the Austrian designer and manufacturer Thonet. Bentwood is currently enjoying a revival of interest, in both contemporary designs and reproductions of the old rockers and chairs, now frequently teamed in rooms with straight-lined modern furniture. *See also* Thonet, Michael; Thonet furniture.

Bergère (*bear-ZHEHR*)

An upholstered armchair with closed, upholstered sides developed in France during the eighteenth century. Unlike much period furniture, the bergère is extremely comfortable, which explains its continuing popularity.

Bernini, Giovanni (1598–1680)

Italian architect and sculptor, master of the baroque style, whose most famous work is the colonnade of St. Peter's, Rome.

Bertoia, Harry

Modern sculptor who will be remembered in the furniture field for his upholstered wire-mesh contour chairs manufactured by Knoll Associates.

Bessarabian rug

Tapestry-woven or knotted-pile rug made in Rumania during the eighteenth and nineteenth centuries, generally in bold, brilliantly colored floral patterns against dark backgrounds.

Betty lamp

Early American iron or tin oil lamp, small, shallow and shaped like a pear, with a wick in the smaller end. It was usually hung from an iron rod on a stand or ratchet suspended from the ceiling.

Bevel

A slanted or sloping edge on the glass of a mirror, the wood of a table leg (where it is usually called chamfer) or the metal rim of a table top.

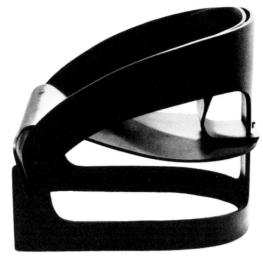

BENT PLYWOOD lounge chair designed by Joe Cesare Colombo of Milan.

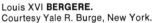
Louis XVI **BERGERE.**
Courtesy Yale R. Burge, New York.

Chrome-plated wire mesh chair designed by **HARRY BERTOIA.** Collection, The Museum of Modern Art, New York. Gift of the Manufacturer, Knoll Associates, Inç.

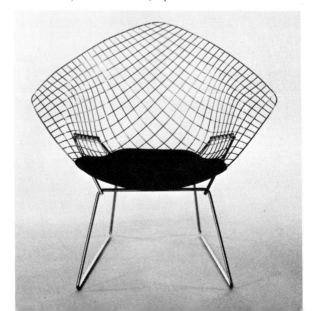

27

Bibelot (*bib-LOH*)

A small decorative object of less value than an objet d'art but more than a trinket—in literal translation, a plaything.

Bible box

Originally, a plain or carved wood box with a slanting lid that held the family Bible, the top serving as a reading stand. Later, it was mounted on legs and in this form developed into a desk.

Bibliothèque (*bib-lee-oh-TEHK*)

French word for an extremely large bookcase, architectural in concept, but not necessarily built in.

Bidet (*bee-DEH*)

Originally a small, portable piece of hygienic equipment with a porcelain or metal liner and cover, which may be seen today, sans cover, as an end-table-cum-planter. The modern version of the bidet, although standard in European and Latin-American bathrooms, is still regarded in the U.S. as rather risqué.

American 18th-century **BIBLE BOX,** painted oak and pine. The Metropolitan Museum of Art. Gift of Mrs. Russell Sage, 1909.

BIBLIOTHEQUE.
Courtesy Yale R. Burge, New York.

Biedermeier (1810–1850) (*BEE-d'r-my-ehr*)

Simplified bourgeois equivalent of the French Empire style that prevailed in German-speaking areas of Europe during the early and mid-nineteenth century. It was dubbed Biedermeier after an imaginary, bumbling German literary figure, "Papa Biedermeier," who became synonymous with the solid German middle class. Furniture woods were usually light in tone—pear and other fruitwoods, maple, birch, some mahogany—with matched veneers, ebony inlays and carving simulated in painted details of black and gold. Period Biedermeier pieces with their admixture of sophisticated decoration and naïve proportions are fashionable today as accents in contemporary rooms and are reproduced frequently in more chaste, scaled-down versions.

Bilbao mirror (*beel-BAH-oh*)

A type of eighteenth-century mirror with a frame of marble, or marble and wood, named for the Spanish port of its origin.

Billiard table

A massive piece of furniture designed for a gentlemanly game of skill, predecessor of our plebeian pool. Oliver Cromwell, Pepys and Louis XIV, who had at Versailles a billiard table elegantly covered with gold-fringed red velvet, were all devotees of billiards. The early-sixteenth-century billiard tables were ponderous oaken affairs, hard to play on. After 1836, when slate tops and rubber cushions were introduced, the game was refined to its present form and became more widely practiced.

Bird cage

On furniture, an openwork wood box between the base and top of a tilt-top table, which takes its name from the slatted and barred design of real cages. These decorative confinements flourished along with the vogue for exotic birds in Europe during the Renaissance, reaching a height of artifice in the eighteenth and nineteenth centuries, when the early, simple, circular domed structures of wicker or metal gave way to fanciful and elaborate creations of brass, wire and wood resembling lanterns or miniature mansions, painted, gilded or enhanced with all manner of ornamentation in the currently prevailing style. Today, while bird cages are still in favor as decorative accessories, they are less likely to be domestic aviaries and are more apt to be empty or filled with plants.

BIEDERMEIER STYLE

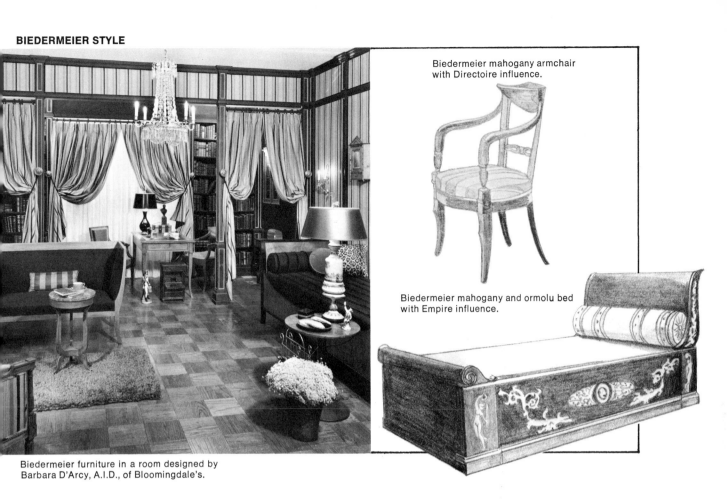

Biedermeier mahogany armchair with Directoire influence.

Biedermeier mahogany and ormolu bed with Empire influence.

Biedermeier furniture in a room designed by Barbara D'Arcy, A.I.D., of Bloomingdale's.

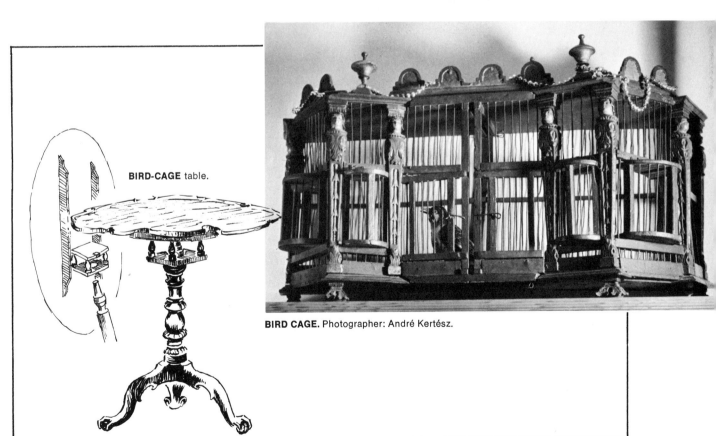

BIRD-CAGE table.

BIRD CAGE. Photographer: André Kertész.

Bird tureen

Fashionable serving piece of the Rococo period, when ducks, geese and similar birds were fashioned in faïence at the Strasbourg factories, in porcelain at Meissen and Chelsea.

Biscuit ware

Pottery with a thin glaze produced by only one firing, often samples of pieces to be produced.

Bisque

White unglazed porcelain, usually in the form of busts and figurines, turned out by many of the great porcelain houses.

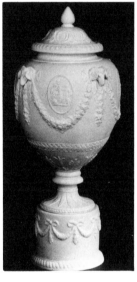

Modern **BISQUE** urn by Mottahedeh.

Black and white

A perennial color scheme that, plus or minus an accent color, has been around since the time of the Romans and is still rated as one of the most striking and effective of all color schemes. Notable exponents of this decorating die-hard in our time include Ruby Ross Wood, Melanie Kahane, Billy Baldwin and Cecil Beaton.

Blackamoor

Decorative Negro figure that upholds a table top or candelabra, much in evidence during the Baroque, early-eighteenth-century and Victorian eras, and still reproduced.

Blanc de chine *(blang duh sheen)*

A type of delicate, highly glazed Chinese porcelain in warm-to-cool tones of white, mostly seen in decorative figurines such as the goddess Kwan Yin, Foo dogs and lotus bowls.

Bleached finishes

Light finishes obtained by chemically bleaching dark woods such as mahogany and walnut. In the process the brilliance of the wood is lost, but the resulting wood tone, treated with a plastic sealer, is permanent.

Bleu de roi *(bluh duh roh-AH)*

The king was Louis XV, the color is the strong shade also known as Sèvres blue, the name was a diplomatic flattery on the part of the factory which enjoyed his royal favor.

Blind

A light- and air-controlling shade over a window, a treatment first recorded in Europe when Marco Polo brought back to Venice from China the idea of a louvered shade, promptly dubbed a "Venetian blind." Spring and roller blinds of calico, leather and other materials were introduced to England in the eighteenth century, to be followed in the Directoire and Victorian periods by fanciful hand-painted "paper curtains," a more lighthearted and decorative type of blind.

Collection of miniature **BLACKAMOOR** figures. Interior designer: David Barrett, A.I.D. Photographer: André Kertész.

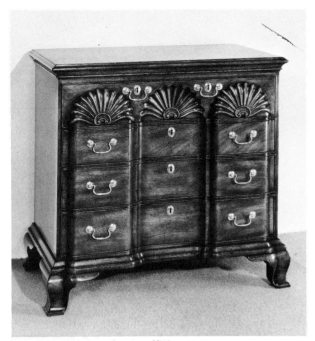

BLOCK-FRONT chest. Courtesy Kittinger.

Block front

A term applied to the front of a desk or chest which has three vertical panels, the center concave, the ends convex. Panel tops end in carved shells. Attributed to John Goddard of Newport, Rhode Island.

Block printing

Early form of printing practiced before the machine age and still current in the handicrafts field. A pattern or picture is printed by hand on paper or fabric with a series of carved wood blocks coated with dye, each of which produces one part of the design in a single flat color.

Blocked linen

Linen on which the design has been block-printed (applied with carved wooden blocks), rather than screen-printed, the more usual method.

Blond finishes

These include chemically bleached wood finishes, and such processes as pickling, where plaster is rubbed into the grain of soft woods, and pigmentation, in which light opaque fillers are used in open grains, and the surface is sealed to keep in the color. The popularity of blond finishes has brought back into fashion the lighter woods, such as maple, birch, aspen, avodire, holly and primavera, often in combination with darker woods.

Blue and white

A crisp color combination that works well with dark woods. Traditionally associated with the seventeenth century, the heyday of blue-and-white patterns in tiles—delft, azulejos—and china—Canton, Meissen, Worcester—it is today interpreted in the light, bright room schemes of such noted interior designers as Michael Taylor.

Bobêche (boh-BEHSH)

A small saucerlike projection around the top of a candleholder designed to catch the wax drippings. It may or may not be fixed and is made, according to the style and material of the candleholder, of metal, porcelain or glass, occasionally with pendant prisms.

Bocage (boh-KAHZH)

From the French *bocage* (little wood), a word applied to tapestries woven with a design of trees, branches and leaves, or a landscape with woods. In ceramics, bocage implies a background of foliage, blossoms and trees against which porcelain figures pose.

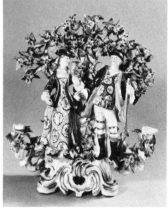

BOCAGE Bow Group, 1760–1765. Courtesy D. M. & P. Manheim Antiques Corp., New York.

Bohemian glass

Originally, a type of glass which was first made in Bohemia in the eighteenth and nineteenth centuries, enameled, then cut and engraved. Today the term usually refers not to the country of origin, but to the overlay or luster-enameled ruby or amber glass cut through to clear glass.

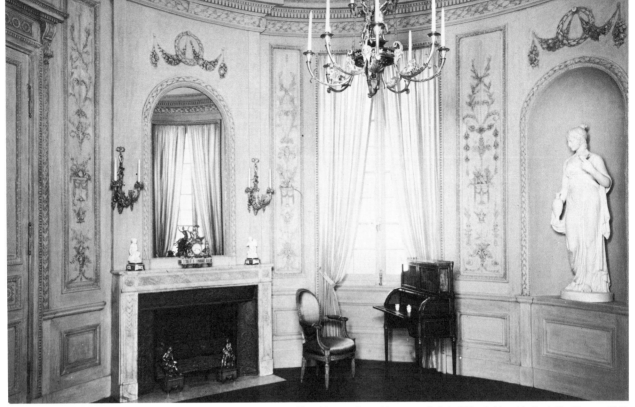

Louis XVI oak **BOISERIE,** painted greenish gray, in a room in The Metropolitan Museum of Art. Gift of Mrs. Herbert N. Straus, 1943.

Boiserie (*bwah-zeh-REE*)

French word for the delicate eighteenth-century paneling and decorative woodwork, now loosely used to refer to any paneling.

Bolection

A series of moldings, often used around a fireplace instead of a chimney piece, or to form a projecting panel on a wall.

Bombé (*bohm-BEH*)

Term for furniture or objects with a surface that bulges or swells, either on the front, the sides or both, such as a commode.

Bonbonnière (*bohng-boh-n'YEHR*)

French bonbons or sweetmeats were popped into this small, decorative eighteenth-century box, an elaborate trifle fashioned of precious metal or tortoise shell, inlaid with gold and encrusted with jewels. Anyone who owns a bonbonnière today is more apt to display it than load it with candy.

Bone china

Hard-paste porcelain strengthened by the addition of bone ash, the standard English porcelain since 1800, distinguished by its intense whiteness and translucency.

Bonheur du jour (*boh-NUHR duh zhoor*)

A delightfully named, elegant little French lady's writing desk developed during the time of Louis XVI, which looks like a small cabinet with a drop front and slender curving legs. Still in fashion for small rooms because of its diminutiveness.

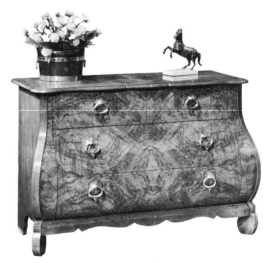

BOMBE chest. Courtesy Baker Furniture, Inc.

Bonnet top

The arch contour, often broken, on the top of clocks, highboys, secretaries, etc., which continues from front to back of the piece.

Bonnetière (*bohn-neh-t'YEHR*)

A tall, narrow cabinet designed in the eighteenth century for the singular function of holding the elaborate hats of the period. Today it has been elevated to the role of displaying books or decorative objects and performs economically on a short wall.

Book table

A table built not for, but of books. Three or four large leather-covered volumes were joined together, set on legs and hollowed out to form a secret compartment which frequently concealed the *pot de chambre*. Today's version is generally of wood, painted to simulate the original, and the compartment holds magazines and similar gear.

Borax

Commonly used to describe a type of cheap, showy furniture with waterfall fronts, extraneous and tasteless ornamentation, and "printed" finishes. In the nineteenth century, manufacturers of the cleaning compound Borax offered premiums of furniture, which may well have inspired the name.

Border

A band of continuous design around the edge or enclosing a section of fabric, wallpaper, carpets, etc. Trimmings, such as tapes and braids, with this type of design.

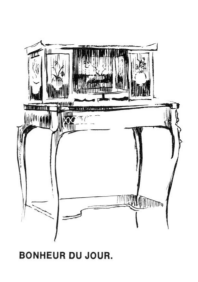

BONHEUR DU JOUR.

BONNETIERE.

Wallpaper **BORDERS** frame a dining area. *right.* Courtesy Wallpaper Council. Decorative carpet border, *below.* Courtesy Patterson, Flynn & Johnson, Inc.

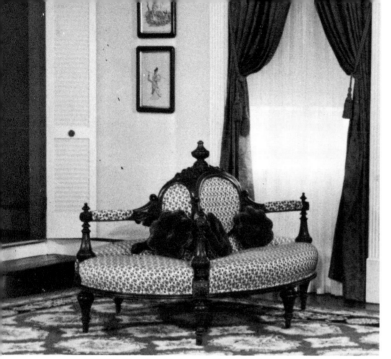

BORNE. Courtesy Patterson, Flynn & Johnson, Inc.

Borne

Victorian conversation piece—a circular or oval overstuffed sofa with a central column that formed the back. Placed in the middle of the room, it gave a circle of acquaintances a likely spot for a tête-à-tête.

Boss

A projecting ornament placed at the point where the ribs of a vaulted or flat ceiling or the moldings of furniture intersect.

Boston rocker

An enduringly popular mid-nineteenth-century piece of Americana. Machine-made rocking chair with straight side posts and spindles, with or without arms, and usually decorated with stencil designs.

Bouclé (boo-KLEH)

A fabric woven in imitation of astrakhan wool with knots or loops on the surface.

Bouillotte lamp (boo-YOHTT)

The candle lamp of gilt bronze or brass with a painted tole shade that was set on or hung over the bouillotte table. Wired, it now serves as a popular desk or table lamp.

Bouillotte table

A Louis XVI circular game table, generally made of mahogany with openwork brass gallery and trim and marble top. An extra top, or bouchon, one side covered with leather and the other with baize cloth, filled the space between marble and gallery for a playing surface. Today, few of these tables are used for games; most serve as lamp tables.

Boulle (bool)

Inlay of brass in wood or tortoise shell identified in the work of Louis XIV's celebrated cabinetmaker, André Charles Boulle.

Bow

The first porcelain factory in England, which flourished at Stratford-le-Bow (hence the shortened name) from 1750 until it was bought by the Derby factory in 1776. The most collected and copied of the Bow china pieces are the delicate figurines—the Muses, rustic couples, commedia dell'arte characters, busts of military heroes, and animals and birds. On some of the early pieces, which were painted with oil colors and unfired, the decoration has worn or washed off, leaving them as white as blanc de chine.

Bow front

The arched contour of the front of a chest.

Box pleating

A series of folds in fabric, pressed and sewn flat. A decorative finishing touch for the skirt of a chair, sofa or bed or the heading of a curtain.

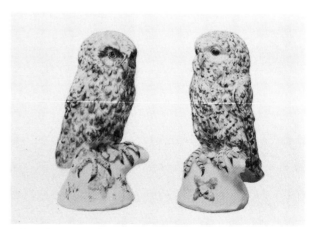

BOW owls, c. 1760. Courtesy Victoria and Albert Museum, London. Crown copyright.

Bracket

Variously, a small decorative wall shelf; a wall lighting fixture; the support or brace between the leg and top of a table, the leg and case of a chest, or the leg and seat of a chair. This may be treated decoratively, as in the pierced Chippendale brackets.

Bracket clock

An eighteenth-century clock that stands on a wall bracket, usually matched to the clock case.

Bracket foot

A simple type of furniture foot with a straight outer edge and a curved inner edge found on eighteenth-century English and American furniture. Chippendale and Goddard and Townsend pieces have more elaborate versions.

Brasses

In decorating, a term synonymous with mounts, or cabinet hardware.

Brazilwood

A reddish wood from Brazil, mostly used at the beginning of the nineteenth century for inlay work and decoration.

Breakfront

A large bookcase or cabinet, the center section of which projects or breaks beyond the two end sections.

Breuer, Marcel

Eminent architect and designer, one of the leading spirits of the Bauhaus school. His chrome-plated steel-and-leather armchair, designed in 1925 and a contemporary classic, has exerted a significant influence on modern furniture.

Brise-soleil (breeze-soh-LAY)

Apt French name for jalousies or louvered windows that screen out the sun but let in cool breezes. They can be standard window size or floor to ceiling, with louvers that operate vertically or horizontally. Many of Le Corbusier's early designs employ the brise-soleil.

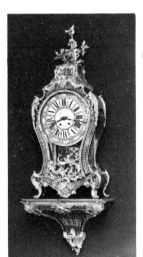

Louis XIV **BRACKET CLOCK.** Courtesy Richard V. Hare, New York.

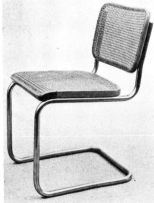

Side chair designed by **MARCEL BREUER,** 1928. Collection, The Museum of Modern Art, New York.

BREAKFRONT. Courtesy Wood & Hogan, Inc., New York

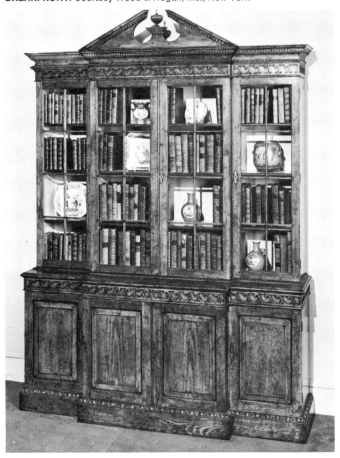

Bristol

Variously, a soft-paste eighteenth-century English china; eighteenth- and nineteenth-century English glass from the Bristol factory; a term loosely applied to many different varieties of opaque and semiopaque glass of which the turquoise-blue Bristol milk glass is but one.

Bristol blue

Originally, this was the cobalt blue of the English glass made at the Bristol factory, but it is now generally accepted to be the rich blue-green, almost turquoise, color of Bristol milk glass.

British Colonial

A style of architecture and furniture developed by British settlers in the West Indies, India and South Africa, based on Georgian designs and interpreted in local materials. Most of the furniture was simple and functional. Notable examples are the campaign chest, the planter's chair and the beautifully dovetailed Bermuda chest.

Broadcloth

A twill, rib or plain-weave fabric of wool and rayon, cotton and rayon, or cotton and silk, suitable for upholstery, slipcovers and curtains.

Broadloom

Solid-color or patterned carpeting woven on a broad loom in widths of nine, twelve, fifteen and

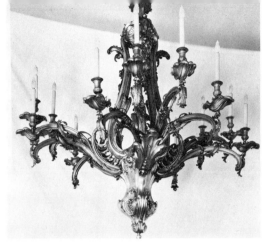

BRONZE DORE rococo 12-light chandelier, marked Caffieri, Paris, 1751. Reproduced by permission of Trustees of The Wallace Collection, London.

eighteen feet. The quality is determined by the closeness of the tufts and the number of rows per inch. The weave may be Axminster, velvet, tapestry, etc.

Brocade

A rich fabric woven on a Jacquard loom with raised patterns resembling embroidery, the preferred material for upholstery, draperies and hangings in the Renaissance, in the eighteenth century, and in today's interpretations of period or traditional room schemes.

Brocatelle

A heavy fabric, usually of silk, with large designs that appear embossed rather than woven.

BRITISH COLONIAL dining table and chairs in Adam style. Brimmer Hall dining room, Jamaica, West Indies.

Broken pediment

A triangular capping found over doors, windows and on furniture in which the peak of the triangle has been cut out and, in some cases, replaced with a carved finial, or a shell or eagle motif. The side lines are either straight, curved or deeply scrolled.

Bronze doré

French term for gilt bronze or bronze dipped in gold.

Brownstone

Reddish-brown sandstone; the building material indelibly associated with nineteenth-century New York City row houses, high, skinny structures with tall windows and a narrow hall and rooms. The brownstone is the New Yorker's nostalgic equivalent of the Londoner's Georgian terrace house, and, although certainly less classic, is becoming equally treasured as a link with a more graceful past.

Brush jar

A deep cylindrical porcelain jar designed by the Chinese to hold writing brushes, revived in the nineteenth century for the amateur artist and today converted to a container for flowers or pencils.

Brussels carpet

Carpeting of worsted yarns woven on the Wilton loom in a variety of designs and colors. The pile loops are uncut, otherwise it resembles a Wilton.

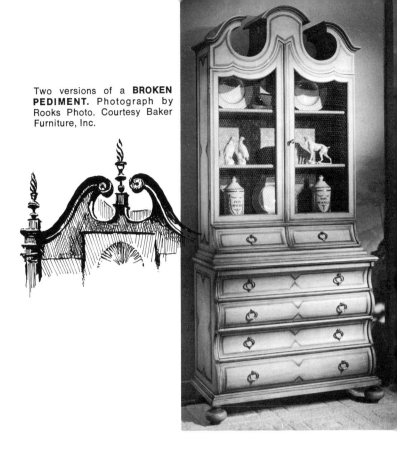

Two versions of a **BROKEN PEDIMENT.** Photograph by Rooks Photo. Courtesy Baker Furniture, Inc.

Brutal Look

A concept of exterior and interior design showing influences of the Egyptian, Mayan and medieval. It emphasizes massive fortress or cavelike forms and effects, characterized by the use of crude materials (stone, sheet metal, heavy beams, thick plasterwork), rough textures in fabrics and materials, ponderous shapes in ironclad furniture.

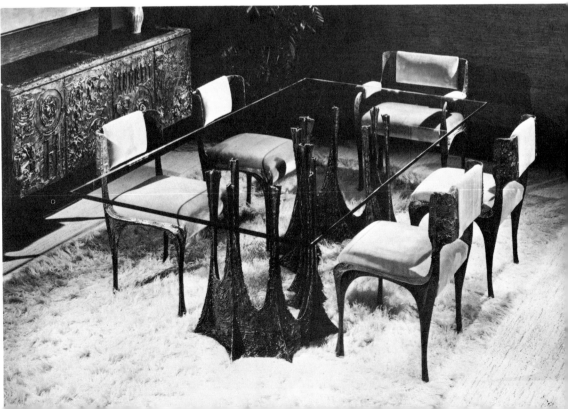

BRUTAL LOOK in furniture designed by Paul Evans for Directional.

Bucket seat

A type of contoured upholstered seat found in contemporary furniture, borrowed from the sports roadsters of the 1930's.

Buckram

A plain-weave jute cloth sized and stiffened with glue, used for curtain headings and valance and for interlining draperies.

Buffet (*bew-FEH*)

An auxiliary piece of dining furniture set against the wall to hold food and serving dishes. Originally a fifteenth-century Italian cupboard, it developed during the seventeenth and eighteenth centuries into different pieces of furniture and can now, by extension, mean anything from a sideboard or dresser to a side table or a simple contemporary storage piece for linens, china, glass and silver.

Buffet-bas (*bew-feh-BAH*)

Capacious low sideboard with drawers and paneled doors found in French Provincial dining furniture. Introduced in the Louis XV period, it was often beautifully carved and was, on occasion, as long as nine feet.

Built-in furniture

Cabinets, chests, bookcases and other pieces of furniture that are integrated with the architecture of a room. This is hardly a new concept. The Japanese have followed it for centuries, and the peasants of the Middle Ages had built-in beds, chests and seats (the more nomadic rich made possessions portable). Today, even freestanding furniture is often designed to appear as if it were built in.

Bull's-eye mirror

An eighteenth- and nineteenth-century style of circular ornamental mirror with either convex or con-

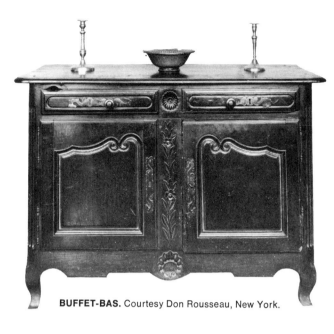

BUFFET-BAS. Courtesy Don Rousseau, New York.

cave glass. When candle brackets are attached, it is called a girandole. The most popular types have eagle pediments and ball decoration around the glass.

Bulto (*BOOL-toh*)

Carved, polychromed figure of a saint, found in the Spanish-colonized southwest U.S. and Latin America. *See also* Santo.

BUILT-IN cabinets, counter and shelves in a room designed by David Barrett, A.I.D.

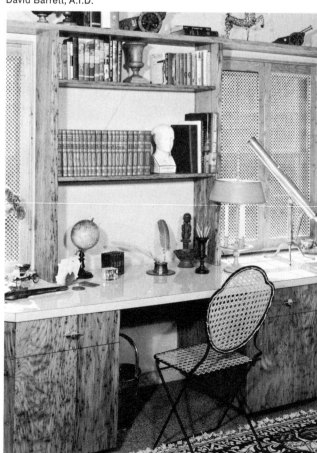

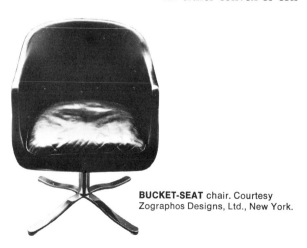

BUCKET-SEAT chair. Courtesy Zographos Designs, Ltd., New York.

Bun foot

A type of foot found on early-seventeenth-century furniture that looks like a slightly flattened ball.

Bureau

One of those words that change meaning according to century or country. Originally it referred to the cover used to protect a table when letters were written. To Sheraton a bureau was what we call a secretary. In the United States today a bedroom chest of drawers is commonly called a bureau.

Bureau plat (*bew-ROH plah*)

A large, handsome French writing table with a flat, oblong, leather-covered top, a row of three drawers, bronze doré mounts and occasionally pullout leaves at each end. Outstanding examples are the Régence-style bureaux plats of cabinetmaker Charles Cressent.

Burge, Yale R., N.S.I.D., A.I.D.

Interior designer and ébéniste, noted for his contemporary interpretations of French country interiors and handcrafted reproductions of seventeenth-, eighteenth- and nineteenth-century French furniture.

Burgomaster chair

An ornately carved chair with a slanting barrel-shaped back and sometimes a swivel seat, an early and imposing type of "office" chair originated by the European burgomasters, or village officials, to underline their position.

Burl

Also burr. A diseased or abnormal growth on trees, exalted to the status of a veneer wood when sliced into cross sections that show up the beautifully mottled or figured patterns.

Burlap

A coarse fabric woven of hemp or jute fibers in wide widths and a range of colors. A bright, hard-wearing drapery fabric, it was adopted wholesale by the budget-conscious in the 1950's and 1960's, despite the fact that it shrinks considerably when cleaned. Today, plain, flocked or overprinted burlap with a paper backing has made a comeback in another role—as a wall covering.

Burnt sienna, burnt umber

Raw sienna and raw umber which have been put through a "burning" process and then mixed with oils. Burnt sienna, a yellowish-brown, and burnt umber, a dark bluish-brown, are both "graying" pigments, used in decorating to deepen a wall color.

Butler's tray

A large wooden serving tray with either a wood gallery on three or four sides or hinged flaps on all sides that let down to extend the flat surface. With butlers in short supply, the tray, on a folding wood base, often serves as a coffee table.

Butterfly chair

Metal-rod frame chair with a winglike sling seat of leather or canvas designed by Bonet, Kurchan and Ferrari-Hardoy in 1938. At one time the most ubiquitous and copied chair in America and still very much on the scene.

Butterfly joint

See Dovetail.

Butterfly table

A popular Early American drop-leaf table, named for the swinging brackets, resembling the wings of a butterfly, that support the leaves.

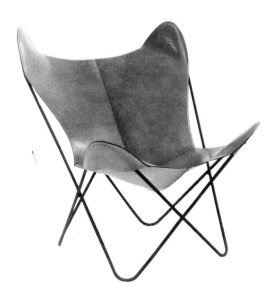

BUTTERFLY CHAIR. Designers: Antonio Bonet, Juan Kurchan, Jorge Ferrari-Hardoy; 1938. Collection, The Museum of Modern Art, New York. Edgar Kaufmann, Jr., Fund. Photographer: George Barrows.

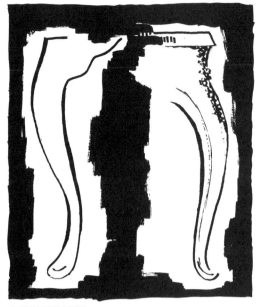

CABRIOLE LEGS.

Cabinetwork

The finer type of interior woodwork and furniture, a far cry from mere carpentry.

Cabochon (*kah-boh-SHOHN*)

A carved, convex oval ornamentation for furniture, copied from the cutting of gems, often found on the cabriole knee of Georgian furniture.

Cabriole (*kah-bree-OHL*)

A type of furniture leg or support that swells outward at the knee, inward at the ankle, terminating at the foot in a short flare, in the form of a conventionalized animal's leg. First appearing in seventeenth-century Europe during the Baroque period, the cabriole leg was adopted by eighteenth-century furniture designers and became almost synonymous with the Queen Anne and Louis XV styles. French cabinetmakers favored a delicate leg terminating in a carved animal's foot—doe, goat, ram or horse—which was replaced in later rococo work by an upturned scroll. English furniture of the same period, notably that of Chippendale, displayed a heavier, carved cabriole with the claw-and-ball foot and shell knee. The excellence of the leg determines the quality of the design, irrespective of style.

Cachepot (*kahsh-POH*)

French term for the elegant cover-up, of porcelain, tole or other materials, that holds and hides a common clay flowerpot.

Café curtains

Tiers of short curtains hung French-café style on rods at various levels so that they can be drawn open and closed to control light and view.

Calamander

An East Indian wood related to ebony, also called coromandel, after the Coromandel coast of India. The wood, which resembles rosewood with dark or black stripes, has a strongly decorative quality that prompted English Regency cabinetmakers to employ it as a veneer and banding wood for table tops.

Calico

Originally, a fine cotton printed with wood blocks in Calicut, India, later copied in coarser American versions.

California Look

A type of decoration characterized by strong visual contrasts—large-scale, low, horizontal shapes in furniture; tall, vertical lines in window treatments and high-rising cabinets; sleek and textured surfaces; white and neutral colors with sharp accents; boldly printed fabrics; dominant, large paintings. Chief exponent of this look is Arthur Elrod of Palm Springs and Los Angeles, who has teamed with William Raiser of New York to form a continent-spanning firm.

Camelback

Characteristic Hepplewhite double-curved chair back. The camelback sofa, a Chippendale design, has only one hump, or curve, across the back.

Cameo glass

An art glass of contrasting colors, cut back and carved in the style of a cameo. Originally made by the Greeks and Romans, it was revived and popularized in the nineteenth century by John Northwood.

Campaign chest

A portable chest of drawers with brassbound corners and handles at either side that was developed in the late eighteenth century to store the gear of officers in the British colonies. The chests were made as both single and stacking units and the upper portion was often fitted as a writing desk. Because of their innate functionalism and austere good looks, which make them perfect contemporary storage units, the chests have been widely copied today.

Canapé (kah-nah-PAY)

French sofa or couch with a curved back that continues into arms sloping around to the front. Originally covered with a canopy, the canapé may have doubled as a day bed.

Candelabrum

Decorative candlestick with two or more branches supported by a single stem, usually found in pairs, when they become candelabra. As the name suggests, this form of illumination dates back to the Roman bronze or marble candlestick or the stand on which a lamp or candlestick was set. Early candlesticks lighted the naves and altars of churches; later lay versions were often extravagantly fashioned of silver, ormolu or gold set with semiprecious stones and regarded as objets d'art. The candelabrum often appears as a classic decorative motif forming part of the design of an arabesque or rinceau.

CALIFORNIA LOOK. Interior design: Arthur Elrod Associates. Photographer: Leland Lee.

CAMELBACK sofa. Courtesy Kittinger.

CANAPÉ. Courtesy Ralph A. Miele, Inc., New York.

Candlestand

The small table with a tripod, pedestal or four-legged base that once held a candlestick but now, as an occasional table, supports an ashtray or glass.

Cane

Flexible furniture material from the rattan palm, split and woven into chair backs and seats and even table tops ever since it was first imported to England by the East India Company in the late seventeenth century. Both simple and sophisticated seating pieces sport caning, which has appeared on everything from Louis XV fauteuils and Sheraton-style settees to Victorian bentwood dining furniture. Today, cane is as popular as ever, either in handmade or less expensive machine-made versions, for furniture, panels and screens.

Caned

Term for furniture with a seat and/or back of woven split rattan. Among the many historic examples: the Charles II or Restoration chair; the caned fauteuils, side chairs and chaise à poudreuse of the Louis XV period; the light and airy Sheraton-style chairs and settees that combined caning with decorated lacquered frames.

Canopy

The wooden frame and fabric hangings over a bed, such as a four-poster. Also, an indoor or outdoor awning of similar design.

Canterbury

Originally, a portable stand partitioned to hold sheet music or cutlery and plates, named for the bishop to whose order it was made. The term now refers to a short-legged magazine rack.

Cantilever

An unsupported projection, designed according to an ancient structural principle. Many chair arms, wall shelves and cabinets are cantilevered.

Canton

Oriental export china, usually blue and white, brought to this country in the late eighteenth century when the China trade was flourishing. Canton is enduringly popular and has formed the nucleus of many a color scheme.

CANE motif on fabric and wallpaper. Interior design by Inman Cook, A.I.D. Photographer: Louis Reens.

CANTERBURY. Courtesy Wood & Hogan, Inc., New York.

Canvas

A rough-textured, plain-weave fabric of cotton, linen or synthetic yarns made in light and heavy weights, solid color and prints. Canvas, used mainly for awnings and canopies, is now in favor also for upholstery and slipcovers.

Capital

The head, or top, of a column that identifies the various orders of architecture—the three Greek: Doric, Ionic and Corinthian; and the five Roman: Tuscan, Doric, Ionic, Corinthian and Composite. In today's plain rooms, the addition of the capital and its corresponding column, either in wood, plaster or papier-mâché, does much to create architectural interest where none exists.

Capiz shell (kah-PEES)

Thin, pearly translucent sheets made from the Philippine windowpane shell and fashioned since Spanish colonial times into screens and accessories, such as the lamp shades, place mats and cigarette boxes we import today.

Capo di Monte (KAH-poh dee MOHN-teh)

Italian porcelain originally made in a factory founded by King Charles IV of Naples at the royal palace of Capo di Monte. The best examples, including beautifully modeled figures marked with a fleur-de-lis, date from this period—1743–1759—and are extremely rare. After this, the factory changed locations and hands and the quality of the work suffered. Eventually the molds were sold to the Doccia factory, and most of the tableware and vases found today, harshly colored and decorated in relief and often marked with a crowned N, are inferior Doccia reproductions.

Captain's chair

A type of Windsor chair with high legs and a low, round spindle back. The captains of nineteenth-century steamers found it a sturdy support while on the bridge or in the wheelhouse.

Carcase

The body or underlying wood structure of a piece of case furniture, which is then elegantly clad with a veneer wood, marquetry or lacquer. The sturdier and more durable the wood, the better the carcase.

Card table

A specialized form of leisure furniture, baize-lined and folding, that originated during the reign of Charles II, although card games had been rife for centuries. Card tables, as status symbols, were often quite elaborate—the Queen Anne walnut table with money cellars, candlestand corners and needlework panels depicting playing cards, for example.

CANTILEVERED table designed by Vladimir Kagan, A.I.D.

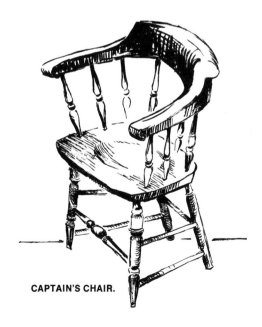

CAPTAIN'S CHAIR.

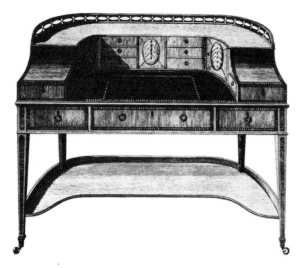

CARLTON TABLE. Plate 60 from *The Cabinet-Maker and Upholsterer's Drawing Book*, by Thomas Sheraton, Third Edition, 1802. Courtesy Victoria and Albert Museum, London. Crown copyright.

Carlton table

Late-eighteenth-century English writing table of mahogany or satinwood with a bank of small drawers and pigeonholes. The center section pulls out or adjusts at an angle for writing or sketching; the apron has wide, shallow drawers for paper.

Carnival glass

An inexpensive, iridescent imitation of Tiffany glass made in the late nineteenth and early twentieth centuries and given away at carnivals or in exchange for soap coupons. Today, although still classed as the poor man's Favrile, it is collected with almost as much zeal.

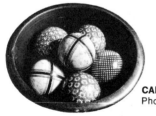

CARPET BOWLS. Photographer: Chuck Ashley.

Carpet bowls

Also known as carpet balls. Solid pottery balls manufactured in England and Scotland for the Victorian indoor sport of the same name, which required a set of six pairs of balls, decorated with colored bands, and a plain white jack. As few houses today boast the mansion-scale home grounds the game demands, the balls are now used decoratively, heaped in baskets or as doorstops.

Carrara glass

Translucent glass used for table and countertops, originally made to imitate the color of milk-white Carrara marble, now also in colors.

Carriage lamps

Ornamental tole, silver or brass oil lamps—the "headlights" of eighteenth- and nineteenth-century carriages. Electrified originals and reproductions now hang on either side of the front door, or light bathroom mirrors and dining-room walls.

Cartel *(kahr-TELL)*

Bronze doré wall clock of the Louis XV and Louis XVI periods, extravagantly ornamented with frames of leafy scrolls and flowers, pastoral figures. Georgian versions of the cartel were of carved, gilded wood.

Cartonnier *(kahr-tohn-YEH)*

A businesslike piece of furniture with cardboard drawers designed for papers, the forerunner in eighteenth-century France of today's file cabinets.

Cartoon

In decoration, a full-sized sketch for the design of a tapestry, rug or wall mural.

Cartouche *(kahr-TOOSH)*

Ornamental medallion in the form of an unrolled scroll with upturned or turned-over edges, inscribed with initials, names, coats of arms. It appeared as the central decoration in architecture or on furniture, but today has declined in importance to a mere motif on china, wallpapers and fabrics.

French **CARTONNIER,** end of 17th century. Courtesy The Metropolitan Museum of Art, Gift of J. Pierpont Morgan, 1906.

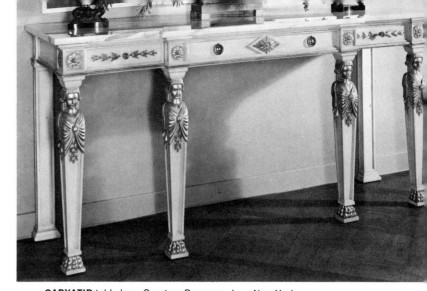

CARVED RUG. Courtesy Celanese Corp.

CARYATID table legs. Courtesy Brunovan, Inc., New York.

Carved rug

Carpet on which pile is cut in different levels to produce a design, either an allover pattern or merely a border.

Caryatid (*KAHR-yah-teed*)

The supporting column shaped like a female figure found in Greek architecture (the male figures were called atlantes). In later centuries, the figures were adapted for table legs, bedposts, mantels, paneling, even lamp bases.

Case goods

The manufacturers' general term for storage pieces, as distinguished from upholstered seating pieces. Today, it may refer to dining-room and bedroom pieces made predominantly of wood.

Casement cloth

Any lightweight sheer fabric used for curtains, as opposed to the heavier drapery fabrics.

Casement curtains

Opaque, unlined draw curtains, heavier than glass curtains, that are hung from a traverse rod. Usually sill or apron length.

Casement window

A window that is hinged either at the top or the side and swings in or out, a feature of many late-seventeenth- and early-eighteenth-century houses. The panes are usually divided and often leaded.

Cassone (*kahs-SOH-neh*)

A large Italian chest decorated with paint, inlays or carving.

Caster

A small wheel, the underpinning that gives furniture greater mobility on its feet. Casters of wood and leather first appeared on European dining furniture and small tables in the early eighteenth century; the brass caster was a late-eighteenth-century improvement.

Cathedral ceiling

An arched, vaulted or gabled ceiling, at least one-and-a-half stories high, adapted from the ribbed construction of cathedrals. It follows the lines of the roof and often has exposed beams with plaster or wood boards in between. Equally popular for contemporary and traditional living rooms.

Walnut **CASSONE,** one of a pair, Italian, late 16th century. Courtesy The Metropolitan Museum of Art. Gift of Stanley Mortimer, 1955.

Cathedral clock

One of the eccentric outcroppings of the nineteenth-century Gothic Revival, this type of clock had steeples, a peaked front, and was sometimes encased in a glass dome.

Wedgwood **CAULIFLOWER WARE** teapot, c. 1760. Courtesy Victoria and Albert Museum, London. Crown copyright.

Cauliflower ware

Pottery designed and colored like a cauliflower, attributed to Thomas Whieldon, an eighteenth-century Staffordshire potter who went into partnership with Josiah Wedgwood. Under Wedgwood's aegis, the green glaze used for the cauliflower leaves was vastly improved and many other potters began to copy the ware, making not only the original teapots, but also bowls, jugs and plates. Wedgwood still makes cauliflower ware, but it is not as fine as the antique, either in the modeling or the glaze color.

Causeuse (koh-ZUHZ)

French term—derived from the verb "to chat"—for a small upholstered settee, larger than a marquise but smaller than a canapé (period sofa).

Cedar

Pale yellow-brown wood with a smooth, fine grain and a delicious fragrance, which accounts for its popularity as a lining for chests, closets and boxes. Eighteenth-century traveling chests were made of cedar, as a protection against moths.

Celadon

Chinese porcelain with a velvety, translucent green glaze varying from gray to blue tones developed to imitate jade. The French name, *céladon,* is said to be derived from that of a character in an eighteenth-century comedy who wore a costume of the same color.

Cellaret

At one time, the deep drawer for bottles in a sideboard. Later it developed into a separate cabinet for liquor, glasses, etc.

Center table

Large, all-purpose, any-shaped table usually plumped in the center of a room or in the center of a seating group.

Chair rail

A strip of molding applied to the wall at the height of a chair top, presumably as a precaution against scuffs and scars. It is often incorporated into paneling, or acts as the divider between dado and upper wall.

Chair table

Seventeenth-century form of dual-purpose furniture, a chair with a large circular or rectangular back that worked on pivots and could be pulled forward to rest on the arms, making a table. Also called a monk's chair. American versions in pine or maple are being reproduced today.

Chair-back settee

Popular form of late-seventeenth-century English settee with an open back resembling two joined banister-back chairs. With an upholstered seat and two or three chair backs, it reappeared in the Queen Anne, Chippendale, Sheraton and Hepplewhite styles, in both England and America.

CELLARET. Courtesy Newcomb's Reproductions.

Chaise longue (*shez LOANG*)

A feet-up seating piece that can take various forms: an elongated chair or sofa with a chair back; a deep bergère extended by a matching upholstered stool; a pair of armchairs bridged by a stool.

Chaise percée (*shez pehr-SAY*)

A caned chair with a lift-up seat, the elegant hiding place for the *pot de chambre* in the time of Louis XV. Today, it performs much the same function in bathrooms, as a decorative disguise for the toilet.

Chamberlain Worcester

Handsomely decorated nineteenth-century English porcelain made by the Chamberlain plant, a competitor of the Dr. Wall Worcester Company.

CHAMBERLAIN WORCESTER plates. Painted and signed shells, T. Baxter, 1808, and apples, T. Baxter, 1809. Courtesy Victoria and Albert Museum, London. Crown copyright.

CHAIR-BACK SETTEE.

Chamfered

Surface where the sharp edge has been cut away at a 45-degree angle, as in a chamfered table leg. On a larger scale, it is said to be canted. Chamfer can also mean a small groove or channel cut in wood or stone.

Chandelier

One of the oldest forms of decorative illumination, dating back to the fourteenth century and originally a French candleholder. Now, any lighting fixture of wood, metal, glass or porcelain that hangs from the ceiling, especially one with two or more branches.

CHAISE PERCEE. Courtesy Paul Associates, New York.

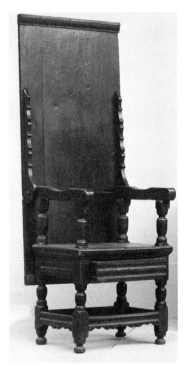

CHAIR TABLE, New England, 1675. Courtesy The Metropolitan Museum of Art. Gift of Mrs. Russell Sage, 1909.

CHARLES X chairs circle dining table in a room designed by James Amster, F.A.I.D. Photographer: Henry S. Fullerton.

CHECKER motif on floor and tablecloth. Interior design by Robert Mason and Michael Vincent, A.I.D. Photographers: Stone & Steccati.

Chantilly (*shahng-tee-YEE*)

French soft-paste porcelain with an opaque white glaze originally made at Chantilly during the eighteenth century, and marked with a hunting horn. The decoration was in the Japanese style, with painted designs inspired by Kakiemon.

Charger

The large, flat serving dish or plate on which, in medieval times, a joint of meat was carried to the table by a servant also known as a charger. Early chargers were made of silver or pewter, later ones of ceramic, decorated with flowers, birds or family crests.

Charles X

A classification that now refers primarily to the pale honey-colored fruitwood furniture in simplified Empire style made during the reign of this French monarch (1824–1830).

Chauffeuse (*shoh-FUHZ*)

A small chair with low seat (rush or upholstered), designed for a vantage point at the fireside, child-size in scale but sturdy enough for adults.

Checker, chequer

A decorative design derived from the checkerboard, with alternating squares of two colors, usually black and white.

Chelsea

Porcelain made at Chelsea, England, from 1745 to 1770. Best-known today are the elaborate services for dinner, dessert, tea, coffee and chocolate; figures and other ornamental pieces; snuff and patch boxes; and the much-copied covered dishes in the forms of birds and animals. The three distinctive ground colors of the Chelsea services—a rich claret-red, a turquoise-blue and a pea-green—set them apart from other porcelains.

Chelsea pottery

The products—mostly figures, bowls and tiles—of a pottery started in Chelsea, London, by David Rawnsley, which has since spread its branches to Mexico and the Bahamas. The craftsmanship and design are of an exceptionally high standard.

CHELSEA rabbit tureen, red anchor mark, c. 1755. Courtesy Victoria and Albert Museum, London. Crown copyright.

Chenille

Fabric or carpeting with a fuzzy, caterpillarlike pile, whether of silk, wool, cotton, linen or synthetics, is commonly called chenille. *See also* Chenille carpet.

Chenille carpet

The most luxurious and longest-wearing of all pile carpeting. Custom-made wall-to-wall carpeting is usually chenille, for it can be woven in any design and color, any width up to thirty feet and practically any shape.

Cherrywood

A warm-toned reddish-brown wood that was popular with Early American cabinetmakers and also in Europe for country furniture and such nineteenth-century styles as Biedermeier. Reproductions of provincial furniture are often made of cherrywood, now more generally known as fruitwood.

Cherubs

Also called amorini or putti. The chubby, winged child figures or heads that, from the Renaissance on, have appeared in decoration in many roguish postures on everything from mirrors to bed canopies. *See also* Putti.

Chesterfield

A large, completely upholstered, overstuffed sofa.

Chestnut

A light gray-brown wood with a coarse, open grain and broad markings that ages to a pale golden-brown. In the early eighteenth century, chestnut was used for tables and desks, but today we mostly see it in paneling or as a table top in country furniture.

Chest-on-chest

American name for the English tallboy, a piggy-back combination of two chests of similar design one resting on top of the other. The upper chest is slightly narrower, with a row of small drawers over three or four long, graduated drawers. The lower chest usually has three or four long drawers and bracket feet.

Cheval glass

A portable full-length mirror that swings from two vertical posts fastened to a trestle. Smaller versions, designed to top a chest or table, have a drawer between the posts.

Chevron

Molding found in Norman and Romanesque architecture, more simply known as zigzag.

Chiaroscuro (k'yah-roh-SKOO-roh)

Art term for the interplay of light and shadow or black and white. A modern example of chiaroscuro is black-and-white op art, which quickly moved from paintings to fabric, wallpaper and plastics.

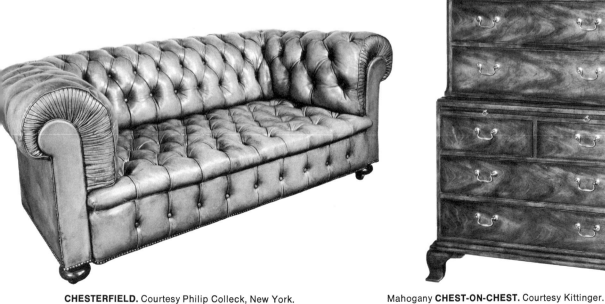

CHESTERFIELD. Courtesy Philip Colleck, New York.

Mahogany CHEST-ON-CHEST. Courtesy Kittinger.

Chiavari chair (k'yah-VAH-ree)

Simple, lightweight, rush-seated chair made in Chiavari, Italy, from a basic design refined for mass production by Gio Ponti.

Chiffonnier (shee-fohn-YEH)

The tall, narrow chest, similar to a semainier but with fewer drawers, developed in eighteenth-century France to hold ladies' needlework and other oddments. The French name means, literally, a collector of scraps or bits and pieces. In nineteenth-century England, the chiffonnier was a type of sideboard with drawers hidden behind doors in the lower section, and occasionally shelves at the top, a design that was adopted in America for a bedroom chest.

Chiffonnière (shee-fohn-YEHR)

Similar in purpose to the chiffonnier, but different in design, this slender-legged sewing table of the Louis XV period has a rectangular top over three small drawers. Louis XVI chiffonnières often had a brass gallery around the top, presumably to corral balls of embroidery yarn.

CHIFFONNIER.
Courtesy Don Rousseau, New York.

CHIAVARI CHAIR.
Courtesy Piazza Originals.

Child's chair

The two types of chair tailored for the small set have changed little since they were first made in seventeenth-century England and early Colonial America. One is the long-legged high chair or feeding chair; the other, a short-legged, miniature version of an adult chair, generally of wood and sometimes with a slip seat.

Chimney piece

The framework around the fireplace opening, a tempting field for embellishment that has traditionally lent itself to adornment by skilled craftsmen, such as the chinoiserie of Chippendale and the jasper-ware medallions of Wedgwood. Modern architects and designers are more apt to stress the importance of the chimney piece as the focal point of a room by facing it with marble, lustrous wood and other decorative architectural materials.

China cabinet

Early form of show-off storage, a large, rectangular cabinet with shelves and glass doors in which seventeenth- and eighteenth-century collectors arranged their prized Oriental porcelains.

China silk

A semisheer, plain-weave silk fabric, popular for curtains and lamp shades.

Chinese Chippendale

A type of English eighteenth-century furniture of the Chippendale school in which Chinese motifs, materials and designs were incorporated into the prevailing styles—dragon feet on chairs and tables, pagoda tops on cabinets and beds, fretwork on chair backs, and painted lacquer finishes.

Chinese household furniture

Simplicity of line, minimum ornamentation and polished woods (mainly rosewood, sandalwood) characterize the furniture made for Chinese houses since the fifteenth century. In its functional beauty, it has much in common with the best of our contemporary design. Among the most representative pieces are small, low-slung tables and storage chests for the seating platform, or k'ang, and small open cabinets designed to stand on tables or chests to display porcelains. Chairs, a later development, are slightly higher than the European equivalent, with

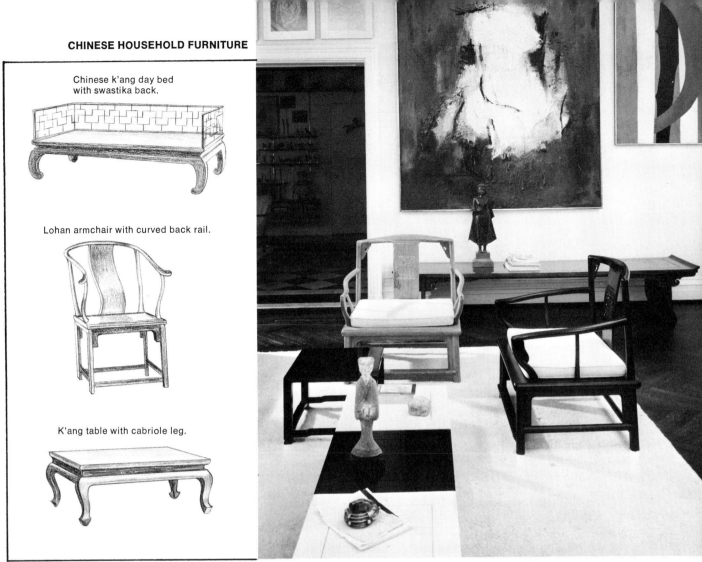

Chinese k'ang day bed with swastika back.

Lohan armchair with curved back rail.

K'ang table with cabriole leg.

Chinese household furniture in a Western living room designed by J. Patrick Lannan. Photographer: Tom Yee.

a stretcher that serves as a footrest, and stools replace chairs for dining. The Chinese bed has four posts and a tester, like the European. Specialized types of table include the writing or painting table, the lute table and a long, narrow side table.

Chinese influence

One of the major style influences in furniture design in the eighteenth and ensuing centuries. The cabriole leg, so much a part of English Queen Anne and French Louis XV furniture, was undoubtedly sparked by a similar Chinese design. Certainly the use of lacquer as a finishing material in the same period derived directly from Chinese lacquered pieces, and Chinese Chippendale was the result of the great English designer's fascination with the many facets of chinoiserie. Even the Victorians, in their untiring pursuit of the exotic and novel,

turned out clumsy and ornate pieces in the Chinese style. So-called "Chinese Modern," the hit of the 1930's and 1940's, was based on Chinese household furniture and today many contemporary designs reflect the best aspects of the Chinese influence: simplicity of line and construction, minimum ornamentation and the use of beautiful woods and lacquered surfaces.

Chinese red

The brilliant orange-red found in Oriental lacquer. During the English and French craze for chinoiserie, the color ran riot—large cabinets and secretaries were painted Chinese red and, in the Regency period, even whole rooms. Today, this stimulating shade is confined to a minor role as an accent color.

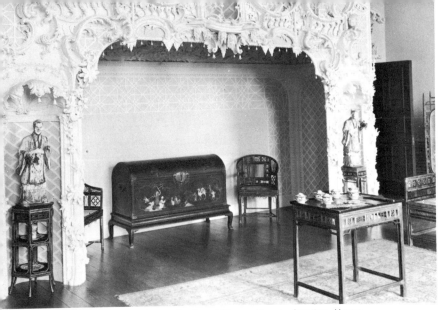

Gilded **CHINESE CHIPPENDALE** armchair.

French-style ribband-back **CHIPPENDALE** armchair.

CHINOISERIE alcove in the Chinese Room, Claydon House, Bucks, England. Courtesy The National Trust. Photographer: A. F. Kersting.

Chinoiserie (*chee-nwah-zeh-REE*)

Popular French term in the eighteenth century for things Chinese or reminiscent in decoration of the Chinese fashion. Today, the word refers to painted or lacquered Chinese designs in furniture.

Chintz

A thin, printed cotton fabric, often glazed, that has been popular for draperies and slipcovers since its introduction in the eighteenth century.

Chippendale (1740–1799)

The most outstanding of the Georgian styles, developed by the master cabinetmaker and furniture designer Thomas Chippendale II (he was the son and the father of cabinetmakers). While Chippendale derived his inspiration from preceding English, French and Chinese sources and worked in a variety of styles, he added a skill and stamp of his own and his expertise was sought after by such guiding geniuses of the time as Robert Adam. Mahogany was Chippendale's favorite wood, from which almost all his furniture was made. Some pieces were lacquered or gilded, occasionally veneered, but never inlaid, painted or with applied decoration. The most reproduced of all English furniture, Chippendale has been and still is the most popular here. *See also* Chinese Chippendale; Irish Chippendale.

Chroma, or color intensity

The measurement of the intensity—or amount of pigment—in a color. The primaries are full-intensity colors. The grayed shades (mustard, green olive, terra cotta, earth tones) have a low intensity. The chroma of a bright color is high, that of a dull one, low.

Churrigueresque (*choor-ree-gay-RESK*)

A seventeenth-century Spanish baroque style introduced by the architect Churriguera, characterized by heavy, curving lines and bold, elaborate surface ornamentation. It carried over into furniture and accessories and remained popular until the mideighteenth century in Spain, Portugal and the Spanish-colonized countries of Latin America, where surviving examples, such as the heavily carved Moorish-style balconies of the eighteenth-century Torre Tagle Palace in Lima, Peru, can still be seen. An outstanding example of churrigueresque is the Transparente in the Toledo Cathedral.

Cinnabar

A type of eighteenth-century Chinese lacquerwork that took its name and rich vermilion color from the cinnabar (red mercuric sulphide) in the lacquer. Modern cinnabar work from Hong Kong—lamp bases, urns, boxes of all sizes, and other decorative objects—cannot hold a candle, in craftsmanship, to the antique.

Ciseleur (*sees-LUHR*)

French name for the great metalworkers of the seventeenth, eighteenth and nineteenth centuries. These craftsmen "chiseled" bronze and precious metals into ormolu mounts, clocks, lighting fixtures

and furniture, and their modeling, undercutting, sharp edges and finishes were as detailed as the finest work of a jeweler.

Clamshell molding

A single-curve molding commonly used for window and door trim.

Clapboard wall

The horizontally planked wall common to Early American interiors, particularly around the fireplace. When vertically planked, it becomes a palisade wall.

Classic

The arts, sculpture and architectural styles of ancient Greece and Rome, which were the wellspring for the classic revivals of the late eighteenth and early nineteenth centuries. Although there had been a resurgence of interest in classicism during the Renaissance, it was later archeological discoveries at Pompeii and Herculaneum that inspired the classic style of Louis XVI and strongly influenced the work of the Adam brothers, Hepplewhite, Sheraton and Wedgwood in England and the Directoire designers in France. The ancient Greek and Roman furniture from which so much later design stemmed was one with the architecture of the times, where proportion and symmetry were in perfect balance. The Greek klismos, a side chair, inspired a similar style in French Directoire, English Regency and the contemporary furniture of the twentieth century. The folding stool, borrowed from Egypt, developed into the Roman curule with curved X-form legs and is now a classic of contemporary design. The kline, or couch, used by both the Greeks and the Romans, was the inspiration for the Récamier chaise longue; and the Roman throne chair, a derivation from the Greek, cropped up again during the Renaissance and was a favorite chair style of the French Empire. *See also* Greek Revival; Neoclassic or Classic Revival.

Claw-and-ball foot

European adaptation of the ancient Chinese motif of a dragon's talons gripping a jewel, found in furniture from the Romanesque period, including many of Chippendale's early pieces where the cabriole leg terminates in a ball held in a bird's claw.

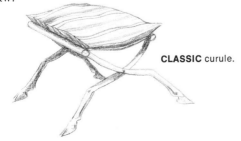

CLASSIC curule.

CHURRIGUERESQUE façade, San José Mission, San Antonio, Texas. Photographer: André Kertész.

Clendinning, Max

Young Irish architect-designer working in England and best-known in the U.S. for his deep-cushioned chairs of painted, bolted-together plywood sections, some squared off, others in free-form jigsaw-puzzle shapes.

Clerestory (or clear story)

A highly placed window favored by modern architects, but hardly new. It was a standard means of introducing top-level light to the lofty interiors of Roman palaces and medieval churches, libraries and refectories.

Clichy (*klee-SHEE*)

French glass factory that flourished at the Paris suburb of Clichy from 1840 to 1870, turning out fine crystal and beautiful paperweights.

Cloisonné (*kloh-ah-soh-NEH*)

A type of enamelwork in which different glaze colors in the design are separated by fine metal dividers, or cloisons. The finest examples of cloisonné come from China and Russia.

Coalport

English porcelain first made in the late eighteenth century and still in production today. Most characteristic Coalport: elaborate, often gilded tea and dinner services in the styles of Chelsea, Dresden and Meissen; vases and small decorative pieces ornamented with flowers modeled in relief.

COALPORT potpourri bowl, c. 1820. Courtesy D. M. & P. Manheim Antiques Corp., New York.

Cobbler's bench

Workmanlike piece of colonial furniture with a seat, bin, last holder and tool compartment, now copied as a coffee table for "Early American" rooms.

Cockfight chair

A switched-around seating piece designed so the user straddled the seat and faced the back, resting his arms on the padded top rail. Also known as a voyelle or voyeuse. Variations of the cockfight chair were the ponteuse, which had compartments for chips and cards in the rail, and the fumeuse, similarly equipped for the smoker's pleasure. In today's less sportive versions, an upholstered section replaces the shelf, or cache. *See also* Voyeuse.

COCKFIGHT CHAIR. Interior design by Melanie Kahane, F.A.I.D. Photographer: André Kertész.

Cocobolo

A variety of South American rosewood, dark-brown with a purplish tinge, that takes a high polish and is mostly used for inlays on large pieces of furniture.

Coffee table

The ubiquitous low table, made in every conceivable style and form, that fronts a sofa. An offshoot of the eighteenth-century tea table, it holds books, bibelots, ashtrays and the coffee—or cocktail—tray.

Coiffeuse (*kwah-FUHZ*)

The home hairdresser—a French Empire dressing table with an oblong top, usually of white marble, drawers, and a mirror on swivel screws between two uprights that ranged from one-third to the full length of the table. The uprights were often fitted with candle arms to throw more light on the subject.

Collection

A display of personal treasures such as paintings, sculpture, china, primitive art, objects with a similar theme or mementos.

Colonial

In America, the period from the earliest settlements to the Revolution, a designation sometimes mistakenly applied to furniture and accessories of American origin up to 1850. As a generic term it refers to styles developed in the colonies of any country—British Colonial, Spanish Colonial and so on.

Colonnade

In architecture, a line-up of freestanding or supporting columns, either as part of the design of a building, an approach or a decorative flourish. Colonnades were an outstanding feature of architecture in the classic style in the cities of northern Italy and England's Regency spas, and today they have been reintroduced by such contemporary architects as Edward Durell Stone. In furniture, Renaissance and Gothic Revival chairs have colonnaded backs, and modern wallpapers may be printed with colonnaded vistas, a device that visually opens up the limited space of a small hallway.

Color intensity

See Chroma.

Color spectrum

The gamut of rainbow colors from violet through blue and green to yellow, orange and red that occurs when a beam of white light is refracted through a prism.

Color value

The lightness or darkness of a color is considered its value, and the value can be low, medium or high. A shade has a low value, a tint a high value.

Color wheel

A circular chart showing the relationship of primary, secondary and tertiary colors and their values —the tints and shades.

Colorism

A deliberate study in contrasts, the juxtaposition of pale and strong colors to create dramatic effects.

Colorways

Trade term for the various colors in which a textile, plastic laminate or china pattern is produced.

Column

A vertical support or pillar, fluted, carved or plain, topped with a capital that identifies the architectural style.

Comb back

A high back seen on Windsor chairs, with many spindles set like the teeth of a comb into a broad top rail.

Commode (*kohm-MOHD*)

French word for a chest of drawers. The prim Victorians pre-empted the word to describe a stool or box which held a chamber pot.

Compass window

Alternate term for an oriel window.

Complementary color scheme

One in which colors diametrically opposite in the color wheel are combined, but not necessarily in balance—red and green plus white or black qualifies as a complementary color scheme.

Confessional (*kohn-fess-yoh-NAHL*)

The forerunner of the wing chair, a large, high-backed, fully upholstered chair with wings introduced during the Louis XIV period.

Confidante (*kohn-fee-DAHNT*)

Aptly named three-in-one sofa consisting of a center section with two smaller, angled seats at either end.

English **CONFIDANTE**, c. 1770–1780. The Metropolitan Museum of Art. Henry and Anne Ford Fund Gift, 1958.

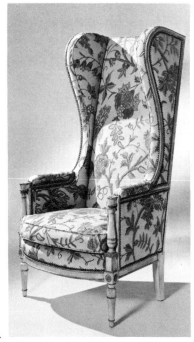

CONFESSIONAL. Courtesy Yale R. Burge, New York.

Conservatory

Glass house or room for the care and rearing (or conserving) of plants, a familiar feature of the Victorian mansion, but seldom seen today.

Console

In effect, a wallflower in furniture. Any slim table or shelf designed for wall support. Usually a small table hung on the wall with curved or otherwise ornamental supports.

Constitution mirror

American mirror of the Sheraton type, dating from about 1791. It was usually gilded, with columns up the sides of the frame, a series of ball decorations under the cornice and a painted panel below. In nineteenth-century versions, the panel often depicted the frigate *Constitution* in action during the War of 1812, which presumably accounts for the name.

Contemporary

A term applied to furniture and objects designed to meet the functional demands of the period. A Louis XV bergère was as contemporary in its day as the pole storage system is in ours.

Contemporary or International style

A uniquely twentieth-century concept of furniture design that originated with the Paris Exposition of Decorative Arts in 1925 and the French style known as Art Moderne and found its first great exponents in the Bauhaus school in Germany, out of which came the outstanding contributions to contemporary design in plastics and metals—the classic example is the Barcelona chair. Before World War II, Swedish Modern swept America and, ever since, the Scandinavian school has remained the greatest producer of contemporary furniture for mass consumption. American designers such as Knoll, Eames, Saarinen and Nelson—all of whom had firm foundations in architecture—also set a high standard of good design that filtered down to the mass market.

In recent years, the still-transitional style has embraced many daring innovations—and quite a few fads. Highly imaginative forms in plastic, polyurethane foam, plywood and tubular metal are constantly emerging from experimental designers both here and in Europe. Notable among them are the sinuous chaises and chairs of Olivier Mourgue and Pierre Paulin of France; the squared-off block furniture of France's Roger Legrand and England's Max Clendinning; the shaped, upholstered plastic Elda chair and bent-plywood chair of the Italian Joe Cesare Colombo; the see-through furniture of America's Neal Small and Laverne; and the molded-fiberglass ribbon chair of Scandinavian designer Verner Panton. While the keynote is plasticity, the general characteristics may be defined as simple, flowing lines, elimination of unessential detail, adventurous adaptation of new materials and an iconoclastic approach to form and function.

Contract

Decorating or contract work. Trade term for interior designs executed for commercial firms on a price fixed by contract.

Modern **CONSERVATORY** in California. Photographer: Max Eckert.

CONSOLE. Courtesy Brunovan, Inc., New York.

CONTEMPORARY FURNITURE DESIGN

1. Chaise longue designed by Olivier Mourgue.

3. Upholstered polyurethane-foam blocks designed by Sebastian Matta.

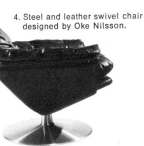

4. Steel and leather swivel chair designed by Oke Nilsson.

2. Ribbon chair designed by Pierre Paulin.

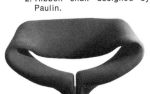

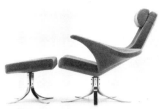

6. "Sea Gull" chair and footstool designed by G. Berg & Stenerik Eriksson.

7. "Margherita" fiberglass table and chairs designed by Raimondi.

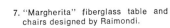

5. "Marcel" upholstered group designed by Kazuhide Takahama.

8. Steel-wire chair and ottoman designed by Warren Platner.

9. "Cognac" fiberglass shell chair designed by Eero Aarnio.

10. Molded plywood chair designed by Charles Eames, 1946.

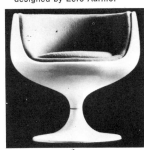

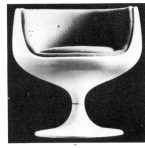

11. "Satellite" inflatable vinyl chair designed by Nguyen Khanh; photographer: Daniel Smerck.

12. Sled chair of stainless steel and cane designed by Ward Bennett.

13. Chesterfield vinyl inflatable sofa designed by Nguyen Khanh.

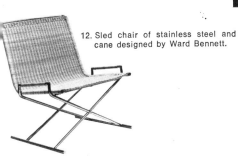

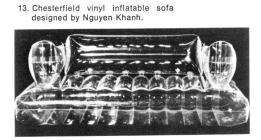

14. Molded fiberglass chair designed by Verner Panton.

15. "Wassily" chrome steel chair designed by Marcel Breuer, 1925.

17. Tempered plate-glass chair designed by Fabio Lenci.

16. Plexiglas chair designed by Spiros Zakas Associates.

57

Courtesy of: Brickel Associates, Inc., New York (12); Dux (4); Fritz Hansen, Inc., New York (6); Knoll Associates (3, 5, 8, 15); Herman Miller (10); Herman Miller AG, Basel, Switzerland (14); Quasar Inflatables (11, 13); Stendig (7, 9, 17); Turner-T., Ltd., New York (1, 2); Spiros Zakas Associates, New York (16).

Conversation group

A scrupulous arrangement of furniture—chairs, sofas, benches, ottomans and small tables—planned to allow a number of persons to engage comfortably in conversation.

Conversation pit

A recess in the floor, padded for seating, that answers the modern dilemma of where to put the sofa by literally sinking it into the room.

Convertible sofa or sofa bed

A conventional-style sofa which conceals an innerspring mattress under the seat cushions and unfolds to make a bed.

Convex wall mirror

Late-eighteenth-century English circular mirror in the French Empire style. The frame, carved and gilded, was embellished with classical motifs and surmounted by a spread eagle—which accounts for its later adoption by and identification with American Federal, although most of the mirrors found in America actually came from England or France. The girandole mirror is a convex mirror with lateral candle arms.

Cool colors

Those with a blue or green content suggesting the sky, water, foliage—about half the spectrum. Not only the pure hues are considered to be cool—red with a high blue content qualifies as a "cool" red (and conversely, green becomes "warm" when it has a high red content).

THREE TYPES OF CORBEL

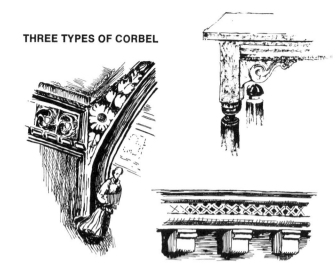

Copies

Replicas or reproductions of pieces from previous periods. In furniture, the scale may be changed to fit the size of modern rooms or some detail may be omitted, but in general the copies are faithful to the originals. In china, the colors may change and occasionally a new shape is added.

Coquillage (koh-key-YAHZH)

From the French coquille (shell), the term for the shell motif in ornamental design. Synonymous with the rococo, it is also found in Chippendale's French-style furniture.

Corbel

Architecturally, a bracketlike projection from a wall that supports a beam or molding, first used on Gothic buildings. Early corbels were carved or molded in fantastic shapes, such as gargoyles. Today, corbels salvaged from old buildings are attached to the walls of modern rooms as decorative brackets or simply to add interesting detail.

Corduroy

Cotton velvet with wales, or ridges, in the pile. An informal fabric once seen only in rooms reserved for games or children, corduroy, particularly the wide-wale variety, has recently been taken up for upholstery in elegant living rooms.

Corner chair

An open-arm chair with not one but two backs on adjoining sides, a leg at each corner and a fourth leg in the center of the front. Also called a roundabout chair. Today, it is often used as a desk chair.

CORNER CHAIR, front and back. Courtesy Yale R. Burge, New York.

Cornice

A decorative crown, referring either to the top of a piece of furniture or, more generally, the finishing molding of a column or ornamental wood border installed above windows to conceal drapery and curtain rods and to add a finishing touch. *See also* Cove.

Cornice lighting

Striplights concealed behind a cornice or cove of wood in such a way that the light is directed upward to be reflected softly from the ceiling of a room, thus creating a sense of overall illumination. Also called cove lighting.

Cornucopia

The horn of plenty, a decorative furniture motif since the Renaissance.

Coromandel screen

A type of Chinese paneled screen, heavily lacquered in rich, dark tones and decorated with either bas-relief patterns or landscapes, figures, houses and flowers. The name, which derives from the Coromandel coast of southeast India, was presumably adopted because the screens were originally shipped from there to Europe by the East India Company during the seventeenth century.

Cost plus

A type of contract decorating where the client is billed for merchandise at wholesale cost plus a percentage for design, shopping and overhead.

Couch

French seventeenth-century forerunner of the day bed, a restful affair on which the fatigued could recline supported by arms and cushions at one or both ends.

Counterpane

The decorative bedcover with raised or quilted pattern that topped nineteenth-century beds.

Country Chippendale

A simple, transitional American country version of Chippendale furniture, generally chairs. With the recent vogue for all provincial styles, Country Chippendale has become rare, and more expensive than it has any right to be.

COROMANDEL SCREEN. Photographer: Grigsby.

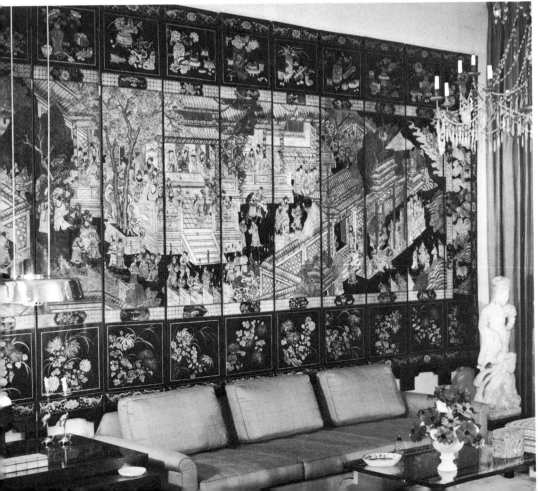

Country Look

An informal, comfortable, provincial style of decorating, rustic or sophisticated, that adapts equally well to city apartments and country homes. Almost anything of this nature goes in the Country Look—provincial furniture from different countries; Early American pine or clean-lined modern furniture; clear, strong colors and fabrics ranging from linens, cottons and chintzes, wools and tweeds to velvets and silks. Backgrounds may be "old" plaster or brick, barn siding, pecky cypress, rough-hewn beams or documentary prints.

Court cupboard

A movable closet or buffet of elaborately turned and carved oak that held and displayed china and other tablewares in the sixteenth and seventeenth centuries.

English oak **COURT CUPBOARD,** c. 1610. Courtesy Victoria and Albert Museum, London. Crown copyright.

Rustic version of the **COUNTRY LOOK.** Interior design by Howard Perry Rothberg. Photographer: Otto Maya.

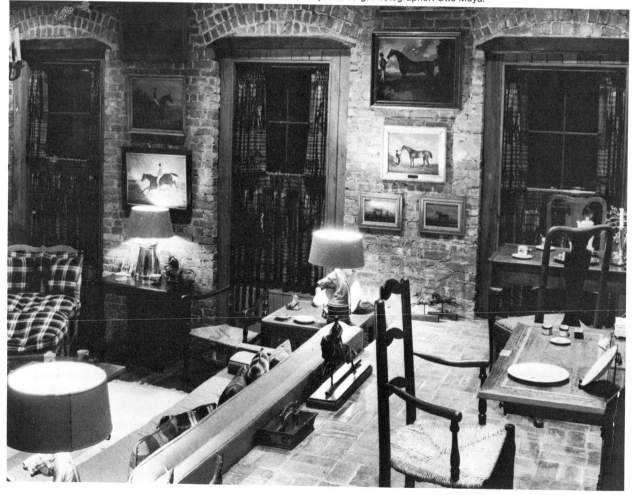

Courting mirrors

Small mirrors with inlaid or painted glass frames brought to America from China on the clipper ships, presumably as gifts from sailors to their sweethearts, and now reproduced here.

Cove

Also called cornice. The concave surface that joins the wall to the ceiling. *See also* Cornice.

Cranberry glass

Nineteenth-century English and American glassware of a distinctive ruby-red color with a purple tinge, seen in goblets, pitchers and the fonts of oil lamps. Old cranberry glass is both collected and reproduced.

Crash

Comprehensive term for a group of cotton or linen fabrics with loose, coarse yarns and uneven, rough texture; sheers are used for glass curtains, heavier weights for slipcovers and over curtains.

Crazing

A network of tiny cracks on the surface of a glaze.

Crédence (kreh-DAHNSS)

A massive and elaborate type of French Renaissance two-part buffet for the storage of valuable plate. The oblong horizontal upper section, usually paneled and carved, with one or more doors, was mounted on a stand with a carved frieze and four supports fastened to a floor-level display shelf. The crédence had traceried iron mounts often backed with red velvet to show off the detail.

Credenza

Italian name for the French crédence, a side table of Gothic persuasion which developed into a sideboard for carving meat and displaying plate. Today, in addition to acting as a display cabinet, it may be used to hold books or a TV–hi-fi system.

Creil (kray)

Glazed soft-paste pottery made in the French town of Creil-sur-Oise during the late eighteenth and early nineteenth centuries and ornamented with black stencil designs on one of three ground colors —white, canary-yellow or water-green (rare). Motifs were drawn from such assorted subjects as

Modern **CREIL** by Mottahedeh.

days of the month, military heroes or balloon ascensions. Since no true Creil has been produced for many years, its rarity and distinctive character have made it a choice collectors' item.

Crest

In decoration, the upper part of chairs, mirrors and secretaries, often carved, when it is known as cresting.

Cretonne

A cotton or linen fabric conspicuous by its large floral and flamboyant designs on a plain, damask or rep-weave background. Regarded as an essentially country-house material for slipcovers and curtains, cretonne has the virtues of being easily laundered and difficult to muss.

Crewel

A showy type of embroidery worked with colored worsted yarns and long, loose stitches on natural or white linen, cotton or wool grounds. Crewel had a tremendous vogue in the seventeenth century and is currently enjoying a revival in contemporary colors and motifs as well as the familiar traditional ones. While multicolor designs of early crewel were often based on printed India cottons, such as the tree-of-life pattern, we reverse the process by printing the designs of crewel in drapery, upholstery and slipcover fabrics.

Crocket

The projecting flowers or foliage of Gothic architecture that decorates the angles of spires, pinnacles and canopies or is carved at intervals on the edge of vertical moldings. The motif reoccurred in English Gothic Revival furniture, on cabinets and bookcases.

CRYSTAL in the dining room, Luton Hoo, Bedfordshire, England. Courtesy the British Travel Association.

Crossbanding

On furniture, a veneer band or strip where the grain runs crosswise.

Crystal

A many-faceted mineral, this clear, transparent quartz has for centuries been cut into prisms to reflect and intensify the light of chandeliers and girandoles. Chunks of natural, uncut crystal make wonderful decorative paperweights. Since glass is often cut to imitate the sparkle of crystal, the name has been adopted for stemware and other table accessories.

Cubism

One of the art movements that followed Impressionism in which cubes and other abstract geometric shapes, rather than representation, were emphasized. Picasso, Gris and Braque were all exponents of Cubism.

Cumming, Rose (1887–1968)

Grande dame of decorating whose highly individual and flamboyantly eclectic style, far ahead of its time, reflected her personality and preoccupation with the visual relationship of beautiful furniture and objects, regardless of era. Although her taste ran to the antique rather than the modern, she pioneered in the 1920's and 1930's the use of strong, clear tones and unconventional, striking color combinations that were then regarded as avant-garde but later became clichés.

Cupboard

In medieval times, an open framework fitted with boards or shelves to hold cups. It gradually evolved into a piece of furniture, either fixed or movable, with enclosed shelves for dishes, linens, food, etc. Among the many types of cupboard are the ambry, armoire, panetière, wardrobe, press, kas, court cupboard and encoignure. Cupboard can also refer to an enclosed compartment in a piece of furniture, such as the cupboards in Sheraton sideboards.

Cupola

Decorative dome set on a roof, either as a skylight to illuminate an inner hall or stair well or to break up a long, horizontal elevation by directing the eye upward. Cupolas were a feature of many Georgian, Palladian and Greek Revival houses built in the classic tradition.

Curule (kew-REWL)

The Roman bench or camp stool with curving X-form legs, a classic shape echoed in furniture design of succeeding centuries, notably the Directoire campaign chair and the Mies van der Rohe Barcelona chair.

Custom

Decorating jargon for anything designed and/or made to order.

Cutting

Interior designers' term for a small, pinked piece of fabric used as a sample. Also called a swatch.

Cyma curve

A simple S-shaped curve that takes its name from the Greek word for wave. The cyma recta is the ogee molding; the cyma reversa, the reverse ogee molding.

Silk **DAMASK** fabric by Scalamandrè,
late French Renaissance design.

Dadaism

From the childish French word for hobbyhorse,
dada, came the adopted name of an anarchistic
artistic cult led by Tristan Tzara that produced
nonobjective art with deliberate shock value as a
means of breaking through the prevailing bour-
geois concepts of art. The movement had a brief
life, from 1916 to 1922, and was eventually ab-
sorbed by Surrealism. Dada exponents: Marcel
Duchamp, George Grosz.

Dado

The lower part of a wall topped by a chair rail,
decorated with a panel of wood, paper or paint.

Dais

In medieval times, the high table at which hosts
and guests dined, or the raised platform on which it
stood. By extension, a platform at the side of a
room, now mostly used to elevate and set off a bed
or a dining area.

Damask

A reversible, self-patterned and usually self-colored
fabric of silk, cotton, wool, linen or synthetic fibers
made on the Jacquard loom. Favored since the
seventeenth century as a formal, traditional fabric
for upholstery and curtains, damask has the engag-
ing quality of also combining easily with contem-
porary furniture. The name is derived from
Damascus, where the material was first made in the
twelfth century.

D'Arcy, Barbara, A.I.D.

Display-decorator for Bloomingdale's, New York,
who brought back high-style decorating on a de-
partment-store level. Her interiors are distin-
guished by the use of bold color combinations—
black with a vivid accent; sharp tones of one color
family—and by massed groupings of unusual ac-
cessories.

Davenport

Originally a small writing desk; now a common
U.S. term for an upholstered sofa.

Davenport (ceramics)

Earthenware, stone china and bone china made at
Longport, England, from 1793 to 1882 in a deco-
rative range that embraced the country freshness of
sprigged blue-and-white patterns and other cottage
styles, copies of Imari and the more opulent pat-
terns of Chelsea and Derby.

Davenport table

A long, narrow table placed behind a davenport or
sofa, especially when the sofa stands out in the
room. Also known as a sofa table.

Day bed

A bed treated as a sofa, with twin ends, to serve as a
seating piece during the day. Or, alternately, a sofa
that becomes a bed.

Deacon's bench

American name for a Windsor settee with four back divisions contoured like chair backs.

Deal

The English term for pine, originally from the German word for plank.

Decalcomania

A mania that is both pretty and practical, also known as transfer. A picture printed in reverse on paper is transferred to an object (china, furniture, etc.) by first sticking the paper on and then peeling it off, leaving the picture behind. This was yet another of the eighteenth-century's decorative stratagems, devised as a timesaving substitute for hand painting when the demand outstripped the supply—as, for instance, on Staffordshire ware. Today you mostly see decalcomania on children's furniture and walls.

Decor

Straightforward French word for decoration that in this country has been debased by being applied wholesale to the appearance of anything from a restaurant to a rest room, now regarded as a tasteless cliché.

Decorative hardware

The handsome metal accouterments for a house—locks, pulls, hinges for furniture and doors; decorative curtain rods, rings and tiebacks; elaborate bathroom fittings such as faucets and towel bars.

Decorator's item

Current cant for any unusual or eye-catching piece of furniture or accessory, which may or may not have real value.

Découpage (day-koo-PAHZH)

The fanciful eighteenth-century art of decorating the surfaces of household objects (chairs, tables, screens, urns, boxes) with paper cutouts and then applying several thin layers of varnish to produce a hard, almost indestructible finish. Like the fantasy finishes (faux marbre, faux lapis), découpage still has its devoted practitioners.

Delft

Specifically, the tin-slip or enameled faïence made in the town of Delft, Holland, since the seventeenth century. The blue-and-white pottery is the most familiar and popular, although there are other versions in polychrome or aubergine on a white ground. The Delft factories also turn out the traditional blue-and-white tiles that have enjoyed equally long life and favor.

Delftware

English name for any tin-glazed earthenware or faïence whether from the Netherlands or elsewhere.

Della Robbia

Tin-glazed terra-cotta reliefs modeled by the Della Robbia family of Florentine sculptors. Most familiar are the borders of wreathed fruits and reliefs of the Madonna.

DECORATIVE HARDWARE

Courtesy Paul Associates, New York.

DELFT JAR.

DECOUPAGE panel. Courtesy The Cooper Union Museum, New York.

Demilune

Term for a console table or fan window that takes the shape of a half circle.

Denim

Anglicized from *serge de Nîmes* (Nîmes being the town in France where the fabric was first made), the word "denim" denotes a heavy cotton sold by weight, usually yarn-dyed and woven in twill (parallel or diagonal lines or ribs) and geometric figures.

Dentils

A row of evenly spaced cubes that stand out from a cornice molding like projecting teeth. An architectural detail found in Ionic, Corinthian and Composite orders and in interiors of the Georgian persuasion.

Derby

English porcelains made at Chelsea, Bow and Derby from 1756 to 1848, but all bearing the Derby mark (the Bow and Chelsea factories were taken over by the founder of Derby, William Duesbury). Among the more notable products are the figurines, either undecorated white or painted and gilded, and the elaborate table services, especially those in imitation of the Japanese Imari designs. The porcelains were known as Crown Derby from 1786 to 1811, Bloor Derby from 1811 to 1848 and Royal Crown Derby from 1877 to 1889.

de Wolfe, Elsie (1865–1950)

Turn-of-the-century actress who became an interior decorator and is generally credited with founding that profession in America. Her style was based on eighteenth-century furniture, floral chintz and "suitability." The introduction of lattice as an indoor decorating device was one of her innovations, initiated by her gardenlike scheme for the members' dining room in the Colony Club.

Diaper

A diagonal pattern made up of regular repeats of small geometric or floral motifs, often found on porcelains and also in tapestries woven in Ypres, in the sixteenth century, hence the name.

Dimity

A sheer woven cotton fabric popular for curtains and bedcovers. It comes in corded, striped and checkered patterns.

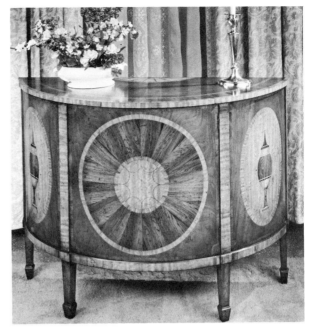

DEMILUNE commode. Courtesy Wood & Hogan, Inc., New York.

DERBY dessert basket and stand, c. 1760. Courtesy Victoria and Albert Museum, London. Crown copyright.

DIAPER-PATTERN fabric and wallpaper by Howard & Schaffer, New York.

DIRECTOIRE acajou fauteuil with gilt mounts and inlaid marble table with gilt, bronze and mahogany base.

Directoire (1795–1804) (*dee-reck-t'WAHR*)

A simple and direct style of transitional furniture with a character of its own that emerged during the Directory and Consulate of France, between the fall of Robespierre and the rise of Napoleon. Still clinging to the classic tradition of Louis XVI, the furniture was mainly straight-lined, with a judicious use of classic curves, but motifs derived from the antique—swans, stars and lyres—were augmented by symbols of the French Revolution. Local walnut and fruitwood were used rather than imported mahogany, and combinations of metals. The charm of Directoire persists today in antiques and reproductions of such enduring designs as the Récamier chaise and the folding campaign chair.

Director's chair

An inexpensive wood-frame folding chair with X-shaped turned legs and canvas, leather or plastic seat and back slings. Originally the on-set throne for Hollywood directors and movie stars and now a universal favorite for casual indoor and outdoor seating.

Distressed

Finish designed to age furniture prematurely, achieved through extreme measures that include beating with chains, stabbing with awls, shooting with BB's.

Divan

The epitome of luxurious lounging, this low, upholstered and tufted, backless and armless couch was an emulation in furniture of the voluptuous pile of rugs and cushions on which the Turks loved to recline. Contemporary versions hug the floor and are often covered in soft, supple leather.

Documentary

A reproduction of a design taken from an antique or old fabric or wallpaper, either a faithful copy of the original or a rescaled or recolored version.

Dogtooth

Simple ornamental repeat motif of Norman and Early English architecture, consisting of a series of wedge-shaped carvings like the teeth of a dog.

Dolphin motif

A decorative motif employed by maritime nations since the days of the Greeks and the Romans and adopted by the French because it symbolized love— Madame Pompadour owned ormolu dolphin candlesticks. Along with the ram, the eagle, the sphinx and the lion, the graceful dolphin was a dominant furniture motif in the Regency period, appearing in carved and gilded form on chair and table legs and cabinet bases, notably the dolphin chairs and settees at the Royal Pavilion, Brighton. In America, the dolphin motif was reproduced in Sandwich glass collections.

Dome

A rounded, raised roof on top of a building. Private houses today seldom support domes, which are mainly confined to public buildings, such as the Capitol in Washington, D.C. *See also* Cupola.

Domino wallpapers

Imitations of marble graining printed on sheets of paper, similar to and named for those produced by the Dominotiers in sixteenth-century France.

DOGTOOTH pattern in upholstery fabric. Photographer: Otto Maya.

Donegal carpets

Hand-knotted carpets made in County Donegal, Ireland, since 1898. The early carpets were inferior to those made in France and Spain, but the present-day versions are of exceptionally fine craftsmanship and are often similar, in color and design, to eighteenth-century Savonnerie carpets.

Dormer window

A window built out from a sloping roof to bring light to a top-floor or attic room.

Douglas fir

Also called Oregon pine. A strong, durable, honey-toned softwood with a curly grain, used for modern furniture.

Doulton pottery

Wares from a factory that first produced simple salt-glazed stoneware in the nineteenth century and progressed to more decorative "art pottery." By permission of Edward VII, Doulton became Royal Doulton in 1901, and it was then that the factory introduced rouge flambé, sang de boeuf and crackle glazes from rediscovered glazing and coloring techniques of the Sung and Ming potters of China. Probably most familiar today are the Royal Doulton figurines and Toby jugs.

Dovetail

A type of joint usually found in drawer construction in which two notched pieces of wood in the shape of a dove's tail interlock tightly at right angles. A variation of this is the butterfly joint that fastens boards lengthwise and is now mainly used decoratively in the construction of desks, table tops and flooring.

Dowel

A form of construction joint in which the sections are joined by fitting round pegs or pins into corresponding holes.

Draper, Dorothy (1890–1969)

Interior designer whose trademark, in the 1940's, became the huge red cabbage roses and green-and-white stripes she lavished on rooms in wallpaper and fabric.

Draperies

The essential window dressing. Fabric panels, either stationary at each side of the window or made to draw across on rings or traverse rods. Although the words "curtains" and "draperies" (never drapes) are now used interchangeably, technically curtains, or glass curtains, are the inner layer of fabric that covers the glass, draperies the outer, more decorative layer. Bed hangings are also known as draperies.

Draw curtains or traverse curtains

Curtains and draperies that slide back and forth on a track through a system of cords and pulleys operated either by hand or electrically.

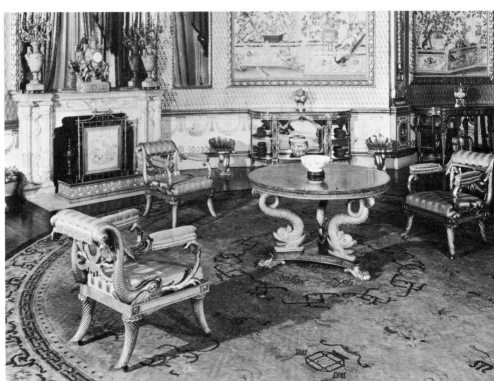

DOLPHIN MOTIF in furniture. Royal Pavilion, Brighton, Main Salon. Copyright *Country Life*.

Drawing room

Abbreviation of the eighteenth-century withdrawing room, where diners assembled after dinner. In more recent days, the show-off room of the house, where guests were received. Now a rarity, in speech or in fact.

Dressing table

Almost any form of table, elaborate or simple, that is designed to further the art of primping—by means of a mirror, drawers or compartments for cosmetics and toilet articles, and kneehole space for the user. Among the more noteworthy examples are the Beau Brummel, a version for dandies, and the French poudreuse, or powder table.

Drop handle

A pendantlike pull for drawers or doors, a feature of seventeenth-century furniture.

Drop repeat

A design technique for printing fabric and wallpaper in which the pattern on the left and right edges is not in direct horizontal alignment, thus making the scale seem larger, the pattern livelier.

Drum table

A round table resembling a drum, often leather-topped, with a band of drawers set into a deep apron.

Dry sink

A nineteenth-century cupboard with recessed well lined in metal for washing dishes. Water was brought to the dry sink since it had no plumbing

DRUM TABLE. Courtesy Kittinger.

DROP HANDLE.

connections, but today plants or a bar may be installed instead.

Dual purpose

Term applied to a type of room or piece of furniture with twofold functions—for example, study-guest room, living-dining room, sofa-bed.

Duchesse (dew-SHESS)

Combination upholstered chair and ottoman that pair up to form a couch or variation of a chaise longue, usually broad of seat and long on comfort.

Duck

Heavy plain-weave fabric, printed or solid color, of cotton or synthetic fibers, suitable for slipcovers on indoor or outdoor furniture and cushions. Similar to canvas, but a flat, rather than a twill, weave.

Dumbwaiter

Self-service invention of the eighteenth century, an English circular table with three or four tiers revolving around a center post, with drawers and trays designed to hold plates, silver, bottles and glasses. The single-tiered version developed in America for condiments is called a "lazy Susan." Another, less silent version of the dumbwaiter was the creaking rope-pulley lift that in Victorian days carried dishes and food from basement kitchen to upstairs dining room.

Dummyboard figures

In England and the Low Countries during the seventeenth and eighteenth centuries these boards, cut out and painted to resemble human beings, animals or pieces of furniture, were stationed at the end of dark corridors to act as friendly guideposts. We stand them beside the fireplace or hang them on the wall, purely as decoration.

Duppioni

A silk fabric with long, thin slubs which give it an irregular textural surface.

Duquette, Tony, A.I.D.

Set designer-decorator who works mainly for the movie medium. His rooms are massed with beautiful objects set off by subtle colors in an often Oriental splendor—the total effect is one of museumlike profusion, exotic and occasionally bizarre.

DUMMYBOARD FIGURES. The Old Palace, Bromley-by-Bow. English, c. 1606. Courtesy Victoria and Albert Museum, London. Crown copyright.

Dust ruffle

A floor-length fabric ruffle, shirred, pleated or tailored with kick pleats, that is attached to a bedspread, the box spring or the bedrails, not so much to keep dust from under the bed as to cover the legs of the frame and the base of the box spring. It is usually topped with a matching coverlet. Also known as a petticoat or flounce.

Dutch Colonial

Architecture and furnishings associated with the seventeenth-century Dutch who settled on Long Island and in the Hudson River valley. Based on a simplified baroque, the style is heavy but pleasing. Among the more noteworthy pieces was the kas, or chest, which was often ornamented with painted decoration.

Dutch furniture

Primarily, that of the seventeenth century, when furniture reached its height of artifice with exotic woods, tortoise-shell and ivory marquetry, ebony moldings, and interiors painted with landscapes or flowers by the leading artists of the day. The eccentric chests and tables of the eighteenth century, sinuous with serpentine and bombé fronts, elaborately curved and shaped sides and bases, are currently collected and copied.

DUTCH BOMBE DESK in the baroque style. Courtesy The Antique Shop, Inc., Newport, Rhode Island.

69

EAMES black hide chair and ottoman. Courtesy Herman Miller, Inc.

Eagle motif

An imperious and imperial symbol in decoration since the days of the Romans. In whole or in part (heads, wings, feet), the eagle motif was regularly revived, usually when a nation was passing through a phase of glorying in its successes, notably the days of the French Empire, when it appeared in carvings, fabrics, wallpapers and bronzes, and the American Federal period, when the feet supported couches and the carved bird perched on top of mirrors. Today, the eagle motif is mainly seen on copies of earlier pieces, on carpets, or as a decorative wall plaque or overdoor.

Eames, Charles

American architect and industrial designer, one of the greatest influences on furniture design in this century. The chair he designed with Eero Saarinen, consisting of molded plywood forms attached to a light metal frame, won first prize in the International Furniture Design Competition sponsored by the New York Museum of Modern Art in 1939. Among the many other Eames chairs are the fiberglass shell, wire cage, and his black-hide version of the traditional club chair and ottoman. His work is intentionally and successfully mass-produced.

Earthenware

Specifically, pottery made from baked earth or clay, as distinct from stoneware or porcelain. Among the better-known examples of earthenware are the seventeenth-century tin-glazed delftware and Josiah Wedgwood's cream-colored queen's ware.

Ease-of-care

Term applied to fabrics of, or containing, synthetic fibers that regain their original appearance after washing with a minimum of pressing or ironing. Sometimes known as "fabrics with a memory." Fabrics labeled "wash and use," "permanent press" and "permanent pleated" come in this category.

Eastlake

English Gothic Revival furniture designed by Charles Eastlake in the nineteenth century, mostly of cherry and embellished with tile panel insets, heavy hardware and metal mounts.

Easy chair

Any comfortable padded or upholstered chair or lounge chair. Probably the first to qualify for this adjective was the French bergère, but after the invention of spring and cushion construction in the nineteenth century, sitting became decidedly easier. Although the words "easy chair" conjure up visions of the overstuffed, such sleek contemporary models as the Eames and Bertoia lounge chairs are equally comfortable and buoyant.

Ébéniste (eh-beh-NIST)

The French name for a cabinetmaker. The name arose during the French Renaissance, when ebony (ébène) was a favorite furniture wood and the ébénistes who worked it belonged to guilds which protected them against undercutting by foreign craftsmen. From 1741, ébénistes stamped their work with their name or initials after it had been approved by a committee set up by the guild.

Ebonize

The process of staining wood to the lustrous black of ebony, first developed in the eighteenth century when the vogue for ebony furniture was at its peak.

Ebony

A hard, fine-grained, brownish-black wood from tropical countries, mainly Africa, India and Ceylon. The Egyptians and Babylonians made ebony furniture, combining it with silver, gold and ivory, and the Greeks and Romans also prized the wood highly. In Europe from the fifteenth century on it was much in favor as a veneer wood, especially with the eighteenth-century English cabinetmakers and French ébénistes, who took their name from it. Ebony had a brief renaissance in the 1920's, chiefly for cabinets and pianos.

Eclecticism

The art of selecting the best from several sources, applied in decorating to an uninhibited mixture of styles of previous periods with designs of today.

Edging

Any decorative finish around the edge of a panel, shelf or table top. Veneered panels are often protected by a thin edging of solid wood.

Edwardian

Furniture and decoration characteristic of the reign of England's Edward VII, an era when the bourgeois dowdiness of the late Victorian age gave way to the hedonistic extravagance and display of Edward and his queen, Alexandra.

Egg

Ovoid shape that has been both a decorative motif and fertility symbol since pagan times. The egg motif appears in architecture and furniture (*see* Egg and dart). The egg shape, interpreted in precious and semiprecious stones, metal, marble, porcelain and crystal, has been a treasured Easter gift since the seventeenth century, reaching its zenith in the enameled and jeweled bibelots of Carl Fabergé, jeweler to the Czars.

Egg and dart

The carved design on an ovolo molding consisting of a string of alternating egg and dart shapes. One of the most widely used carved ornamentations for woodwork and furniture, current since the seventeenth century.

Egg chair

Descriptive name for Arne Jacobsen's plywood-and-steel upholstered chair with distinctive ovoid contours, one of the most successful of the contemporary Scandinavian designs.

Églomisé *(eh-gloh-mee-ZEH)*

Hand painting on the reverse side of glass, backed with gold or silver foil, a technique named for its originator, the eighteenth-century French designer

EDWARDIAN sitting room. Courtesy Warner Bros., *My Fair Lady*. Set design: Cecil Beaton.

EGG CHAIR designed by Arne Jacobsen. Courtesy Fritz Hansen, Inc., New York.

Jean Baptiste Glomi. The popularity of the pictures spread from Europe to America and many Federal mirrors have scenes executed in églomisé. Oriental paintings of this type made for the export market in the European taste often have figures with Occidental faces in Oriental costume.

Egyptian taste

Ever since Napoleon's African campaign of 1798, when Egyptian designs and decorations were absorbed into the Empire style, Europe and America have engaged in an on-and-off flirtation with the decorative glories of ancient Egypt. The Victorians had their versions and the latest outcropping, fortunately short-lived, coincided with the release of the movie *Cleopatra*.

Elevation

A two-dimensional scale drawing of a plane, wall, side or section of a room or building indicating the placement of doors, windows and other features.

Elizabethan

A style of furniture and decoration that took form during the reign of Elizabeth I of England (1558–1603), basically Gothic, with Italian Renaissance overtones. Most easily recognizable are the bulbous, melon-turned legs, the Tudor rose and channeled decoration.

Elm

A tough, light-brown hardwood, similar to oak, that stains and polishes well and makes an excellent veneer wood. Eighteenth-century English furniture—tables, bookcases, Windsor chairs—employed elm, often in combination with yew.

Embossing

Form of projecting surface decoration in which designs are stamped, molded or hammered from the reverse side. Also known as repoussé work. Embossing embellished late-nineteenth-century tin ceilings, metal cornices and silver hollow ware.

Embrasure

Originally, the narrow aperture in the thick stone walls or parapets of castles for the archer's bow and arrow. Now, a term for the sloping sides of windows and doors.

Embroidery

The fine art of ornamenting fabric with needle and thread. The stitchery we practice today was developed in Italy during the sixteenth century.

Enamel

A decorative colored glaze on ceramic or metal surfaces which becomes hard and shiny after firing. Examples of enamel run the gamut from the exquisite antique Battersea enamels to the simple contemporary enamel picnic ware from Hong Kong. Paints or finishes which imitate this type of glaze are also known as enamel.

Encaustic

From the Greek for "burned in," an old method of painting employed by the Greeks and Romans in which colors were mixed with hot wax and then applied with a brush or spatula. The inlaid tiles of medieval monasteries and their nineteenth-century copies are described as encaustic, and Wedgwood

Battersea **ENAMEL** boxes. Courtesy Philip Suval, New York.

used the process to decorate his black basaltware in red and white, in emulation of the Greek and Etruscan vases.

Encoignure (ahn-kwahn-YEWR)

Corner cupboard in French. Any piece that cuts corners to save space and gain storage, but not a large corner cupboard.

End table

Any small table positioned at the end of a sofa or by a chair. The period, style or original purpose are immaterial.

English bond

Bricklaying pattern that alternates rows of headers (short ends) and stretchers (long sides), an effect used today for interior flooring, either in brick or vinyl imitations.

Engraving

A type of print made, like an etching, from a drawing incised on a steel or copper plate. Black-and-white or hand-colored engravings were the rage in the late eighteenth and nineteenth centuries.

Entablature

In architecture, the upper element of a classical order, made up of an architrave, frieze and cornice. The entablature tops the column and is often richly molded, carved or decorated.

Epergne

Table centerpiece made in graduated tiers of crystal, porcelain or metal, which may be used to hold flowers and fruit or bonbons.

Escritoire (ehs-kree-TWAHR)

French alternate term for a secrétaire, or small desk.

Escutcheon

Originally, a shield-shaped armorial crest. Now the plate over a keyhole or behind a handle on furniture and doors. Escutcheons are generally of metal, but today's versions, which can be elaborate or elegantly simple, are also fashioned of ivory, marble, crystal and plastics.

Étagère (eh-tah-ZHEHR)

A pyramid of open shelves intended for the display of objects, better-known in humbler circumstances, thanks to the Victorian era, as a whatnot.

Etching

A print made from a drawing etched on a steel or copper plate. As the design wears from the plate rapidly, the prints are generally limited in number and signed by the artist. A collection of etchings in sepia or black makes a handsome showing when massed on a wall.

Extension table

Originally, pairs or trios of tables that could be joined together with special hardware to form one long surface. Now, any table that can be extended with leaves.

Modern **ETAGERE.** Courtesy Parzinger Originals, Inc., New York.

ESCRITOIRE. Courtesy Yale R. Burge, New York. Photographer: Guerrero.

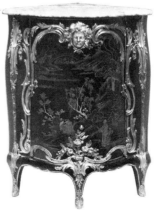

18th-century French oak **ENCOIGNURE** stained black, veneered with panel of Chinese lacquer; gilt bronze mounts. Reproduced by permission of Trustees of The Wallace Collection, London.

FAIENCE enameled earthenware ewer, Faenza, Italy, 15th century. Courtesy Victoria and Albert Museum, London. Crown copyright.

Fabergé, Carl (1846–1920) (*fah-bear-ZHEH*)

Jeweler who made fabulous trifles for the Czars and most of the European courts in the gilded era before World War I. Among his more famous bibelots were Easter eggs in precious stones and enamels, exchanged as gifts by the Imperial family; miniature animals carved from semi-precious stones; and shimmering jeweled flowers. Many of these small treasures escaped the Russian Revolution with their owners and now command astronomical prices. Fabergé-type jeweled flowers from France, though not so costly, have some of the same elegance and make a luxurious accessory for a coffee table.

Façade

The front elevation of a building, usually applied to those of sufficient substance to put up a good front.

F.A.I.D.

See A.I.D.

Faïence (or Fayence) (*fah-yahngs*)

From the Gallicization of Faenza, the Italian center for majolica during the Renaissance, came this name for a type of tin-glazed or tin-enameled earthenware made throughout Europe from the sixteenth to eighteenth centuries. Delft and majolica are two of the best-known examples.

Faille

A fabric of silk or synthetic fiber woven with a heavier weft thread to produce a flat, ribbed surface.

Fakes

With the increasing demand for antiques has come the fine art of counterfeiting not only furniture but also porcelains, silver and practically any type of antique object. This is a practice that can be condoned only if the seller owns up to it, but all too often the fake is palmed off as the genuine article. A good craftsman can make a new piece of furniture look antique or replace a worn or damaged part of an old piece with another of a different period (this is known as marrying) to give it the look of the original. Hallmarks are often transferred from damaged or badly designed antique silver to a more handsome, unmarked piece, a trick that is definitely not kosher. In these cases the buyer should beware, or find a reputable and trustworthy dealer. In the case of reproductions of old china (Creil, Lowestoft), it is usually fairly easy to spot the copy, but when it comes to glassware made from the original molds, it is again advisable to depend on the reliability of the dealer.

Fall front, or drop front

Writing cabinet or secretary with a flap that falls to disclose a series of compartments, pigeonholes and drawers. The earliest, seventeenth-century models had drawers or doors in the lower section. Later, the size of the flap was often reduced and a glass-doored bookcase section was added above the writing surface. The finest and most decorative examples are the secrétaires à abattant of the Louis XV and XVI periods, ornamented with marquetry and gilt-bronze mounts. While the fall front was considered a great convenience by the prolific letter writers of the seventeenth and eighteenth centuries, it is out of favor today because of its unwieldiness and instability.

Famille jaune, rose, noire, verte (fah-MEE zhohn, rohz, nwahr, vehrt)

Chinese porcelains of the Ching Dynasty made principally for export from the mid-seventeenth century to the beginning of the twentieth. The four types are distinguished mainly by their ground colors—yellow, pink, black and green—and the names are French because the first catalogue of Chinese porcelains was written in that language.

Family room

A uniquely twentieth-century American room for relaxation with family and friends, a development and refinement of the old playroom or rumpus room. Family rooms are decorated more informally, but often more lavishly, than living rooms and are apt to be equipped with every known device for at-home entertainment, from bars and indoor barbecues to game tables, television, stereo, and home movie screens and projectors.

Fan-back chair

Chair with spindles in a radiating fan shape, such as a fan-backed Windsor chair.

Fanlight

Originally, a window in the shape of an open fan that, set over a door or French window, decorated the exterior of a house. The term is now applied to any area of glass over a door, no matter what its shape.

Fascia

The broad, flat band between two small moldings around doors or windows, or the strips of marble, brick or slate around a fireplace aperture.

Fauteuil (foh-TOY)

A French open-arm chair with either upholstered or caned seat and back, as distinguished from the completely upholstered bergère.

Faux bois (foh bwah)

Literally, false wood—a decorating deceit achieved through paint. The graining is usually exaggerated and need not necessarily duplicate actual wood tones.

Faux marbre (foh mahrbr)

A decorative deceit in paint that simulates or exaggerates the grain of marble. See also Marbleizing.

Favrile glass

Iridescent case glass of late-nineteenth-century vintage prized today for its exotic color range and beautifully executed interpretive designs. Although the Favrile of Louis Comfort Tiffany (also called Tiffany glass) is the best-known and most collected, other versions of this type of glass were made in this country and Europe, notably Durand in New Jersey; Aurene, produced by the Steuben Glass Works in Corning, New York; and Gallé, creation of Émile Gallé of France.

Régence **FAUTEUIL.**
Courtesy Yale R. Burge, New York.

FALL-FRONT chest desk.
Courtesy Baker Furniture, Inc.

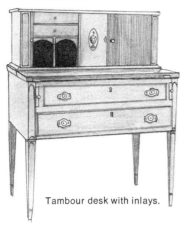

Tambour desk with inlays.

Mahogany case clock.

Federal (1780–1830)

The patriotic style of the transitional era from the Revolution to Victorian-age America. It embraced a welter of design influences, both imported and native. After the War of 1812, the American eagle became the dominant motif, introduced in every conceivable manner from supports on chairs and tables to finials on mirrors and clocks and decorations painted on glass and china. The most important designer of this period was Duncan Phyfe, who set the pace for the other cabinetmakers. *See also* McIntire, Samuel; Phyfe, Duncan.

Felt

A fabric made by matting wool, mohair or mixed fibers under heat and pressure. Felt, which is made extra-wide and dyed in a multitude of colors, has become extremely popular in the last few years as an inexpensive fabric for upholstery, bedspreads, curtains and table covers, although it has the disadvantage of being hard to clean.

Fender

Fence around a fireplace to corral logs, ashes and cinders, a precaution adopted around the beginning of the eighteenth century when most houses had wooden interiors. The front of the fender was straight or serpentine; the corners were rounded. Early fenders were strictly functional affairs of plain brass, but by the 1750's ornamental scrolls and bosses were added and the fender was often designed to match the apron of the grate. Under the influence of Adam, it became pierced and decorated with motifs that were repeated in the fireplace, grate and andirons, and humble brass was superseded by steel and, in exceptional cases, silver.

Fenestration

From *fenestra,* the Latin for window, a word coined to describe the arrangement of windows on the façade of a building, and now broadly used for the decorative effect of such an arrangement in relation to its surroundings.

Festoon

A scalloplike garland or fillip that may be suggested either in fabric, looped and draped above a window, or in wood as a carved motif in furniture.

F.F.F.

Abbreviation, in trade parlance, for fine French furniture.

Fiberglass

Fiber made from thin spun-glass filaments. It is then woven into a strong, durable fabric resistant to soil and flame. Fiberglas is the trademark name of Owens-Corning for both fiber and fabric.

Fiddle back

Chair of the Queen Anne persuasion with a back splat resembling the swelling shape of a violin.

Figurehead

Carved figures, usually of bosomy females, that decorated the bows of sailing ships. Now regarded as lively examples of Americana and folk art, old or reproduction figureheads have settled ashore, mostly on the walls of family rooms.

18th-century French furniture, known in trade parlance as **F.F.F.** Interior design: Pierre Scapula. Photographer: Prigent.

Filigree

A delicate, lacy openwork design pierced in metal or cut in wood.

Fillet

In architecture, a narrow, flat strip of wood or stone that separates two curved moldings or flutes of a column, or a band that terminates a series of moldings. In cabinetwork, a rectangular-sectioned wood molding.

Finial

An ornament, usually in the shape of a pineapple or knob, that adds a decorative finis to a post, bedpost, pediment or lamp.

Finish

Polish, paint, varnish or lacquer applied to a wood surface for protection or decoration. The decorative aspect came first. The ancient Egyptians, Chinese, Mesopotamians and Romans embellished their furniture with color and design. Pigment and polychrome decoration, together with gold and bronze leafing, was passed down from the Egyptians to the Romans and the Renaissance decorators, and the Chinese excelled at an early date in the art of lacquer. The protective use of oil and wax polishes seems to have originated in the early Middle Ages, and varnishing, although it was known to the Egyptians, vanished until the eighteenth century, when the Martin brothers invented vernis Martin —a transparent varnish—to bring out the beauty of exotic woods. English cabinetmakers of this period relied on oil, wax and shellac, rubbed to produce a satiny finish, and the end of the eighteenth century saw the emergence of the so-called French polish, a high gloss obtained by rubbing and polishing the wood with resins. The varnish we use today was a mid-nineteenth-century product originated by American finishers who dissolved resins in hot oils. Today, finishes are legion—almost any type can be produced with synthetic lacquers (which have no similarity to the Chinese lacquer) and new ones for special purposes are being developed all the time.

Fir

A soft, whitish wood primarily used for plywood or the carcases of inexpensive furniture.

Fire screen

A decorative device designed to shield the sitter from the heat of the fire, or the room from incendiary sparks. The early cheval, or horse, screen of the Middle Ages was a formidable, full-sized affair with a large central panel between fixed sides with trestle legs. The pole screen, a daintier eighteenth-century version, protected only the face by means of an adjustable panel mounted on a slender pole. The frames of the original fire screens were of wood, plain or gilded, and the panels were covered with tapestry, painted canvas, leather, paper or lacquer. Today's fire screen is purely utilitarian, a freestanding metal-mesh guard or a draw screen attached to the top of the fireplace.

Fireback

Decorative cast-iron plate designed to fit on the rear wall of a fireplace and reflect the heat of the fire, most often seen today as a wall plaque.

Fitzhugh

Eighteenth-century Oriental export ware with a border of stylized bees and pomegranates first made for the Earl of Fitzhugh. The pattern is now reproduced by such porcelain companies as Spode.

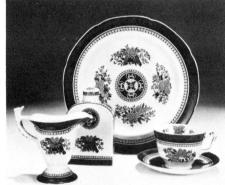

Modern **FITZHUGH** by Spode.

Flambeau (*flahm-BOH*)

Decorative motif in the shape of a flaming torch found in late-seventeenth- and eighteenth-century furniture. It often formed a finial on high-rise furniture such as the highboy and longcase clocks.

Flame stitch

Seventeenth-century needlepoint design of Hungarian origin that resembles the wavering outline of flames, popular for upholstery fabrics. Today, the design is frequently woven or printed to suggest the original handwork. *See also* Point d'Hongrie.

Flat arch

An arch, usually brick, with only a slight rise in its curve.

Flemish bond

Bricks laid in a design of alternate headers (short ends) and stretchers (long sides).

Flemish scroll

An S- or C-curved ornamentation found in seventeenth-century Dutch, Flemish, English and American furniture and today in the bold damask designs of wallpapers and fabrics.

Fleur-de-lis, or Fleur-de-lys (*fluhr-duh-LEE*)

A decorative motif originally based on the Egyptian stylized iris and adopted by the Bourbon kings as their royal standard, hence the French name.

Flip-top table

Card or dining table with a fold-over top that opens up into two facing leaves, like a book, and is supported either by pivoting the top to the opposite axis or by a swing-out leg or runner.

Floating furniture

Furniture without visible means of support—legless, wall-hung and cantilevered. Also, a phrase used to describe an island of furniture grouped in the center of the room, away from the walls.

Flock design

Raised design on fabric or wallpaper accomplished through felting, in imitation of the rich Venetian cut velvets.

Floral damask **FLOCK** wallpaper by Scalamandrè.

Floor plan

Basic room-by-room arrangement of a house or apartment, with or without furniture indicated.

Floriated

Decorated with an allover floral motif. A term often applied to porcelains, fabrics and wallpapers with this type of design. When the floral pattern completely covers the surface, it is called mille-fleurs.

Flow-blue

English nineteenth-century transfer-decorated earthenware where the pattern flows into the glaze. Relatively inexpensive when originally manufactured, it is now prized by collectors and has consequently skyrocketed in price.

Fluting

A series of parallel, perpendicular channels, or grooves, cut into a flat surface, particularly columns and legs. In reverse, it is known as reeding.

Flyspecking

A form of painted distressing in imitation of the flyspecks in antique finishes, which are themselves faithful copies of the real flyspecks on antiques, simply the result of sloppy housecleaning.

Focal point

A decorating element that dominates a room by virtue of its size or of the decorative treatment bestowed on it to draw the eye in its direction. May be architectural (fireplace, built-in book or storage wall), or a piece of furniture (like a breakfront, armoire or screen), or a collection of art objects.

Foil papers

Metallic-surfaced papers, often overprinted, copied from the early tea-chest liner papers and made by the roll and sheet as wall coverings.

Folding furniture

A concept that dates back to the folding chairs and couches of the Egyptians, with each succeeding era coming up with its own version. The most attractive was the campaign furniture of the Directoire period; the most ingenious, that designed by Sheraton, although too often the mechanical aspects hampered the artistry of the design.

Conolly's **FOLLY,** County Kildare, Ireland.
Designed by Richard Cassels in 1740.

Folly

An architectural extravaganza and eccentricity with no practical purpose which wealthy eighteenth- and nineteenth-century gentlemen were wont to construct on their estates.

Footman

Another mute servant, like the silent butler, this oblong or oval stand of brass or gleaming steel stood in front of the fireplace to keep the dishes hot in the days before more advanced aids to pleasurable dining were developed.

FOOTMAN.

Footstool

Small bench or hassock that teams with a chair to support the sitter's feet. Originally a step-up to a throne, it was adopted wholesale in the eighteenth century, when the formal etiquette of court seating gave way to a more relaxed and comfortable posture, something of a necessity in an age when gout was the fashionable disease. Today's footstool, designed as an extension of an easy chair and upholstered to match, is larger, more luxurious and a prop for legs as well as feet—witness Arne Jacobsen's chair-with-stool and Charles Eames's cushiony black leather two-piece chaise longue.

Formica

Trade name of a rigid laminated plastic widely used to cover counter and table tops, shelves and buffets, and all manner of other surfaces. It can be bought in various forms—veneers, thick panels with a colored and/or patterned surface on both sides, and as a thinner board, decorated on one side only.

Fornasetti, Piero

Milanese designer and master of the art of applying designs to plastic, porcelain and fabric by a photographic technique. His witty pastiches of classical motifs and architectural orders appear on table tops, washbasins, screens, ashtrays and dinner services.

FORNASETTI cabinet. Interior design: George Headley. Photographer: Grigsby.

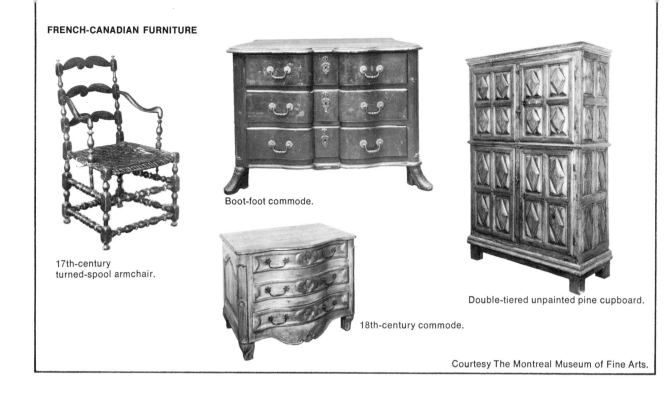

17th-century
turned-spool armchair.

Boot-foot commode.

18th-century commode.

Double-tiered unpainted pine cupboard.

Courtesy The Montreal Museum of Fine Arts.

Fortuny print

Cotton fabric originated by the artist-designer Mariano Fortuny (1871–1949) and made in Venice by a secret process that gives it the look of brocade. The antique patterns and unusual colors of Fortuny prints have assured their enduring success as curtain and upholstery fabrics.

Fountain

A decorative development of one of the earliest man-made devices for pumping and circulating water for drinking and washing. Traditionally found in private or public courtyards and gardens, in city streets and squares, and currently, in small, electrically operated recirculating models indoors.

Four-poster

American term for a bed with four elongated corner posts, but without a wood canopy.

Fragonard, Jean-Honoré (1732–1806)

French court painter during the reigns of Louis XV and Louis XVI, noted for his delightful wall decorations and murals.

Franklin stove

One of Benjamin Franklin's many inventions, a cast-iron wood-burning stove-cum-fireplace still around, in several of its many versions, as both a decorative and functional piece.

French bed

Another name for the nineteenth-century sleigh bed with its high, scrolled head- and footboards. It was often surmounted by a wall-hung canopy.

French-Canadian furniture

The provincial furniture of Norman persuasion made in Quebec by French colonists and settlers, noted for the excellence of the carving—on native pine rather than European fruitwood. The most important pieces are the armoire, the buffet-bas and the bahut, followed by the simple chairs with heavy, woven rush seats and a variety of occasional tables.

French door, casement or window

Arrangement of two vertical side-hung windows, often multipaned, that reach to the floor and open like the halves of a double door, either between rooms or from house to balcony, garden or terrace. Predecessor of the sliding window wall.

French Empire (1804–1815) (ahm-PEER)

The style dictated by Napoleon, based on copies or adaptations of Greek and Roman pieces, plus a strong Egyptian influence. The furniture reached ponderous proportions, often ostentatiously ornamented with bronze and gilt appliqués, with table legs frequently terminating in the shape of lions, griffins or human figures. Dark mahogany was the

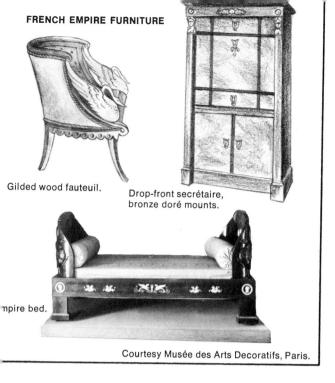

FRENCH EMPIRE FURNITURE

Gilded wood fauteuil.

Drop-front secrétaire, bronze doré mounts.

mpire bed.

Courtesy Musée des Arts Decoratifs, Paris.

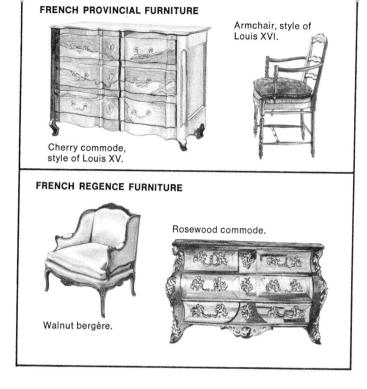

FRENCH PROVINCIAL FURNITURE

Armchair, style of Louis XVI.

Cherry commode, style of Louis XV.

FRENCH REGENCE FURNITURE

Rosewood commode.

Walnut bergère.

favored wood and marble was highly regarded. It is to the French Empire style that we owe such enduring motifs symbolic of conquest as Roman eagles, wreaths, torches, lions, the sphinx, the pineapple, the letter N framed in a victor's wreath, and another Napoleonic emblem, the bee. Empire influences may be recognized in German Biedermeier, American Federal and English Victorian furniture.

French heading

A decorative topping for curtains; the fabric is gathered in small folds, or pleats, at five- or six-inch intervals and is stitched together about four inches from the top.

French period

Gaucherie coined by the uninformed for furnishings in the French style and tradition, whether it be authentic Louis XV or a Victorian copy of French Empire. Antique dealers are understandably confused—and amused—when asked, "Do you have any French period?"

French polish

A shellac finish with a mirror gloss.

French Provincial (1650–1900)

Not a period of design but a conglomeration of styles developed by the provincial craftsmen of France, mostly adaptations in plainer terms and materials of court furniture. Those based on Louis XV and Louis XVI are the most familiar. French Provincial pieces, with their simple curving lines, are essentially functional—for example, the buffet, cupboard and armoire; the lit clos, or built-in bed; the panetière, or breadbox; and the comfortable rush-seated chairs. Woods of the provinces were used in combination with metals—in Lorraine, walnut and fruitwoods with polished steel hardware; in Normandy, oak with brass fittings; in Provence, chestnut with copper. Decoration was limited to restrained but well-executed carving, painted designs and handsome hinges and handles. Today, French Provincial furniture is the most duplicated and offers the widest variety of pieces.

French Régence (1715–1723) (*reh-ZHAHNSS*)

A transitional style that emerged during the regency of Philippe, Duc d'Orléans, bridging the massive, masculine grandeur of Louis XIV and the more graceful, feminine persuasion of Louis XV. Rococo ornamentation was introduced and the cabriole leg with doe foot was much in evidence. Pieces designed for personal storage appeared in France during this time, including the commode, the secrétaire and the chiffonnier.

Fresco

A type of mural painting in which the colors are applied to the plaster while it is still wet and fresh (fresco), so setting them.

Fret

An interlacing geometric pattern, either carved (on a flat surface) or pierced (in grilles, galleries and chair backs). Also a wallpaper and fabric motif.

Fretwork mirror

Chippendale-style American wall mirror of the late eighteenth century. The wood frame had a fret-scrolled arched crest, often with a central carved motif, such as a shell, and a fret-cut base. Also known as a silhouette mirror.

Frieze

In architecture, the central portion of the classic entablature, a horizontal band, usually decorated with carving or sculpture, between the architrave and cornice of a building. Also, a flat, wide decorative strip at the top of a wall.

Friezé (free-ZEH)

A type of fabric or carpeting with uncut loop pile—designs are made by the contrast of uncut and cut loops, by different colored yarns or by overprinting.

Fringe

Upholstery or drapery trimming consisting of loose threads, which may be twisted or plaited and may be of silk, cotton, wool or combinations of materials, attached to a narrow horizontal band.

Fruitwood

Not one, but many woods from the various fruit trees—pear, apple and cherry being the most common. Traditionally favored for small pieces of furniture, particularly of the provincial type. Today, most fruitwood veneers are merely finishes that duplicate the color and grain of fruitwood.

Functionalism

Furniture design determined by basic use rather than by decorative style.

Fur

Since primitive man tossed an animal skin over his bed as a coverlet, the soft and warming touch of fur has been enjoyed in the home, either in its natural state as a bed throw or rug or woven into cloth. Today, versions of fur crop up everywhere—real pelts on floors or as upholstery; make-believe furs of synthetic fibers as fabrics; fur patterns woven into carpets or printed on fabrics, wallpapers, plastics and ceramics.

Furring

Thin strips of wood applied to a wall as a level support for paneling, wallboard or shelves.

FRET pattern in wallpaper. Courtesy Window Shade Manufacturers Association.

Real and fake FUR. Interior design by Inman Cook, A.I.D. Photographer: Louis Reens.

English **GAME TABLE,** c. 1740. Courtesy Victoria and Albert Museum. London. Crown copyright.

Gadroon

A decorative edging of twisted convex flutings, often found on silver platters. The ornamentation, which originated in the Renaissance, was frequently used on the bulbous supports of Elizabethan furniture.

Gallé glass

Art glass, the French version of Favrile, named for its originator, Émile Gallé, a leading exponent of the late-nineteenth-century school of Art Nouveau. Although Gallé glass was made after the master's death, his signed pieces are the most valued and valuable today.

Gallery

Ornamental railing along the edge of a table, a shelf or a serving tray. The term also describes a long hall that is hung with paintings.

Galloon

A narrow tape, ribbon or braid used as trimming on upholstery or curtains.

Game table

Table with a playful purpose, perhaps the earliest form of furniture designed solely for amusement. Each game—dice, cards, chess, backgammon—had its own special table and, in the sixteenth century, even needlework covers for the tops in appropriate patterns. Our only addition to the roster of game tables is the poker table.

Garden furniture

Furniture designed for the outdoors did not really take hold until the eighteenth century, when seats and tables were fashioned for alfresco conversation groups in wood, wrought-iron and the newly modish bamboo. Those of iron, the sturdiest material, are the main survivors. In the nineteenth century, garden furniture appeared in every conceivable style from Gothic and Oriental to rococo and rustic, mainly interpreted in unyielding cast iron. Today, garden furniture emphasizes the light, comfortable and functional look. Wood, aluminum, tubular steel, fiberglass, cane and rattan are all popular, and designs range from the strictly outdoor to those that look equally well indoors.

Garden room

Extension of the glass-walled modern version of the solarium or conservatory, a family room or second living room where the indoor cultivation of flowers and plants shares space with some other family activity—study, music, barbecuing, etc.

Garden seat

The barrel- or drum-shaped stools of porcelain, stone, wood or metal, originally used as seating pieces in Chinese gardens, and in the United States as decorative end tables.

Garderobe *(gahr-duh-ROHB)*

Originally, a medieval privy built out from the castle walls over a moat or ditch. In France the

name was given to a type of Louis XV armoire with paneled doors and became by adoption an English term for a small dressing room where clothes were hung.

Garniture de cheminée (*gahr-nee-TEWHR duh shuh-mee-NEH*)

A set of five vases for the mantelpiece, generally with the same pattern and coloring, in the traditional Chinese shapes—three covered baluster-shaped jars and two trumpet-shaped beakers. Seventeenth- and eighteenth-century European porcelain and faïence factories copied the idea from the Chinese.

Gate-leg table

Drop-leaf table popular in England and America during the seventeenth and early eighteenth centuries. The leaves are supported by a gate-type leg with stretcher that swings out from the center section.

Gaudi, Antonio (1852–1926)

Spanish architect and designer famous for his fantastic sculptural buildings and interiors in the Art Nouveau idiom, but with almost surrealist overtones. The unfinished Sagrada Familia Church in Barcelona is perhaps the clearest statement of his naturalistic, extraordinary style.

Gaudy ware

A crude but colorful American earthenware based on English and Imari decorations. The three basic types are gaudy Dutch, gaudy Welsh and gaudy ironstone.

Gauze

A loose openwork fabric based on the leno weave. The warp yarns, instead of lying parallel, come in pairs and twist between the filling yarns, producing an open, lacy effect.

Gazebo

A garden shelter, open summerhouse or belvedere usually built at a high point where it can command a view of the countryside, or at the end of a garden path. The cupola built on the roof of a house to take in a vista is also known as a gazebo.

GAZEBO in a garden.

Dining room designed by **ANTONIO GAUDI,** Casa Battló, Barcelona, Spain, 1905–1907. Courtesy The Museum of Modern Art. New York.

Genre

Any art form which draws its subject matter from everyday life.

Geometric print

A measured pattern based on triangles, circles, diamonds, etc., on fabrics and wallpapers, often taking the form of stripes, plaids, polka dots.

Georgian

Architectural and furniture styles prevailing during the reigns of the four Hanoverian kings of England, George I, II, III and IV, including the work of such famous designers as Chippendale, Sheraton, Hepplewhite and the Adam brothers. The early Georgian period was from 1714 to 1750, middle Georgian from 1750 to 1770 and late Georgian from 1770 to 1810.

Gesso

Finely ground plaster which is formed while wet into raised decorations on furniture, walls or moldings, allowed to dry and then gilded or painted.

Gibbons, Grinling (1648–1720)

English wood carver famous for his realistic sculptured festoons and garlands of fruit, flowers, vegetables, leaves and other manifestations of nature, which have been widely copied in materials other than wood.

Gilding

Decorative artifice that turns the surface of metal, wood, stone and plaster to gold. The Egyptians, the first gilders, applied gold in thin, beaten layers, the origin of gold leaf. Later processes of water gilding, oil gilding and fire gilding (for metal) have continued unchanged for centuries, although fire gilding has been largely replaced by a method akin to silver plating, vermeil being the exception. Most furniture is now gilded by a combination of two processes: gold leaf is first applied and fixed with an adhesive, then burnished.

Gilt

Descriptive adjective for any object gilded with gold leaf or bronze powder.

Giltwood

Eighteenth-century alchemy for turning a wood surface to gold, a process still practiced today. The method involves coating carved wood (pine in England and America, oak in France) with a thin layer of gesso and then gilding it with the oil or water technique.

Gimp

Flat decorative tape used as a finishing trim to conceal upholstery tacks or stitching in draperies.

Gingham

A cheerful, casual yarn-dyed fabric of lightweight cotton or synthetic fibers, usually woven in crisp checks or stripes.

Gipsy table

A small, round late-nineteenth-century tripod table that was draped with a fringed or beaded cloth, obviously named for the standard prop of crystal-gazing Gipsy fortunetellers.

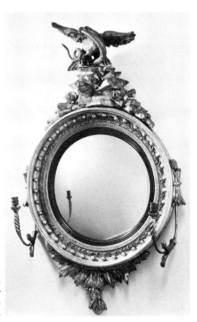

American **GIRANDOLE,** c. 1790. Courtesy The Metropolitan Museum of Art. Rogers Fund, 1921.

Girandole (*zhee-rahn-DOHL*)

A word that has gone through various decorative interpretations. The original girandole was a late-seventeenth-century French wall candelabrum with a reflective mirror. Later, nineteenth-century versions were merely convex circular mirrors, of the type known as a bull's-eye, with or without candle brackets. The term was also erroneously applied to candelabra in the shape of figures holding branches hung with crystal prisms.

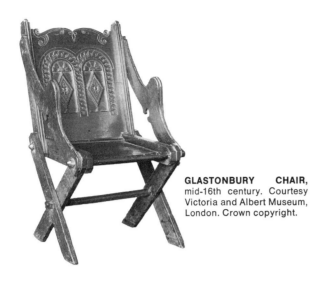

GLASTONBURY CHAIR, mid-16th century. Courtesy Victoria and Albert Museum, London. Crown copyright.

Girard, Alexander

Architect and designer whose bold, individual sense of color and design has had a great influence on decoration, notably through his many exhibitions of home furnishings, textiles and objects for Herman Miller and The Museum of Modern Art and his arresting interiors for the New York restaurant La Fonda del Sol, based on the folk art of Mexico and South America.

Glass curtains

Sheer curtains of any translucent material from silk gauze to fiberglass that are kept drawn across the panes of a window to filter the light and give privacy.

Glastonbury chair

Sixteenth-century English ecclesiastical folding oak chair with a slanting paneled back, sloping arms and X-shaped legs.

Glaze

The thin, transparent coating of glass fired on pottery, porcelain and stoneware to give a hard, shiny, nonporous finish. The Chinese were the originators and masters of the process and no one has matched the range and richness of their colors. Also, a liquid glaze applied to walls and furniture to produce a finish similar to that on china.

Glazed chintz

A printed chintz or plain cotton fabric, one side of which is glazed by a calendering process or paraffin treatment to stiffen it and give it a glossy sheen. The glaze formerly disappeared after successive washings, but is now permanent, thanks to modern advances in processing.

Glazing

Hard finish with a softening influence on the color of the final coat of paint. Shellac or varnish with added color is applied as a thin wash, then wiped off, to subdue the base color.

Globes

The terrestrial and celestial types have been looked on as both decorative and functional objects since the eighteenth century, when cartographers and cabinetmakers joined forces to turn out globes of superb quality on elaborate mahogany stands with turned, reeded or fluted supports or elaborate carvings of dolphins or lions. Modern globes on gleaming contemporary steel or brass stands are equally beautiful though less ornate.

Gobelins (gohb-LAN)

Famous French tapestry factory. It was started in the fifteenth century by the brothers Gobelin as a dye factory and became noted for weaving from 1601 to 1662, when it was taken over by Louis XIV, who appointed the court painter Charles Le Brun director and head designer. During this time, the manufacture of other decorative materials (textiles, metalwork, wood carving) was added and the Savonnerie carpet factory was merged with Gobelins. Today the state-controlled Manufacture Nationale des Gobelins is still renowned for its tapestries, including such modern masterworks as Marc Chagall's *The Creation,* part of a triptych commissioned by André Malraux as a gift to the Parliament of Israel.

Goddard and Townsend

The names of John Goddard and his son-in-law John Townsend, cabinetmakers of Newport, Rhode Island, during the latter half of the eighteenth century, are synonymous with fine American furniture. Among their pieces, many of which are still reproduced, are the distinctive block-front chest and desk and secretaries with shell carving.

Gondola chair

A low chair with a broad seat and a back that sweeps downward in a gondolalike curve to form the arms. Gondola sofas are similarly designed.

Gothic (1100–1500)

Austere style of the Middle Ages inspired by the architecture of the great Gothic cathedrals with

their pointed arches, flying buttresses and pillars decorated with molding and unique details. Due to the instability of Europe, constantly warring, household effects were designed to be mobile. Chests and coffers were the main furniture. Folding chairs and throne chairs were carried for lords and ladies and for court sessions, and boards set on trestles were makeshift tables. An easily transportable enclosure, consisting of framework, curtains and canopy, provided privacy and warmth for sleeping. All furniture was unpolished heavily carved oak, with panels in chests decorated with linen-fold or tracery carving or with painted designs based on floral or grotesque animal or human forms. Today, Gothic furniture survives in modern versions of the four-poster bed and in joint and coffer stools used as end tables or for decorative storage.

Gothic taste

English fad for pseudomedieval forms in architecture, interior design and furniture that flourished in the eighteenth and nineteenth centuries—Horace Walpole was its earliest and one of its greatest proponents and even classic designers such as Chippendale cautiously introduced such elements as tracery work and trefoil, quatrefoil and cluster columns in their furniture designs. The Victorians, typically, carried the whole thing to extremes. Their furniture and houses, both interior and exterior, aped the Gothic style. Today, eighteenth-century Gothic has antique status, and some of the antic Victorian versions are adopted, more for their amusing than admirable qualities.

Gouache (goo-AHSH)

A painting technique often employed for murals in which the water colors are mixed with a thickening agent, such as gum, to make them opaque.

Gout stool

Leg rest with an adjustable top for supporting a suffering limb, much in demand in England during the gout-plagued eighteenth and nineteenth centuries.

GOTHIC FURNITURE OF THE 15TH CENTURY

English oak stall chair.

Italian beech folding chair.

French oak chest.

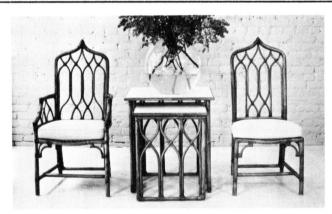

Contemporary **GOTHIC TASTE** in rattan by McGuire.

GOTHIC TASTE of the Victorian era. Courtesy Victoria and Albert Museum, London. Crown copyright.

Governor Winthrop desk

An American fall-front desk of mid-eighteenth-century vintage, designed in the Chippendale style, which has graduated drawers on bracket feet and, in the upper writing section, pigeonholes with small drawers underneath. Despite the name, it is highly unlikely that the two Governors Winthrop of Massachusetts and Connecticut ever owned such desks, since they lived some one hundred to one hundred and fifty years earlier.

Graining

Painted pretense that simulates, either exactly or in an exaggerated fashion, the natural grain and color of wood. Also called faux bois. A strategem employed by clever craftsmen throughout the centuries, notably in Regency England and Colonial America, to transform inferior wood or plain plaster.

Graphics or graphic arts

Lithographs, serigraphs, woodcuts, etchings and engravings. Their value depends on the number of runoffs—the fewer, the better. Generally no more than fifty are made before the plate is destroyed.

Grass cloth

A handsome wall covering of woven grass glued and stitched to a paper backing invented by the Chinese more than two thousand years ago and now made in a variety of weaves and colors, some with metallic paper grounds.

Grate

Firebox of iron or steel, shaped like an open basket on legs, which evolved from the early log-bearing grid that was set in the chimney recess, above the hearth.

GRAINING painted on door and walls in the Maria Mitchell House, Nantucket.

GRASS-CLOTH wall panels in a room designed by Barbara D'Arcy, A.I.D., of Bloomingdale's, New York. Photographer: Guerrero.

Greek pottery

Pottery in the classic mold, with the stylized shapes and decoration of ancient Greece, copied and imitated through the centuries. The originals were purely functional; the concept of the vase as an ornament did not emerge until much later. Greek pottery was neutral and subtle in coloring—brown or black on a light ground, buff or red on a black ground. The basic forms, which can be seen in museums and private collections, are: the hydria, a three-handled, narrow-necked, bulbous waterpot; the krater, a wide-mouthed mixing vessel; the amphora, for storing wine; the oinochoai, oil or wine jugs; the aryballoi, ball-shaped, narrow-necked bottles for oil; the kotylai, deep cups with a flat base; and the kylikes, wide, shallow cups with pedestal bases and flattened feet. Museum shops sell copies of this pottery and the Greeks themselves make modern interpretations of the old shapes.

Greek Revival

The late-eighteenth-century surge of interest in every aspect of Greek classicism, when architectural columns and moldings, furniture, statues, urns, vases and other art forms were copied to adorn the homes of the wealthy. In the nineteenth century, furniture shapes changed to conform to classic standards—ornament was restricted, lines were simplified, and surfaces were left severely alone. Accepted motifs were the lyre and lion foot. Sheraton,

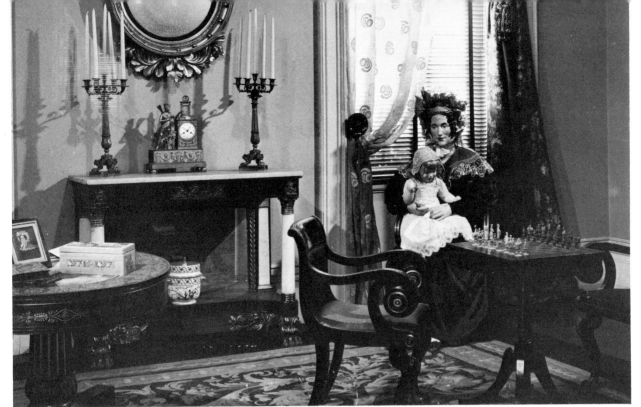

GREEK REVIVAL interior. Whitney Alcove, c. 1830. Courtesy The Museum of the City of New York.

Hepplewhite and Duncan Phyfe styled their furniture in the classic idiom and all three produced versions of the so-called Grecian chair.

Greenhouse

Initially, a small, partially glazed shelter for plants that was designed in Tudor times for the winter care of orange trees, the imported evergreens or "greens" that gave the greenhouse its name. These developed during the seventeenth century into the French *orangerie,* an elegant, architect-planned structure, and in the nineteenth century, as glazing techniques improved, into vast edifices.

Greer, Michael, F.N.S.I.D., A.I.D.

American interior designer whose forte is bringing tradition up to date; reviver of the vogue for French Directoire and Empire steel furniture.

Greige goods

Also known as gray goods. Fabric in an unfinished state, just off the loom or knitting machine.

Grenadine

One of the sheer curtain fabrics, like marquisette, but finer. Woven plain or with figures or dots.

Grille

Latticework of wood or metal in either simple crisscross, geometric or more elaborate Moorish motifs. Employed as decorative obscuration in window panels, screens, room dividers and walls of buildings. Also a design printed on fabric or wallpaper to add dimensional quality.

Grisaille (*gree-ZIGH*)

Decorative painting confined in color to tones of gray (*gris* in French). It usually depicts figures which appear in relief.

Tole GRISAILLE tray by Mottahedeh.

Gros point

A coarse needlework cross-stitch, larger than petit point, worked in bold colorful designs for rugs, upholstery, chair seats, etc. One of the traditional domestic arts currently revived to lend the handmade touch to contemporary rooms.

Grosgrain

Silk, cotton or synthetic-fiber fabric with a ribbed, or rep, surface. Ribbons, curtains, bedspreads and sometimes upholstery are made of grosgrain.

GROTESQUES as carved decoration for a chair.

Grotesques

Fantastic and fanciful forms and figures—human, animal or floral—that often appear as carvings on furniture.

Grotto

An artificial imitation of a natural cave, often embellished with shells and semiprecious stones, part of the cult of studied simulation and admiration of nature that flourished in England and France during the eighteenth and nineteenth centuries. Grottoes were often equipped with a live-in anchorite for greater realism.

Ground color

In fabrics, carpets, wallpaper, china, the background color on which others are imposed.

Guéridon (gay-ree-DOHN)

Small French table generally topped with marble and used either as an occasional table or as a cocktail table.

Guérite (gay-RITT)

The French for "sentry box," an apt description of this version of the hall porter's chair with its high, hooded back and closed sides, designed to protect the sitter from drafts. It was widely used in France during the sixteenth and seventeenth centuries. In the eighteenth century, fashioned in wicker, it moved outdoors and became a standard piece of garden furniture, the role in which we are accustomed to see it today.

Guilloche (ghee-LOHSH)

In Greek architecture, a repetitive motif composed of equidistant circles enclosed in a winding, interweaving band, in either a single, double or triple strand. Furniture and moldings of the Italian Renaissance and Louis XV and XVI periods were carved with a single guilloche. Today the motif appears on carved wood and paper moldings.

GUILLOCHE on a demilune console table. Courtesy Brunovan, Inc., New York.

French GUERIDON, 18th century, signed Topino. Courtesy Philip Colleck, New York.

GUERITE. Courtesy Ralph A. Miele, Inc., New York.

English **HALL CHAIR**, c. 1800 (from Wooten Hall, Cheshire, England). The Metropolitan Museum of Art. Gift of T. H. Fitzhenry, 1906.

Hadley chest

Early type of New England chest with a hinged top, short legs and one, two or three drawers. The chest was crudely carved in simple floral designs, often with the owner's initials on the center panel.

Haircloth

Another name for horsehair. Under either designation, this hard-wearing lustrous material, used extensively in nineteenth-century England and America for upholstery, is not so prickly a product as it sounds, being actually a combination of horsehair with worsted, cotton or linen yarns, woven plain, in stripes or in patterns.

Hall chair

Eighteenth-century English wood chair designed to add style, if not comfort, to the halls and corridors of Georgian mansions—Sheraton suggested its suitability for waiting servants or strangers come to conduct business. Both seat and back were made of wood, usually mahogany, and the family crest (if any) was painted in the center of the back panel.

Hall porter chair

A high-backed, hooded chair designed as a protection against the drafts of cold and lofty halls and corridors. *See also* Guérite.

Hall tree

Once a familiar sight in the family hall, these wood or metal stands that blossomed with hats, coats and umbrellas are back in vogue again, this time as much for their decorative as for their practical value.

Hallmark

Originally, the official stamp of the goldsmiths' guild in London, certifying articles made of gold and silver. Hallmarks on silver guaranteed the sterling standard (925 parts pure silver to 75 parts copper) and also identified the maker, date and city of origin. The word is generally used today to denote high quality.

HANDKERCHIEF TABLE. Courtesy Kittinger.

Handkerchief table

Aptly named American drop-leaf table with a triangular top, like a handkerchief folded corner to corner. Actually, the table consists of two triangular hinged sections. When the drop leaf is raised, the table becomes square.

91

HARD-EDGE painting by Paul Gedeohn. Courtesy Jack Lenor Larsen. Photographer: John T. Hill.

Hand screening

Silk-screening process in which dye is manually forced with the aid of a rubber squeegee through silk covered with a stencil, thus forming a pattern on the material beneath. The operation must be repeated for each separate color. *See also* Screen prints; Silk screening.

Hand-tufted carpet

A handmade cut pile carpet woven like an Oriental, but of heavier wool and with a coarser texture.

Hangings

Window and bed curtains and wall hangings belong in this category, which harks back to medieval times. Then men of wealth carried their own portable furnishings around with them, hanging them up in the bare and chilly interiors of castles to protect them from drafts and add a measure of comfort and color to their stony surroundings.

Hard edge

A style of modern painting using strong contrasts of flat color without shading. It may be either abstract

Bed HANGINGS. Courtesy Celanese Corp. Interior design by Mark Hampton.

or representational. Exemplars: Piet Mondrian, Hans Hofmann, Alexander Liberman.

Hardboard

Generic name for lightweight, durable board of compressed wood pulp, which substitutes for solid wood in areas where stress is no factor, such as partition walls, doors, screens, ceilings and furniture carcases.

Hard-surface flooring

A classification that covers all the rigid flooring materials—soft and hard woods, marble, brick, flagstone, mosaic and ceramic tile—and the resilient floorings—vinyl, cork and rubber tile, linoleum.

Hardwood

Generic term for the timber from any broad-leafed tree—such as oak, elm, chestnut, beech, birch, mahogany, walnut or teak.

Harewood

English figured sycamore, a whitish wood that was frequently dyed silver-gray by eighteenth-century cabinetmakers for inlay and marquetry work, as a contrasting veneer to rosewood and mahogany.

Harlequin table

This ingenious Sheraton invention secretes storage space in a center section that rises automatically when the leaves are raised, revealing compartments for toilet or writing articles. In the 1930's copies were adapted for bars and cellarets.

Harvest table

Long, narrow American provincial dining table with one or two shallow drop leaves, at which farm hands were seated at harvesttime.

Hassock

An opulently stuffed, completely upholstered footstool, often of chair-seat height.

Headboard

The panel or board at the head of the bed which acts as a support. Headboards know no limitations of style and material—they can be contemporary or traditional, simple or elaborate, made of wood, leather, cane, metal, or fabric-upholstered.

Heart-shaped chair back

Hepplewhite chair back with the outline of a heart, a development of the shield back.

Hepplewhite

A style of eighteenth-century English furniture with both grace and substance, named for its designer, cabinetmaker George Hepplewhite, whose inspiration was drawn chiefly from classic sources and the prevailing French styles of the Louis XV period. Credited as the father of the modern sideboard, Hepplewhite favored serpentine fronts, six legs and the concave corners that distinguish his pieces from the convex models of Sheraton. Mahogany was his chosen wood and his furniture is also known for embellishment, in the form of beautiful veneers or painted scenes, and japanning. Among the characteristic features of the Hepplewhite style are slender, fluted legs and spade feet; chairs with shield backs; a preponderance of curves; carving employed sparingly and generally classical, with the exception of the Prince of Wales feathers motif. Today Hepplewhite furniture belongs primarily in dining rooms and as an accent in other rooms.

HEPPLEWHITE STYLE

Feather-back chair.

Show-wood frame sofa.

Breakfront bookcase.

Herend

Hungarian porcelain noted for its colorful decoration of butterflies, insects, flowers and fruit.

Herringbone

Venerable V-shaped pattern, derived from the chevron, in which wood, stone or brick is laid horizontally or vertically for walls, paths and floors, with the alternate courses pointing in opposite directions. In the eighteenth century, the herringbone pattern also appeared in the veneer of walnut furniture. Today it is found not only in hard-surface flooring, but as a design on fabrics, wallpapers and carpets.

Hicks, David

British designer with an international clientele whose special style includes the use of deep-color backgrounds and bold, contrasting patterns with eclectic combinations of furniture and accessories. Best-known in this country for his strongly geometric carpet designs for Harmony.

Highboy

A tall chest of drawers, usually made in two parts: a tablelike base with legs and an upper chest. From *haut bois,* French for "high wood."

High-key colors

Colors of high intensity or brightness—the primaries, secondaries and tertiaries.

High-riser

A bed within a bed, similar to a studio couch, but different in that whereas one mattress is stored under the other, each is on separate springs. When the under mattress and spring are pulled out, they raise to standard height, hence the name. A latter-day version of the old colonial trundle bed.

Hikie (*hee-kee-EH*)

A contemporary lounging piece—low, wide, oversized, armless and backless—which originated in Hawaii and may have derived from the simple bed of the Polynesian natives—a pileup of layers of lauhala mattresses.

Hinge

A two-part metal joint that connects door to frame, lid to box, drop-front panel to desk. Among the many varieties are the T, the H, the loop and others of more decorative mien.

Hitchcock chair

Chef-d'oeuvre of Lambert Hitchcock, the early-nineteenth-century cabinetmaker and designer. His widely copied chair, based on a Sheraton original, has a broad pillow-back band, turned and splayed legs and a rush or cane seat. It was usually painted and frequently stenciled with fruit, flowers or patriotic motifs.

Hogarth chair

A type of mid-eighteenth-century Chippendale chair with a hoop or shaped back and sturdy cabriole legs.

Holland cloth

The traditional fine-woven manila-colored linen made into window shades and roller blinds. The once-plain fabric has recently blossomed into pastel colors and stripes.

Hollywood bed

A box spring and mattress with legs (or on a bed frame with legs), a headboard and sometimes casters. The size varies from twin to king and the headboard sets the style.

Honan

A pongee-type fabric, the finest of the Chinese wild silks.

Honeysuckle motif

One of the most enduring of all decorative motifs, a stylized fanlike spray of petals derived from the

Greek anthemion. It was first revived during the Renaissance and enjoyed a great vogue during the Empire and Regency periods. This motif can be frequently spotted today in decorative ironwork balconies and grilles.

Hood

In architecture, any canopy or projection over a door or window, generally semispherical or curved. In furniture, the shaped top, usually curved, on a highboy, clock case or hall porter's chair.

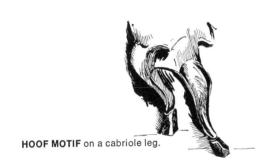

HOOF MOTIF on a cabriole leg.

Hoof motif

Also known as "pied-de-biche." This mark of the beast—goat, doe, ram and horse—was one of the many exotic fancies borrowed from early Egypt by eighteenth-century English and French cabinet-makers, who favored it as a termination for the cabriole leg.

Hooked rug

A rug with a pile surface made by pulling strips of cloth or coarse yarn through canvas. Chiefly associated with "Early American" rooms.

Hoop back

A type of chair back in which the rail forms a continuous curve. Most common in Windsor chairs, Chippendale-style chairs of the late eighteenth century and contemporary Scandinavian types.

Horn furniture

Fantasies fashioned of horns and antlers, which dictate their extravagance of form. Originally intended for nineteenth-century hunting lodges and trophy rooms and collected by such disparate types as Queen Victoria and Theodore Roosevelt, the furniture has lately been taken up again by interior designers and those with a taste for Victorian camp. Lethal-looking pieces ranging from chairs, sofas, tables and beds to étagères, chandeliers and mirrors are being incorporated into contemporary rooms where their antic shapes stand out in contrast to linear modern furniture. There are four basic types of horn furniture, mostly importations, although some was made in the Far West from the 1860's. One type is made of elk and stag antlers, another of buffalo, steer and cow horn. A third, more elaborate version of buffalo and steer horn inlaid with mother-of-pearl came from India, and a fourth, a combination of antlers and wood, from Austria.

Horsehair

A stiff, harsh, slippery, woven fabric containing hair from the tail or mane of a horse. Plain, striped and checked horsehair-covered furniture dates from about 1775, but it had its greatest acceptance in the Victorian era, when comfort was less prized than durability and the horsehair-upholstered sofa and dining-room chair were commonplace. *See also* Haircloth.

Hue

Another name for a pure color, such as red or green. A tint is a hue lightened with white; a shade is a hue grayed with black. One hue can have many tones.

HORN CHAIR. Photographer: Otto Maya.

Hunt board

Early-nineteenth-century American sideboard of a height appropriate for self-service at buffet hunt breakfasts. The most common examples are the Hepplewhite and Federal designs.

Hunt table

A crescent-shaped or long sideboard table with drop leaves to extend the serving surface, designed for hunt breakfasts. The distinguishing feature is the height, tall enough for everyone to stand around it comfortably. With drawers, it was called a hunt board. Today the semicircular hunt table is used as a buffet, a desk or, lowered, as a coffee table.

Hurricane lamp

Breezeproof candlestick with a glass shade set into the bobêche, which is often trimmed with crystal prisms. Today hurricane lamps may still depend on candle power, or they may be wired and fitted with flame-shaped bulbs.

Hurricane shade

The tall, cylindrical glass shade that fits over a candlestick, shielding the flame from the wind.

Hutch

Chest or cabinet on legs which supports an open-shelf deck. As a sideboard this was popular in early American households.

HURRICANE LAMP.
Courtesy Parzinger
Originals, Inc., New York.

Hepplewhite **HUNT BOARD.**
Courtesy Newcomb's Reproductions.

HUTCH. Courtesy Patterson, Flynn & Johnson, Inc.

Japanese **IMARI,** 18th century. The Metropolitan Museum of Art. Gift of Charles Stewart Smith, 1893.

I

Imari

A style of decoration executed in blue, red, yellow, gold and green on a white ground, originating on Japanese porcelain made solely for export. It was widely copied by many of the European porcelain houses, notably Derby, Spode, Worcester and Minton, which based their "Japan" patterns on the designs, despite their complete lack of any link with true Japanese design. The porcelain is still being made in Japan, but in cruder, less felicitious versions of the now rare antique Imari.

Imbrication

A fish-scale decoration that originated in ancient Rome, found in furniture carving and fabric and wallpaper designs.

Impressionism

A nineteenth- and early-twentieth-century school of painting in which visual impressions were expressed in broad, sweeping terms without minute detail or defined outline. Impressionist painters: Claude Monet, Camille Pissarro.

Inchbald, Michael

British interior designer noted for his skilled interpretations of the eclectic look—adroit combinations of antique furniture and accessories with modern materials and colors.

India print

An inexpensive printed cotton cloth with brightly colored, hand-blocked patterns characteristic of India, such as the tree of life. Mostly sold as bedspread lengths.

Indian Head

Trade name for a vat-dyed, colorfast, "permanent" finish, lightweight cotton fabric suitable for slipcovers, bedspreads, curtains, etc.

Indienne (an-d'YEN)

An inexpensive cotton imitation by the French of the seventeenth- and eighteenth-century printed cottons imported from India.

INDIAN HEAD polka-dot fabric. Courtesy B. Altman & Co., New York. Photographer: Grigsby.

Indirect lighting

Light from a hidden source that is reflected off a flat surface such as a wall or ceiling to give a soft overall illumination.

INLAY on a chest. Courtesy Manheim Gallery, New Orleans.

Inlay

A form of surface decoration dating back to the ancient Egyptians in which one material—wood, metal, ivory, shell or semiprecious stones—is set flush into the cutout surface of another. The eighteenth-century English and French cabinetmakers excelled in the technique of wood inlay. Today, much machine-made furniture is embellished with some forms of inlay.

Insert

A decorative inlay design formed by setting a shaped piece of one material into the surface of another. In flooring the word may refer to brass set in vinyl tile.

Intarsia

The decorative forerunner of inlay. Designs inlaid in wood through use of contrasting colors and textures of other woods, ivory, metal, tortoise shell or stones set flush with the surface.

Interior designer

Term preferred by the two professional organizations—the American Institute of Interior Designers (A.I.D.) and the National Society of Interior Designers (N.S.I.D.)—to "interior decorator," which has been widely assumed by such nonprofessionals as house painters and housewives. Interior designer implies a person qualified by training and experience not just to decorate, but to plan, design, supervise and execute interiors of a house or public building.

Irish Chippendale

A solid, rather heavy adaptation of Chippendale designs made by Irish craftsmen in the mid-eigh-

teenth century. The furniture, usually of mahogany, is characterized by the extensive use of lion masks and paw feet.

Ironstone

White semiporcelain china that originally contained slag from iron mines, hence the name. Antique ironstone, especially that made by Mason and Wedgwood, is widely collected.

Isometric drawing

Three-dimensional sketch of a room where the walls are drawn at a 45-degree angle to the floor and the vertical lines are projected from it in scale. Although the curved and diagonal lines are distorted, the four walls appear in perspective, allowing the designer to sketch the furniture in position.

Italian Provincial

All-embracing term for the many and varied styles of furniture made by craftsmen of the Italian provinces during the eighteenth and early nineteenth centuries, usually simplified versions of the elaborate designs of Rome, Florence, Venice and Milan. The early pieces show a strong baroque influence, later ones the neoclassicism of French styles, but with rustic overtones. Painted finishes, one of the main features of Italian Provincial, were probably the result both of necessity and of choice—first, as a means of disguising the inferiority of the woods used, and second, to allow full play to the exuberant Italian flair for decoration. Today, Italian Provincial reproductions have improved on the originals in scale but the term itself has come to cover anything "Mediterranean" that is basically straightlined rather than curved like French Provincial.

ISOMETRIC DRAWING.

"Egg" chair by **ARNE JACOBSEN.** Courtesy Fritz Hansen, Inc., New York.

Jablow, Evelyn

Designer of interiors and sleek, contemporary stainless-steel furniture who has successfully taken this modern material out of the kitchen and into the living room.

Jabot (*zhah-BOH*)

Valance heading, a pleated piece of fabric that hangs either over or under the swags or sides of the valance.

Jackfield

Eighteenth-century English black-glazed pottery frequently decorated with unfired gilding or painting that wore off in use, leaving the plain black ware we mostly see today.

Jacobean

Prevailing style in furnishings during the reign of the Stuart kings James I and Charles I. The furniture, in the Italian Renaissance and baroque tradition, is mostly made of oak and is heavily carved, but some small concession was made to comfort by the introduction of upholstered seats and backs.

Jacobsen, Arne

Danish furniture designer best-known for his successful "egg" and "swan" swivel chairs for Fritz Hansen, made of upholstered, contoured plywood and steel.

Jacquard

Elaborately figured fabrics—damasks, brocades, tapestries, etc.—woven on the loom invented in 1801 by Joseph-Marie Jacquard.

Jalousies

Shutters of wood or aluminum slats that adjust like Venetian blinds.

Japanning

A type of lacquerwork in which surfaces of wood or metal are coated with layers of varnish and then dried in heated ovens. May have high-relief, incised or flat designs. A decoration borrowed from the Orient, it attained high excellence in France under Louis XIV and in England under Charles II. Today, japanning is rapidly becoming a lost art.

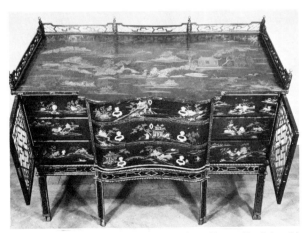

JAPANNING on a commode from Badminton House, English, mid-18th century. Courtesy Victoria and Albert Museum, London. Crown copyright.

Sceaux faïence **JARDINIERE,** French, 18th century. The Metropolitan Museum of Art. Gift of J. Pierpont Morgan, 1917.

JOINT STOOL.

JIGSAW MIRROR.
Courtesy A. L. Diament & Co.

Jardinière (*zhahr-deen-YEHR*)

French term for a decorative wood, ceramic or metal container or stand for plants or flowers.

Jardinière velvet

A silk velvet with a multicolored flower pattern on a light background of damask or satin. A handsome and expensive upholstery or drapery fabric.

Jaspé (*zhah-SPAY*)

A fabric weave characterized by short, irregular streaks caused by warp and weft threads of contrasting colors, named for the French *jaspé* (streaked).

Jasper ware

The most famous and lastingly popular of Josiah Wedgwood's eighteenth-century pottery designs in the classic manner with beautiful stained ground colors (celadon green, violet, sage, black and Wedgwood blue) ornamented in white relief with Grecian figures and motifs. While contemporary jasper ware in the characteristic blue, green and black ground colors is still produced, early pieces in rare colors are those prized by collectors.

Jigsaw mirror

A mirror with a scrolled frame originally cut by hand, later with a jigsaw, popular during the eighteenth and nineteenth centuries in America and England.

Johnson, Philip

Noted American architect whose own house, by carrying the naked glass wall to its logical and beautiful extreme, did much to influence decoration by exposing and silhouetting the interior furniture like sculpture.

Joint stool

Jacobean low stool, usually of oak and not up-holstered, with turned and jointed legs. In today's liberal decorating lexicon the term may refer to an occasional table of this design.

Jones, Inigo (1573–1652)

Leading English architect who studied in Italy and brought back the Palladian style. Under the patronage of Charles I he designed buildings in the classical manner and furniture on Italian Baroque lines.

Juhl, Finn

Danish furniture designer who freed modern furniture from the boxlike form by introducing sculptural, flowing lines in his designs.

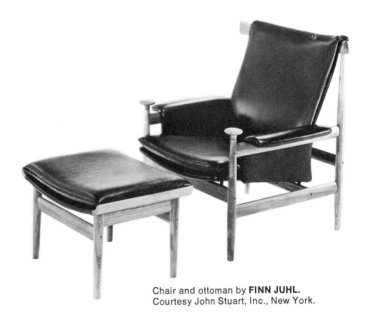

Chair and ottoman by **FINN JUHL.**
Courtesy John Stuart, Inc., New York.

House designed by **PHILIP JOHNSON.** Photographer: Alexandre Georges.

Pine-and-oak painted **KAS**, New York, American, early 18th century. The Metropolitan Museum of Art. Gift of Miss Sarah Elizabeth Jones, 1923.

Kahane, Melanie, F.A.I.D.

Interior designer credited with two of the most striking and successful color combinations of the 1950's—the then avant-garde pink-and-orange scheme and an updating of the classic black-and-white-plus-color—in this case, pumpkin.

Kakemono (kah-kee-MOH-noh)

Vertical unframed Japanese scroll painting.

Kakiemon (kah-kee-EH-MOHN)

Polychrome enamel decoration on porcelain originated by the seventeenth-century Japanese potter Sakaida Kakiemon and so imitated in Europe by the English, French and German porcelain houses that today the word is applied to any decoration in this style.

Kas

Early American cabinet the size of an armoire, made by Dutch settlers. The wood may be walnut, pine, cherry or maple, and the kas is frequently carved, paneled or painted in primitive fashion with ornaments of fanciful flowers.

Kauffmann, Angelica (1741–1807)

A Swiss painter and decorative artist best-known for the work she did in England for the brothers Adam and for Wedgwood from 1766 to 1781—painted panels and ceilings in the neoclassic style and painted decorations and porcelain plaques on furniture. Her portraits and classical scenes also hang in the great English houses, such as Nostell Priory.

KD

Abbreviation for knock-down, a term for furniture that is designed in parts to be shipped unassembled and put together by store or customer. Financial savings in assemblage and shipping costs can be passed along to the purchaser.

Kent, William (1685–1748)

English architect, painter and designer of interiors, landscapes and furniture. His furniture designs, immensely popular in their time, were architectural in concept to fit the scale of his classic houses. Unfortunately, many of the pieces, influenced by the Italian Baroque style, were ponderous and overdone, with florid gilding and carving.

Key pattern

Geometric band or border ornamentation made up of interlacing lines at right angles, derived from ancient Greek architecture and also known as Greek key or fret. We use it on moldings, on fabric trims and as a printed border for fabrics and wallpapers.

Kidney shape

The oval shape with concave front found on desks and dressing tables, a favored form of Sheraton's and other eighteenth-century English and French cabinetmakers.

Kinetics

The logical extension of op art in light-painting, sculpture and decorative design where continuous, free-flowing movement is an integral and essential part of the concept. Alexander Calder was the originator of kinetic sculpture long before the op-art movement. Exponents in other divisions: Earl Reiback, light-painting with his "Lumia" images; Timo Sarpanevo, textiles "paint-printed" with free-form electric patterns.

King-size bed

A superman's supersized bed, wide (from seventy-two inches to seventy-eight inches), long (from eighty inches to eighty-four inches) and luxurious.

Klismos

The reclining chair of ancient Greece. One of the all-time great classic shapes that inspired similar styles in the French Directoire and English Regency periods and our own century.

Knee

In furniture, the upper, thickest part of the cabriole leg, often elaborately carved and decorated.

Kneehole

Descriptive of desks and chests with a center opening flanked by two banks of drawers. Often the space is filled in part way from the back by a compartment with a door.

Knife box

Walnut or mahogany box, often with silver mounts and ivory inlay, designed to hold table silver. They stood, usually in pairs, on buffets in eighteenth-century English dining rooms and today are regarded as purely decorative curiosities.

Knife edge

The single-seam edge on a pillow or cushion. A box edge consists of a double-seam edge with space between.

Knole sofa

A completely upholstered sofa, similar to a tuxedo, with a high back and sides of the same height connected by loosely knotted cords looped over decorative wood finials on the adjoining corners of the back and arms. The sides are often hinged and drop down to form a day bed. The design is supposedly named for and adapted from an original seventeenth-century sofa in Knole House, Kent, England.

Knoll, Florence

American furniture designer who, with her husband, Hans Knoll, founded Knoll International, a firm noted for the high standard of its work in the field of interior design allied to architecture. In addition to Mrs. Knoll's designs, Knoll also commissioned and produced furniture designed by Mies van der Rohe, Eero Saarinen, Harry Bertoia and Isamu Noguchi. After the death of Hans Knoll in 1955, Florence Knoll took over the operation of the company, subsequently selling it to Art Metal in 1960, by whom she is still retained as a design consultant to the group.

Knotty pine

Pine where the knots are conspicuous. The twentieth-century fad for knotty-pine walls to simulate "Early American" is historically incorrect. Only clear pine, free from knots, was originally used, except where the surface was painted.

KNOLE SOFAS in a room designed by Louis Bromante. Photographer: Grigsby.

Lace

One of the earliest forms of handmade fabric. A needle, pin or bobbin is the instrument; sewing, knitting, knotting (tatting) and crocheting, the techniques. Although the finest lace is still the handmade, machines were invented in the eighteenth century that could duplicate the effect with much greater speed and at much less expense. These machine-made versions now go under the general term Nottingham lace, to distinguish them from the hand products, each of which has its own name and style. The latter includes filet, embroidered on net; reticella, which combines drawn and cut work; the elaborate French Cluny, Chantilly, duchesse and Valenciennes; the Irish Limerick and Carrickmacross; the different varieties of Brussels lace. Lace curtains, known since the Renaissance, reached their greatest peak of popularity in Victorian England, when no house was considered well furnished without them, and are enjoying a minor but noticeable revival today.

Lacquer

A laborious build-up of several layers of colored varnish on wood or metal objects, a process originated by the Chinese and also practiced in other Eastern countries, such as India and Japan. The name is derived from the basic natural substance, a resin lac which becomes very hard when exposed to the air and polishes to a high, glossy finish. While lacquer has always been superior to paint both in color and in hard-wearing qualities, the lengthy hand process kept the cost high. Now we have duplicated the colors—although not the patina—of the old lacquerwork on mass-produced furniture with synthetic lacquers.

Ladder back

A type of chair back with horizontal ladderlike slats, common in early American and provincial styles of furniture.

Lalique glass (lah-LEEK)

Decorative, colorless French glass combining clear and white mat surfaces, originated at the beginning of the twentieth century by René Lalique (1860–1945). The engraved, molded and pressed designs of flowers and foliage, birds and animals, were restrained and elegant. Lalique's early work consisted of small pieces, such as perfume bottles (he was supplier to Coty). Later he branched out into bowls, lamp bases, vases and figures.

Lambrequin

Shaped valance of fabric, bound or trimmed with fringe, which crowns a window, the top of a bed or a chair back.

Laminates

Materials in lamination, a process in which thin layers of a given material are bonded to each other or to another material under great pressure. Plywood is a laminate, as are the plastics Formica and Micarta. The development of vinyl plastics gave new dimension to the process and made possible such aids to decorating as laminated fabric window shades, laminated cork veneer and wood veneer floor tiles, laminated Japanese papers shaped into trays.

Lampas

A fabric of figured silk, popular since the eighteenth century, in which a classic design is woven in two or more tones of one color on a different-colored satin ground in a combination of the three basic weaves—satin, twill and taffeta. Always expensive, due to the complicated weaving process.

Lannuier, Charles-Honoré

Nineteenth-century French cabinetmaker who worked in New York in the Directoire and early Empire styles. Many of his pieces may be seen in the main rooms of the White House.

Lantern clock

Seventeenth-century English shelf clock, usually made of brass, in the shape of a lantern. Instead of a pendulum, the clock was run by weights. Today's version is battery-operated.

Lapis lazuli

A semiprecious stone whose beautiful ultramarine color has earned it a decorative niche since the days of the Assyrians and Babylonians. In the eighteenth century, in combination with other scintillating treasures such as gold and malachite, it was turned into objets de luxe—jewel boxes, paperweights, urns. We duplicate the effect at a fraction of the cost in accessories with a faux lapis finish, a ceramic, paint or paper simulation of the real thing.

Larsen, Jack Lenor

Fabric weaver and designer whose unusual collections of offbeat prints and woven fabrics have greatly influenced designers of mass-produced fabrics.

Laureling

A banding of laurel leaves, usually on a half-round molding, applied as decoration to walls or furniture, or, as a motif, printed on fabric and wallpaper.

Lavabo (lah-vah-BOH)

Originally, a functional piece of plumbing. The lavabo is a wall-hung washbasin in two parts (upper part is water container, lower part is basin), both of which are mounted on a wood back. Now used principally for decoration, often to hold plants.

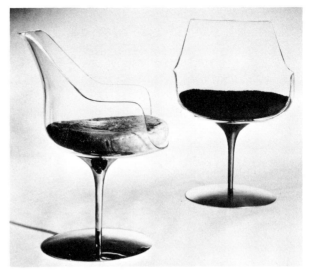

See-through plastic chairs. Courtesy **LAVERNE** Originals, Inc., New York.

Laverne, Estelle and Erwin

Heads of the New York design firm of Laverne, a noted manufacturer of modern wallpapers, printed fiberglass fabrics, steel and marble furniture and the famous see-through plastic chairs.

Lawn

Originally, a sheer, lightweight linen fabric, now made of cotton or synthetic fibers. Often used for glass curtains.

Lawson sofa

A completely upholstered sofa with a low, square back and flaring scroll arms.

Layout

Interior designers' name for a plan or sketch of a room, showing furniture arrangement, color plan and often swatches of fabrics and materials.

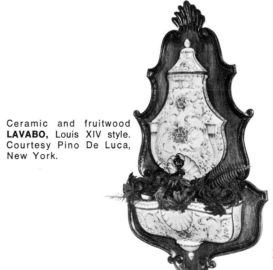

Ceramic and fruitwood **LAVABO**, Louis XIV style. Courtesy Pino De Luca, New York.

Le Brun, Charles (1619–1690)

Painter, decorator and director of the Gobelins factory, generally credited with setting the style identified with Louis XIV. Versailles, for which he designed the meubles de luxe and everything from carpets and paneling to silverware, was his chef-d'oeuvre. Although most of Le Brun's paintings, usually vast canvases depicting religious and mythological scenes, were definitely second-rate, his paintings at Versailles on the ceiling of the Galerie des Glaces and in the Salons de la Guerre and de la Paix exonerate him.

Le Corbusier (1887–1965)

Swiss-born architectural genius Charles-Édouard Jeanneret, who, under his adopted, self-chosen name, designed some of this century's most inspired and controversial buildings in his favored, most plastic material, concrete. His work, which spans continents and embraces everything from furniture designs to the planned city of Chandigarh in India, is essentially austere and functional, based on his philosophy of social organization, yet rich in human values.

Lectern

A bookstand, originally ecclesiastical, made of wood, metal or stone.

Leeds

Eighteenth-century English pottery noted mainly for its creamware—pierced or enameled.

Library steps

Eighteenth- and nineteenth-century boosts to high-up bookshelves. Their forms and styles varied, but mostly they appeared as benches or tables concealing a ladder, often with handrails. Since few houses today boast libraries, the steps now display plants or collections.

Library table

Generally, a large double-pedestal table with drawers and often with book space.

Liebes, Dorothy

Textile designer, weaver and colorist who reintroduced the use of metallic threads in fabrics and brought brilliant color to mass-produced fabrics and carpets.

Lighthouse clock

American nineteenth-century shelf clock, vaguely reminiscent of a lighthouse. The brass dial and works are covered by a glass dome set on a tapering body and octagonal plinth with a small door.

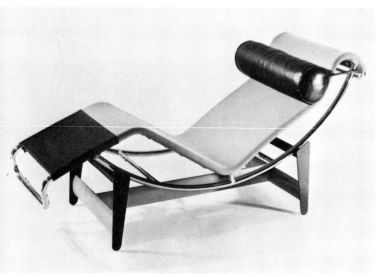

Chaise longue designed by **LE CORBUSIER** from the Collection of The Museum of Modern Art, New York. Gift of Thonet Industries, Inc.

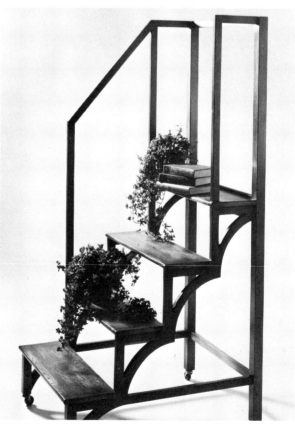

LIBRARY STEPS. Courtesy Yale R. Burge, New York.

Limoges (lee-MOZH)

Famous name in decorated porcelain, which has been made since the eighteenth century by the factory at Limoges, France, and is most recognized in the late-nineteenth-century Haviland-Limoges services. In contrast, modern Limoges is made in simplified shapes with restrained decoration.

Linen fold

Carved paneling, originally Gothic, which represents the vertical folds of linen. May also have been inspired by the folded linen napkin on the chalice in church ritual.

Lion motif

One of the earliest and most common of animal symbols in decoration, found in everything from the architecture of Greek temples to flocked wallpaper.

Lit clos (lee cloh)

The French term for a bed enclosed on three sides with wood paneling. Provincial pieces of the eighteenth century are popular in reproduction today.

Lit de repos (lee duh ruh-POH)

Lighthearted version of a day bed, designed for cat naps in the French fashion. *See also* Turquoise.

Liverpool ware

The black-transfer creamware, often decorated with colors, is the most common of the pottery made in Liverpool, England, during the late eighteenth and early nineteenth centuries.

Loggia (LOHD-zhah)

A room or area that extends on one side into an open arcade or roofed gallery projecting from the side of the house.

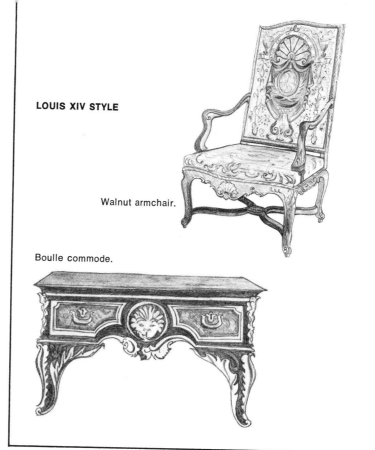

LOUIS XIV STYLE

Walnut armchair.

Boulle commode.

Barrel-shaped **LIVERPOOL WARE** jug, c. 1795. Courtesy Victoria and Albert Museum, London. Crown copyright.

Lotus motif

Decorative motif of ancient Egypt and the Orient, once again fashionable in the current Art Nouveau revival for fabrics and wallpapers.

Louis Philippe (loo-ee fee-LEEP)

French recap of Louis XV styles during the reign of Louis Philippe (1830–1848), often mistaken for Victorian.

Louis Quatorze (1643–1715) (loo-ee kah-TORZ)

A baroque style of furniture developed during the reign of Louis XIV, characterized by sumptuous scale and symmetry, both masculine and magnificent. Carving, although confined to the straight line, was rich and heavy, and plain woods were glorified by gilding and other decorative applications—the famous cabinetmaker Boulle perfected intricate marquetry of tortoise shell, brass, ivory, bone and mother-of-pearl. Gorgeous damasks, velvets and tapestries covered chairs and such newly developed seating pieces as the "confessional." While the style and size of Louis XIV is inappropriate to today's houses, the less grandiose country pieces of this period are currently having a revival.

LOUIS XV STYLE

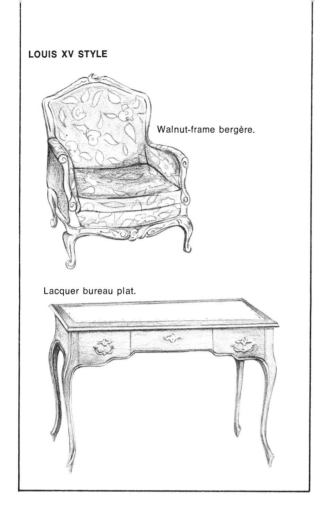

Walnut-frame bergère.

Lacquer bureau plat.

LOUIS XVI STYLE

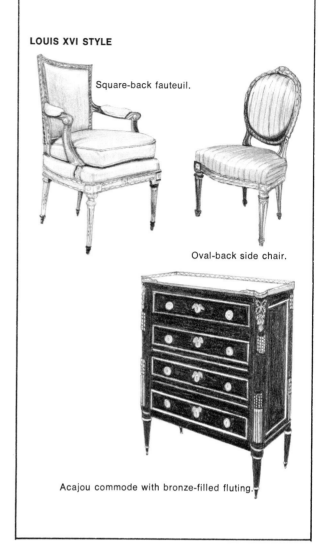

Square-back fauteuil.

Oval-back side chair.

Acajou commode with bronze-filled fluting.

Louis Quinze (1715–1774) *(loo-ee kanz)*

The rococo style that emerged during the reign of Louis XV, considered by many to be the ultimate in decorative furniture. Reflecting the influence of such powerful royal favorites as Madame de Pompadour, Louis XV furniture is essentially feminine in character, smaller in scale and more gracefully proportioned than Louis XIV. Symmetry was avoided, and every possible device was employed to detour the straight line into a soft curve. Every variety of table shared a common characteristic: the slender, sinuous cabriole leg. Comfort was emphasized, although artfully disguised, in chairs, sofas and chaise longues shaped to the human frame and often upholstered with loose down cushions and covered with pretty, delicate fabrics—damask, chintz and printed linen. Decoration was made an intrinsic part of design—marquetry, painting, lacquering, gilding and fanciful chinoiserie motifs. Mahogany, native fruitwoods and walnut with veneers of the more exotic rosewood, satinwood, amaranth and tulip were all favored furniture woods. Today, Louis XV remains the most popular of all the French styles in reproductions and adaptations.

Louis Seize (1774–1793) *(loo-ee sayz)*

A neoclassic style that emerged during the reign of Louis XVI. French cabinetmakers, in reaction against the frills of Louis XV and affected, like the Adam brothers, by the discoveries of Pompeii and Herculaneum, returned to the symmetry and simplicity of the ancient architectural forms. Furniture took the severer straight line, and ornamentation was in the classic manner—laurel, egg and dart, palm leaves, fretwork, rinceaux and ribbons—and from Greco-Roman sources—swans, urns, wreaths, festoons, bound arrows and fanciful animals. New shapes were added to the furniture established under Louis XV, notably the curule bench, the roll-back sofa and glazed display cabinets, known as vitrines. Mahogany was the dominant wood, with ebony, rosewood, tulip and other exotics combined in marquetry; upholstery fabrics stressed toiles and striped satin. While not as universally appealing as Louis XV, Louis XVI is nevertheless easy to live with today because of its simplicity and restraint.

Lounge

Upholstered chaise with a headrest, the standard furnishing for a psychiatrist's office. Also, the sitting room in a public building.

Louvers

Slatted system to control light and air at windows or doors. Louvers may be vertical or horizontal, stationary or adjustable, of wood, metal or plastic.

Love seat

Also called a courting chair. This sociable piece of furniture originated during the Queen Anne period as a double chair and developed into the small upholstered sofa we know today.

Lowboy

A low chest or table with drawers developed in Jacobean England and popular in England and America during the eighteenth century as a dressing table and small writing table.

Lowestoft

Ceramics produced by a small porcelain factory in Lowestoft, England, from 1757 to 1802; mostly tableware, small boxes, naïvely charming figures of dogs, cats and sheep, but also some commemorative gift china mugs, tea caddies, and birthday plaques which are dated and often say "A trifle from Lowestoft." Among the finer pieces are the large punch bowls with painted rococo and Chinese decorations inspired by Chinese porcelains brought to Europe by the Dutch East India Company.

Low-key colors

Colors of low intensity or dullness—the paled tints and grayed shades of the various hues.

Luminous ceiling

Installation of striplights behind translucent panels which diffuse shadow-free light. Primarily used in kitchens, baths or windowless interior areas, and also as an ingenious device for creating a false ceiling in a room which is disproportionately high.

Lunette

A half-moon shape. In furniture, it appears in the demilune console table. In architecture, the fan-shaped window over a door is called a lunette.

Lunéville (lew-neh-VEEL)

French ceramic factory that specialized during the eighteenth century in *grand feu* faïence garden ornaments—busts, crouching lions, etc. Later Lunéville pieces were in the Strasbourg rococo style.

Lurçat tapestries (lewr-sah)

Modern French tapestries woven on state looms under the supervision of Jean Lurçat from cartoons designed by Matisse, Dufy, Picasso and Lurçat himself.

Luster

A candlestick or sconce hung with crystal pendants, or the similarly adorned Victorian footed-glass flower holders.

Lusterware

Term for any ceramic ware that is decorated with an iridescent gold or silver metal glaze. Among the best-known types are the Hispano-Moresque pieces of the twelfth and thirteenth centuries, which had a pink-gold luster in geometric patterns; the gold-and-silver (platinum) luster of nineteenth-century England, with an allover solid color or heavily patterned; the light-golden-yellow ware known as canary luster; the purplish-pink mottled Sunderland ware; and Wedgwood's luminous mottled pink "moonglow." Modern luster lacks the delicacy and charm of the old.

Lyre motif

The shape of this stringed, harplike musical instrument has appeared in all forms of decoration since the days of the ancient Greeks, notably in furniture as a chair back (Duncan Phyfe), as a double or single table base (French and American Empire) and in the Biedermeier style.

LUNETTE.

MARQUISE. Courtesy Brunovan, Inc., New York.

Macramé (*mah-krah-MAY*)

French word for the hand-knotted fringe in geometric designs introduced to Spain and the rest of Europe by the Turks and commonly found as an edging on the woven Spanish rugs, or on curtains, pillows and bedspreads.

Majolica

Of the two distinct types, the earlier is the seventeenth-century tin-glazed pottery with polychrome decoration from Italy, Spain and the Low Countries. The later, nineteenth-century English, American and European majolica is enamel-decorated white earthenware, often in natural shapes, such as vegetables, fish, shells or animal heads.

Makimono (*mah-kee-MOH-noh*)

The horizontal version of the Japanese scroll painting. *See also* Kakemono.

Malachite

A rich yellow-green semiprecious stone with which the Czars decorated the walls of their palaces. While the stone is almost unobtainable today, its colors and markings have been successfully duplicated in paint, vinyl and ceramic finishes.

Manchette (*mahn-SHETT*)

The French word for armpad, the upholstered cushion introduced on the wood arms of eighteenth-century armchairs.

Man-made fibers

Fibers produced from polymers—a chainlike structure of molecules. Acetate and rayon are made from modified or transformed natural polymers; fiberglass from spun glass; polyacrylics, polyesters, polyurethanes and polyvinyls from chemical compounds. Some of the best-known, listed by generic name and manufacturers' trademark, are acetate (Avisco by American Viscose, Celanese acetate by Celanese, Chromspun by Eastman); rayon (American Bemberg by Beauknit Corp., Avril by American Viscose, Coloray by Courtaulds, North America, Inc.); fiberglass (Fiberglas by Owens-Corning, Modiglass); acrylic (Acrilan by the Chemstrand Corp., Creslan by American Cyanamid Co., Inc., Orlon by DuPont); nylon (Antron and Nylon by DuPont, Caprolan by Allied Chemical Corp., Enka nylon by American Enka); saran (Lus-Trus by Southern Lus-Trus Corp., Rovana by Dow Chemical Co., Velon by Firestone Synthetic Fibers Co.).

Marble furniture

Marble has been a favored furniture material since the days of those early decorators, the Egyptians, Greeks and Romans. The Renaissance brought a revival of interest in marble and marble inlays in wood or stone, and the magnificent furniture of Louis XIV and Louis XV shows a lavishment of marble tops with carved borders. The more utilitarian qualities of the stone were stressed in the Victorian era in England and America, when gray-and-white marble tops appeared on dressers, washstands and commodes. Today, we prize the colors and markings of marble for the interest they can lend to the tops and inlays of contemporary furniture.

Marbleizing

An artful painted finish that can make a wood or metal surface look for all the world like marble, except that the graining is apt to be exaggerated and the coloring more flamboyant.

Marquetry

Veneers inlaid with contrasting materials (wood, ivory), but retaining a flat surface.

Marquise (*mahr-KEEZ*)

The French term for an armchair, very wide and completely upholstered, that was originally designed to accommodate panniered skirts.

Married piece

Apt term for objects or furniture made up of parts not originally destined for each other. For example, a period highboy may be divorced from its own damaged or unsightly legs and united with more desirable underpinnings from another piece of the same or another period. Reputable antique dealers and furniture connoisseurs consider this kind of enforced marriage tantamount to faking, despite its often felicitous results.

Martha Washington chair

An open-arm chair with a high, straight upholstered back and upholstered seat in the Adam, Sheraton or Hepplewhite style, named after the wife of the first American President.

Martha Washington table

An oval sewing or work table made in America in the Hepplewhite, Sheraton and American Empire styles during the late eighteenth and early nineteenth centuries. It has two or three center drawers fitted for sewing gear flanked by ends with hinged tops that lift to reveal rounded bins for work in progress.

Mashrabiyyah (*mahsh-rah-BEE-yah*)

The shadowy lattices of turned bobbins that were the open "windows" of Arab houses, admitting light and air while obscuring the interiors. A device adopted here for room dividers, screens and window grilles.

MARBLEIZING on walls, Château d'Aunoy, France, arrahged by the decorator Emmanuel Motte. Courtesy Connaissance des Arts. Photographer: R. Bonnefoy.

MASHRABIYYAH room divider. Interior design by Jack Davidson. Photographer: Nick DeMargolies.

Matelassé (maht-lahs-SAY)

A fabric with a surface pattern that looks like quilting, woven on a loom. The name comes from the French *matelasser* (to pad or cushion).

Maugham, Syrie (1879–1955)

London interior designer who started a vogue for the all-white room in the 1930's and was dubbed the "White Queen."

McClelland, Nancy (1876–1959)

Interior designer and founder of the firm which still bears her name. Notable among her many achievements were the preservation and reprinting of many of the historic wallpapers in leading American restorations, and a remarkable book on the subject, *Historic Wallpapers.*

McCobb, Paul (1918–1969)

Influential contemporary designer whose simple but elegant furniture in walnut and brass for Directional set both a standard and a style for subsequent modern furniture design. His later, less expensive Planners Group of co-ordinated pieces in light, dark and painted finishes had a similarly beneficial effect on the young-budget market.

McIntire, Samuel (1757–1811)

American architect and wood carver from Salem, Massachusetts, famous for his mantelpieces and overdoors, many of which are currently reproduced.

MEISSEN statuettes of Spring and Summer, German porcelain, c. 1755.The Metropolitan Museum of Art, The Michael Friedsam Collection, 1931.

Medallion

A decorative frame, either round, square or octagonal, painted, carved or printed, and usually with figures in the center. Medallions have appeared as decoration on furniture, fabrics and wallpaper since the Renaissance.

Medieval

Descriptive of the arts, architecture and furniture of the Middle Ages, from the sixth to the sixteenth centuries, interpreted today in the more rustic style of the Country Look, through beamed, vaulted ceilings, dark stained floors and sparsely furnished rooms with heavy, upholstered, dark wood furniture.

Mediterranean Look

A fancy-free decorating mélange based on provincial furniture and accessories and colors from countries that border on the Mediterranean Sea—Spain, Portugal, Italy, France and North Africa—and characterized by strong contrasts, bold colors, natural materials in backgrounds, and baroque or Moorish elements such as gilt and painted furniture, wrought-iron grilles and hardware, tile floors and crudely ornate furniture. In this country the Mediterranean Look has been expressed primarily in furniture.

Meissen (MICE-s'n)

The first to make the true hard-paste porcelain, the Meissen factory has been in production ever since its founding at Dresden, Germany, in the early eighteenth century. In this country the best-known of the Meissen products are the elaborate tableware, figures and urns, and the simple blue-and-white "onion" pattern which is not an onion at all but a fruit-and-flower motif.

Mennecy (muh-neh-SEE)

French porcelain and faïence from a factory established in Paris in 1734 and later moved to Mennecy and then to Bourg-la-Reine. The mark D.V. usually found on the underside of the pieces stands for the name of the founder, the Duc de Villeroy. Although similar to the porcelains of Saint Cloud and Chantilly, Mennecy is distinguished by its milky whiteness, faintly wavy glaze, floral or Kakiemon painted decorations in delicate colors, and handles and knobs shaped like branches with leaves and fruit. The Mennecy figurines are exquisitely molded, some in the style of Boucher, others in the Oriental manner.

MEDITERRANEAN LOOK. Design by David Barrett, A.I.D. Courtesy Amtico. Photographer: Otto Maya.

MEDIEVAL interior. Treasurer's House, York, England, The National Trust. Copyright *Country Life*.

Mercerizing

A chemical process that gives cotton fibers or fabrics body, strength and greater ability to absorb dyes.

Mercury glass

Vases, epergnes, bowls and candlesticks of silvered glass made in imitation of sterling silver during the mid-nineteenth century. The glass was double-blown, the interior painted with silver nitrate, the exterior sometimes decorated and etched. It is much in evidence today, both old and new, reintroduced as part of the Wet Look.

Méridienne (*meh-ree-d'YEN*)

A short sofa of the French Empire period, with one arm higher than the other.

MERIDIENNE.

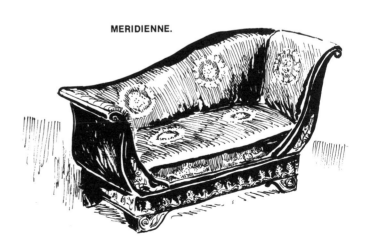

113

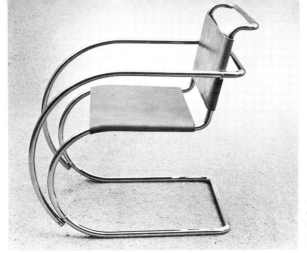

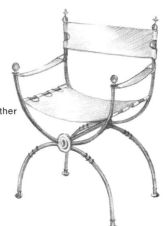

Metal furniture

Every age has had a version of metal furniture, designed according to the prevailing styles and the prevalence of materials. That of the Egyptians, Greeks and Romans was beautifully executed in bronze and iron. In medieval and Renaissance times, the pieces were of iron, heavy but well made. Bronze and brass were the choices for the neoclassic revivals of the Directoire and Empire periods. Today, we have a wealth of old and new metals to draw on—wrought iron, cast aluminum and tubular steel for outdoor or leisure furniture, stainless steel or brushed chrome with a bronze trim for indoor furniture, in either contemporary or traditional French designs.

Metallic cloth

Fabric woven of cotton, wool or synthetic-yarn warp threads and tinsel filling threads. Metallic threads of spun gold, silver or copper were woven into Renaissance tapestries to provide highlights and richness, a practice revived in this century by designer Dorothy Liebes for her woven fabrics and blinds.

Metallics

In decorating, a term that indicates the use of metals—gold, silver, copper, pewter, chrome, steel —or their colors in furniture, fabrics, wall coverings, vinyl flooring and accessories. In the twentieth century, the cool silver tones have largely superseded the gold values favored in the eighteenth and nineteenth centuries.

Meubles de luxe *(muhbl' duh lewks)*

French term for the great or luxurious style-setting furniture designed for the courts of Europe and England. As most of the furniture in palaces was strictly for show and the scale accordingly large and overornamented, it is now assigned to museums or restorations where it belongs.

Mies van der Rohe, Ludwig (1886–1969)

Twentieth-century German-born architect, onetime director of the Bauhaus school, designer of the Lake Shore Drive apartments in Chicago and, in conjunction with Philip Johnson, the Seagram Building in New York. In 1926 he designed the first cantilevered tubular-steel chair and later the celebrated Barcelona chair, displayed in the German Pavilion (which he also designed) at the 1929 Barcelona International Exhibition. The Barcelona chair in profile shows its relationship to the X-form—two curves of steel form the supports, the single curve for the back crossing the reverse curve of the seat. Leather straps underlie the welted leather seat and back cushions.

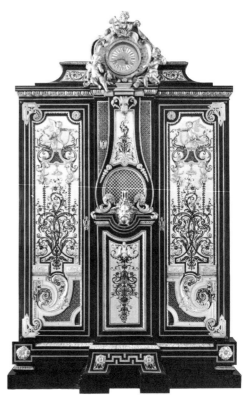

MEUBLES DE LUXE. Mid-18th-century French wardrobe, oak veneered with ebony and Boulle marquetry of brass and tortoise shell; gilt bronze mounts. Reproduced by permission of Trustees of The Wallace Collection, London.

Milium

A coated fabric for lining and insulating draperies, trademarked and manufactured by Deering, Milliken, Inc. Cotton fabric is sprayed with a silvery-colored metal binder, which gives it a light-and-heat-reflecting quality.

Milk glass

Descriptive name for two types of milkily opaque glass, one American, one English. The American glass, of nineteenth-century vintage, is a translucent, almost porcelainlike white glass. The other glass, made in Bristol, England, during the eighteenth century, comes in different colors, of which the most famous is the vibrant near-turquoise hue similar to opaline blue which has passed into the decorator's color palette as Bristol blue, although this is actually a misnomer—the true Bristol blue was a deep cobalt shade belonging to an even earlier glass rarely found today.

Millefleurs (*meel-FLUHR*)

From the French for "a thousand flowers," the name for an allover pattern of flower heads, applied originally to Chinese porcelains with this type of decoration, but now taken to mean any floriated pattern.

Ming yellow

A brilliant sulphur-yellow borrowed from the glaze on Chinese porcelains of the Ming period for drapery and upholstery fabrics, wallpapers and carpets. The porcelains themselves, antique or reproduction, make wonderful color accents in contemporary rooms.

Miniature

Originally, the small picture in illuminated medieval manuscripts that was decorated, or miniated, with red lead (*minium,* in Latin) . Later, the name was applied to the minuscule portraits executed in enamel, oil on copper or water color on ivory in the seventeenth, eighteenth and nineteenth centuries. Today, the precise art of miniature painting has almost died out and the early examples are rare and expensive.

Miniature furniture

Small-scale copies of standard-sized furniture, either highly detailed models of their work made by eighteenth- and nineteenth-century cabinetmakers or less intricate and detailed pieces intended for dollhouses. Today, we have adopted the small cabinets and commodes as occasional tables.

MIRRORED sculpture by Beylerian. Photographed at Celanese House.

Minton

Pottery and porcelains made since 1798 at Stoke-on-Trent, England, by a company founded by Thomas Minton. Among the best-known products are the decorated porcelain tableware and large earthenware pieces, such as the much copied shell plant stand.

Mirrors

Although the human race has always found ways to reflect its own image—witness the early mirrors of polished metal—it was not until the Renaissance that silvered glass appeared, and then it was costly and made only in small pieces—hence the large, elaborately carved frames. During the reigns of Charles II in England and Louis XIV in France, the design of mirrors—by now much larger—was influenced by the interior architecture. With the rococo period came more irregular shapes in delicate frames, and the neoclassic school favored simple shapes in thin gilt frames. Trumeaux set into paneling as overmantels introduced the concept of the mirror as an integral part of the interior design of the room, a trend that was fostered by the later classic revivals and probably reached its culmination in those twentieth-century contributions: the mirrored wall and sculpture. Among the purely decorative types of mirror are the bull's-eye and the girandole.

Walnut armchair with tooled leather back and sling seat.

MISSION FURNITURE

Walnut table with turned legs, iron stretcher.

Mission

An American furniture style based on the pioneer furniture crudely but attractively fashioned of native materials by the Spanish priests and American Indians for the missions of the Southwest and California. Upholstery, generally leather, was studded with large nailheads. Ornamentation consisted of hand-hammered copper appliqués or simple cutout patterns. By reason of their sturdiness, many of these early pieces have survived and today they are freely interpreted as part of the popular Spanish idiom. What we mostly find, however, dates from the unhappy revival of the Mission style in the 1900's, when furniture of heavy oak, finished with a dark, smoky stain, was machinemade to simulate the original handcrafted mortisetenon jointing.

Miter

Also mitre. The joining of two pieces cut or beveled to fit together at right angles to form a corner—two moldings for a picture frame; a striped fabric at all four corners to make a square.

Mixing

Current cant for the popular pulling together in a single room of furniture and decorations of widely divergent periods, styles and countries.

Mobile

Up-in-the-air abstract sculpture originated by Alexander Calder in which kinetic movement is conveyed by an arrangement of suspended shapes, rings and rods that move and undulate with the air currents.

Modern

Design that reflects our era in style and appearance. For example, chairs by Bertoia, Eames and Jacobsen; tables by Saarinen and Knoll; George Nelson's pole storage system.

Moderne (*maw-DERN*)

Furniture style of the mid-1920's that was based on simplified Hepplewhite designs and stressed blond finishes, straight lines, tubular or strap metal frames, with wood grains and inlays to provide contrast. Exemplars of moderne were the architects and designers of the Bauhaus school, whose avant-garde furniture set the pace for present-day contemporary design. *See also* Modernistic.

Modernistic

Term for the jazzy architecture and decoration of the late 1920's and early 1930's, when forms were stepped and zigzagged, furniture was overupholstered and overtufted, and woods were bleached and combined with silvery metals, thick clear glass or the newly discovered plastics. In true movie-set manner, fabrics were shiny and plushy and color schemes ran to the all-white look or pastels accented with white or black.

Modular furniture

Storage units based on standard modules, or sizes, that can be stacked vertically or grouped horizontally, and assembled in various combinations.

Mohair

Originally, an upholstery fabric made from the processed and woven hair of the Angora goat, now usually of synthetic yarns.

MOIRE-COVERED walls. Photographer: David Massey.

MODERN interior designed by Barbara D'Arcy, A.I.D., of Bloomingdale's.

New interpretation of **MODERNISTIC** decoration. Interior design by Barbara D'Arcy. A.I.D., of Bloomingdale's.

Moiré (*moh-ah-RAY*)

A fabric with a hazy, watery look caused by twisting the weave or by pressing the surface with heated rollers.

Molded furniture

Plywood, laminated woods or plastic molded into figure-conforming contours that, even when upholstered, reveal the underlying structure, an instance of form dictated by function rather than by precedent.

Molding

A contoured strip of wood, metal, stone, plaster, plastic or other suitable material applied to woodwork, doors and windows, walls or furniture. There are many different types of molding (ogee, cyma, concave, convex, half round, quarter round among them) and each period style has its own designs.

Mondrian, Piet

Twentieth-century nonobjective painter whose rectilinear designs on canvas have influenced fabric and wallpaper design, as well as the space planning of modern interiors.

Monk's cloth

A heavy cotton fabric with a basket-weave design and coarse, canvaslike texture, primarily used for draperies and popular for budget decorating because of its low cost and good color range.

Monochromatic color scheme

A scheme built around one color family plus black, white or a metallic color. It is most effective when the color gradations are subtle.

Monteith bowl

A deep silver, pottery or porcelain bowl with a notched edge to hold the stems of the wineglasses, originally to cool them in water. Later adapted as a punch bowl and today more often seen as a centerpiece for a table. The French version is known as a verrier.

Creamware **MONTEITH BOWL** by Mottahedeh.

MOLDINGS

Courtesy Paul Associates, New York. **1.** Plain half round with square knuckle; **2.** Greek key; **3.** Scroll; **4.** Bamboo; **5.** Fluted with square knuckle; **6.** Reed and ribbon; **7.** Wreath.

1.

2.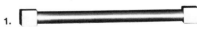

3.

4.

5. **6.** **7.**

Montgolfier chair (*mohng-goal-f'YEH*)

Louis XVI balloon-back chair designed by Georges Jacob to commemorate the balloon ascension of the Montgolfier brothers in 1783.

Moresque

The Moorish influence on Spanish decoration, characterized by geometric patterns in strong colors, such as those found on azulejos, and gilding. Cinema architecture of the 1920's and 1930's took its cue from this style. Today, the designs and coloring are occasionally found in fabrics and wallpapers.

Moroccan rugs

Hand-woven area rugs with thick, shaggy pile in natural-colored wools and geometric patterns. Most favored for contemporary rooms are the black-and-white geometrics and those with brilliant orange and red grounds.

Morris, William (1834–1896)

English artist and designer who attempted to bring art and craftsmanship to the masses as a revolt against the stereotyped, lackluster manifestations of the machine age. In partnership with some like-minded colleagues, he formed a company to produce handcrafted furnishings and accessories. Although their products covered the whole field of design, we are most familiar with the fabric, wallpaper and carpet motifs based on free interpretations of the medieval style and currently being reproduced in this country.

Morris chair

A large easy chair of nineteenth-century vintage with a wood frame, adjustable back and loose cushions, supposedly designed by William Morris. Variations of the design appear in contemporary lounging chairs.

Mosaic

Decorative inlay of small pieces of wood, marble, glass, semiprecious stones and similar materials set in geometric or pictorial designs, a technique that dates back to the Romans. Each age has its own interpretation; ours is the do-it-yourself kit for table and counter tops, complete with materials and instructions.

Moss fringe

An upholstery edging of heavy pile cording, in use since the seventeenth century.

Motif

The predominant figure in a pattern or design repeated variously within a room. For example, a floral motif in curtains may be repeated on pillows or echoed in water colors or prints on a wall.

Mounts

Metal fittings or decoration applied to furniture or objects. During the reign of Louis XV, bronze and gilt mounts supplied most decorative effects.

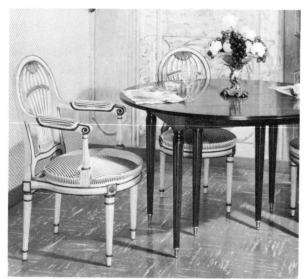

MONTGOLFIER CHAIRS. Courtesy Brunovan, Inc., New York.

MORRIS CHAIR. Courtesy The Brooklyn Museum.

Moustiers (*moohs-t'YEH*)

French faïence in soft greens and yellows or the familiar blue and white made in the factory of the same name founded by Pierre Clerissy in 1679. Such famous artists as André Charles Boulle and Jean Bérain designed for Moustiers.

Muffin stand

General term for any small tiered wood or metal stand, often fitted with plates, designed for the ceremony of the tea service and now more often seen as an occasional table or hors d'oeuvre server.

Mule chest

Predecessor of the chest of drawers, an early type of English and American chest with one or more drawers beneath the lid and sometimes side handles that enabled it to be carried.

Mullion

A slender, vertical upright that divides the panes of a window. In furniture, the tracery on glass doors of a secretary or a bookcase.

Multicolor scheme

A scheme that combines three or more colors plus black or white. Often the inspiration is a many-hued printed fabric or wallpaper.

Muntin

The inside vertical divider of a door or window frame used to mark the division between glass or wood panels.

Mural

Hand-painted wall or ceiling decorating that was current in ancient Egypt, Greece, Rome and China, and reached a peak of artistry in the work of the great Renaissance painters—Michelangelo, Raphael, Veronese and Titian. Today, murals may be hand-painted, but more often take the form of printed wallpaper panels, an extension of the eighteenth-century papier-peint and block-printed murals.

Mushroom table

The single-pedestal table with inverted mushroom base and plain marble or laminate top designed by Eero Saarinen and produced by Knoll.

WILLIAM MORRIS interior. Courtesy Victoria and Albert Museum, London. Crown copyright.

Shell **MOSAIC** fountain at the Frontera Palace, Portugal. Photographer: Denise Otis.

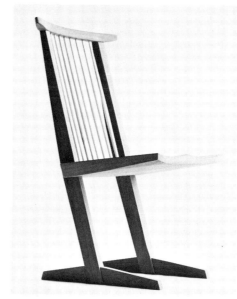

Conoid chair by **GEORGE NAKASHIMA.**

Nailsea

Colored glass made in Nailsea, England, from about 1788 to 1873, mostly in the form of flasks, bottles, mugs, jugs, bowls, rolling pins, bells, canes, candlesticks and witch balls. The decoration mostly consisted of a crude but effective scattering of spots and random splashes of white. A later type of Nailsea flask, attributed to French glass blowers employed by the factory, was of clear glass, striped with pink or yellow.

Nakashima, George

American designer whose inventive but essentially straightforward furniture reveals an appreciation of simple forms and the beauty of natural wood grains. His handmade pieces have an almost sculptural quality and a sense of early American craftsmanship allied to modern design.

Nanking

The European name for the blue-and-white late-eighteenth-century Oriental export ware that we call Canton, presumably because it was shipped there from the port of Nanking, whereas ours came through Canton.

National Society of Interior Designers (N.S.I.D.)

A professional design group founded in 1957, similar to the A.I.D., but also including among its membership design teachers, landscape architects, scenic designers and trade suppliers and manufacturers.

Natural fibers

Those made from natural materials. The three classifications are: animal—silk and wool; vegetable—cotton, jute, ramie and flax; mineral—asbestos and metallics.

Naugahyde

A trademark for a vinyl upholstery material made by the United States Rubber Company (Uniroyal), often but erroneously applied to all such vinyl fabrics.

Navajo rugs

American Indian rugs of the Navajos, who were taught the art of weaving by the Spaniards. At first the rugs were in a plain weave and natural-colored wools, patterned with gray, white and black stripes. Later, when the Navajos learned to extract a red dye from tree bark and to barter for indigo, color crept in and by the nineteenth century the characteristic chevron and diamond motifs and symbolic forms were combined with straight border stripes. Today's Navajo rugs, although still in the old designs, show the long arm of commercialism—they are now made with commercial yarns and dyes in a sophisticated range of color combinations.

Nécessaire *(neh-seh-SAIR)*

Every well-equipped French traveler of the eighteenth century carried this fitted case, with compartments for writing and needlework supplies, toiletries, or a personal dinner, tea or coffee service.

The larger cases, often elaborate affairs decorated with agate and gold, were designed to be set on tables and the name is now applied mostly to this type, rather than the smaller toilet case.

Needlepoint

Cross-stitching done by hand on canvas, linen or net with wool or silk threads which gives the look of tapestry. Both gros point and petit point are types of needlepoint. Seventeenth-century needlepoint throws and upholstery, eighteenth-century needlepoint carpets and rugs, and nineteenth-century samplers with uplifting maxims attest to the enduring vogue for this domestic decorative art. A current revival of needlepoint has seen a welter of hand-worked objects from covered brick doorstops to highly original throw pillows, a laudable updating of needlework designs in contemporary terms.

Nelson, George

Present-day industrial and furniture designer famous for his functional and adaptable modular designs, among them the now classic pole-hung storage system.

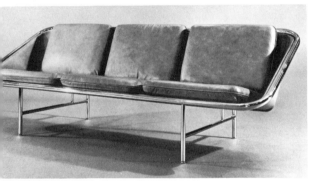

Sling sofa designed by **GEORGE NELSON** for Herman Miller, Inc.

Neoclassic or Classic Revival

Eighteenth-century revival of classic ornament and detail inspired by the excavations at Pompeii and Herculaneum. Among the foremost exponents in England were Josiah Wedgwood and the Adam brothers, especially Robert Adam, the presiding genius of the style. The neoclassic spirit (a reaction against Louis XV rococo) was apparent in the light, graceful styles of Louis XVI, the transitional Directoire and the later, grandiloquent Empire style. English Regency, which drew on both the Directoire and Empire styles, was the later phase of Neoclassic in England. Italian Neoclassic furniture was mostly modeled after the French and English designs. In America, the final flowering took place in the nineteenth-century style we call Greek Revival.

Nest of tables

A matched batch of tables, usually two, three or four, graduated in size so that one fits over the other, a neat, spacesaving stratagem that dates back to the eighteenth century. They are now made in a great range of styles, periods and sizes.

Neutrals

The near colors or no colors—blacks, whites, grays, beiges, browns—usually considered punctuation or breathing space for other colors, particularly those of the four color families (red, yellow, blue, green). Wood tones are also embraced by the term, which may be paraphrased in fashion jargon as the "little nothing" colors.

NEOCLASSIC dining room, Lansdowne House, London. Designed by Robert Adam. Courtesy The Metropolitan Museum of Art, Rogers Fund, 1932.

orcelain **NECESSAIRE** with old mounts. The Metropolitan Museum of Art. Bequest f Kate Read Blacque, 1938, in memory of her husband, alentine Alexander lacque.

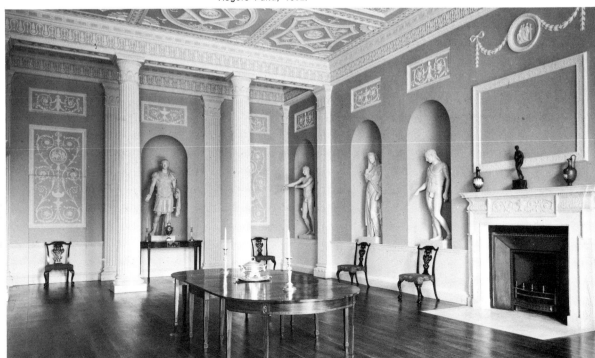

Nevers (neh-VEHR)

Extremely decorative French faïence made at Nevers in the seventeenth and eighteenth centuries, noted for boldly painted Persian and Chinese designs of flowers, foliage and birds in rich colors—purple, yellow, *bleu persan*—and shapes, such as the double gourd, taken from the Chinese. Modern copies of this ware can also be found.

New Hall

Eighteenth-century porcelain appreciated by collectors for its simple, provincial, rather old-fashioned floral patterns and delicate pink, orange and pale-green colors.

Niche

A wall recess for a statue or ornament, now more often the repository for stereo equipment, books or a collection of objets d'art.

Niderviller (nee-dehr-vee-YEH)

French ceramics factory founded in 1754 that specialized in flower painting and figures in the style of Watteau and Boucher, known as *faïences fines,* and plates and platters painted with trompe l'oeil decoration of prints nailed to a wooden background.

Ninon

A sheer rayon, Dacron or nylon fabric made in various weaves for glass curtains.

No-color scheme

Colorless contemporary palette for a room conceived in shades of white, or white plus neutrals, a singular development of the twentieth century that took its cue from the spare, understated lines of modern architecture and furniture.

Noguchi, Isamu

Japanese-American designer of the fanciful Akari paper lanterns and imaginative free-form furniture, particularly the table composed of a sheet of plate glass on a sculptural wooden base that can be rearranged to change the form.

Nottingham lace

Machine-made lace, first made in Nottingham, England, and now in many parts of the world on Nottingham looms.

Numdah rugs

Naïve, colorful felt accent rugs from Kashmir, hand-embroidered in brilliant colors with designs of birds and flowers.

Nursing chair

Sixteenth-century support for the baby-sitter, with a low seat, usually rush, and a high back. In modern versions the seat is often upholstered and the height of the back exaggerated.

Nylon

Generic term for a protean synthetic chemical with super strength, wearability and elasticity that can be formed into fibers, sheets or bristles, and woven into carpets and both flat and pile fabrics.

Nymphenburg

Delicate and decorative porcelain made at Nymphenburg in Bavaria since the eighteenth century. Most famous are the milky-white or colored figures—chinoiseries, commedia dell'arte characters, putti, the "Seasons" and tableware decorated in the rococo style.

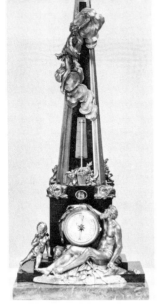

OBELISK mantel barometer of lapis lazuli and gilt bronze, Paris, 1753. Reproduced by permission of Trustees of The Wallace Collection, London.

Obelisk

An upstanding example of the artful influence of ancient Egypt on Western taste. This tall, four-sided column tapering toward the top like a calorie-conscious pyramid rears its phallic shape on London's Embankment and in New York's Central Park (appropriately dubbed Cleopatra's Needle) and, on a smaller scale, ornaments desks and mantels. As a motif, it has cropped up throughout the centuries, signally on the furniture and fabrics of the French Empire after Napoleon's Egyptian campaigns.

Objets d'art *(ohb-zheh d'AHR)*

Literally, objects of artistic worth; generally, accessories of important decorative value and, even if not dear, difficult to come by.

Obsidian

Gleaming black volcanic glass named after its discoverer, the Roman Obsidius. Objets d'art were fashioned of obsidian during the French Empire period, and today its luster is imitated in pressed glass.

Occasional tables

Tables, large or small, of incidental importance in a room scheme, such as coffee tables, end tables, book tables, lamp tables, tea tables, etc.

Of the period

Made during the period in which the design originated, not a reproduction.

Off-white

Shady member of the white family, with a tinge of yellow or gray. Among the many examples: beige, oyster, cream, ivory. Primarily wall colors, off-whites in different fabrics and textures can add up to an extremely effective all-white room scheme.

Ogee

The side view, or profile, of a molding made of two S-curves meeting at a point. Often found on the tops of pediments or the lower edge of an apron.

Ombré *(ohm-BRAY)*

French term for a graduated or shaded effect of tones in one color family, or of different colors. In fabrics, this is known as an ombré stripe.

One-color scheme

More technically known as monochromatic, a scheme based on the various tints and shades of a single color, often with black, white or a metallic color as punctuation.

One-of-a-kind

Furniture, paintings and objects that are truly unique, such as a period Louis XV bergère, an original Picasso or a Fabergé box, or contemporary pieces with the one-of-a-kind handmade look.

OP-ART pattern wallpaper. Courtesy Gimbels, New York. Furniture by Olivier Mourgue.

Onion pattern

An enduringly popular blue-and-white pattern first produced at the Meissen factory around 1735, and widely copied, not only by other manufacturers of ceramics, but also as a design for fabric, wallpaper and cookware. The name "onion" is a misnomer, for the pattern was based on a Chinese composition of fruits, flowers and foliage of peonies and asters—which were mistaken for onions. *See also* Zwiebelmuster.

Op art

Modern art form in which color and line interact to produce a sensation of movement. No longer confined to canvas, op-art patterns now play their trompe l'oeil tricks on fabrics and wallpapers.

Op colors

The strong, clashing color combinations of primaries, secondaries and black and white found in op-art paintings and now in fabrics, vinyl plastics, wallpapers, accent rugs and table linens. As op colors give, through interaction, the visual impression of pulsating or whirling movement, they are apt to produce decorative vertigo unless limited to small areas or accents.

Opaline

Opalescent glass very popular in the nineteenth century and in favor again today. This type of translucent glass comes in lovely shades of blue, pink, green and white. Antique opaline is the pet of collectors and is extravagantly priced.

Open plan

Term used to describe a floor plan which banishes solid walls in favor of large open spaces. Kitchen, living room, dining room, study may be merely suggested in various ways by partial dividers, furniture arrangements and so on.

Organdy

Crisp, lightweight fabric of very fine cotton woven in muslin construction. In decorating, primarily a fabric for glass curtains and usually white, although it may be dyed or printed.

Oriel

A bay window, generally oval, projecting from the wall and supported by a bracket.

Oriental

Decorative description covering furniture, arts and crafts of the Far and Near East that came to this country in the eighteenth century. Now stretched to include a multitude of furnishings with Oriental overtones, no matter what their origin.

Oriental export

Specifically, porcelain made in China for export from the eighteenth to mid-nineteenth centuries, during the Ching Dynasty. It exhibited a mingling of Oriental and Occidental forms and decorations.

ORIENTAL buffet and accessories. Designer: J. Patrick Lannan. Photographer: Tom Yee.

Oriental Lowestoft

Chinese hard-paste porcelain, also known as Chinese export ware, made since the seventeenth century for the lucrative foreign trade. In the nineteenth century, William Chaffers wrote a book on pottery and porcelain in which he mistakenly attributed the porcelain to a small factory in Lowestoft, England. Although the error was corrected, the name stuck.

Oriental rug

A type of rug hand-woven or hand-knotted of **wool** or silk, usually in elaborate allover designs. The number of borders determines the value. Oriental rugs can be divided into fewer than fifty common

ORIENTAL LOWESTOFT shaving dish, c. 1725. Courtesy Elinor Gordon, Villanova, Pennsylvania.

types, named for the place of manufacture or export, which are then divided into these six classifications.

Persian. These rugs generally have an allover pattern in delicate colors almost completely covering the ground color. The designs, a profusion of flowers, vines, leaves and occasionally birds and animals, often start from a center medallion. The more preferred types are the Kerman and Kermanshah, noted for their fine pile and soft pastel coloring; Sarook, also with a fine pile but in stronger reds and blues mingled with paler tones; Saraband, in which the design is a repetitive pattern of palm leaves on a rose-pink or blue ground; Hamadan, a rug coarsely woven of camel's hair in shades of light brown, red and blue; Feraghan, closely patterned with a small flower design or rows of conventional forms; Polonaise, a delicately colored antique silk; Sehna, a small rug with a tiny, tightly woven pattern; Bijar, a rug with an exceptionally thick pile; Ispahan, which has a coarse pile and an involved design on a deep-red ground.

Indian. These rugs have similar motifs of flowers, vines and sometimes animals, but the style is more naturalistic and the colors more brilliant. They are named for the cities of Agra, Lahore and Srinagar and the state of Kashmir.

Turkoman. Rugs woven by the nomadic tribes of Afghanistan, Baluchistan and Turkestan, distinguished by their close weave, short pile, geometric designs (squares, diamonds, crosses, octagons, etc.) and red coloring. Bokhara, the name of one of the rugs, refers to the place from which the rugs were exported, but not made.

Caucasian. Small, boldly colored rugs with geometric designs woven by nomadic tribes of the Caucasus in brilliant, strongly contrasting colors that have great affinity for modern rooms. Among the principal Caucasian rugs are the Shirvan, Kuba, Soumak, Daghestan and Ghendje.

Turkish. These rugs are woven in both geometric and floral designs but in more precise patterns than the Persian or Indian. Their identifying characteristics can be most easily isolated in the prayer rugs, the most famous of which is the Ghiordes. Anatolian and Armenian rugs come under the Turkish classification.

Chinese. Silk rugs easily recognized by their beautiful, soft ground colors—yellow, rose, beige and brown tones—and the fact that the pattern is usually in only one color, blue, the exact reverse of other Orientals. The designs are mostly derived from symbols of the Chinese religions. The finest of the antique Chinese rugs are those of the K'ang Hsi (1661–1723) and Ch'ien Lung (1736–1796) periods.

Ormolu (*ohr-moh-LEW*)

Golden pretenders in gilded brass, bronze or copper ornaments or mounts for furniture introduced by the French ébénistes of the eighteenth century.

Osnaburg

An inexpensive plain-weave, coarse cotton fabric resembling crash.

Ottoman

A luxurious perch that is nothing more than a low, upholstered, backless, armless seat, reminiscent of the Turkish influence of the eighteenth century. Also, a heavy, ribbed silk, rayon or synthetic fabric.

Oval back

A chair-back shape often found in Louis XVI fauteuils and the designs of Hepplewhite.

Over curtains

Draperies that hang over the glass curtains and may or may not draw across the entire window.

Overdoor

Decorative treatment over a doorway—a panel, picture or other ornament. Originally, overdoors were designed as part of the architecture, but in our time, when architectural details are few and far between, we add our own embellishments.

Overlay glass

Cased glass with the outer sections cut through in patterns. Often called Bohemian glass, although it is made in many countries.

Overmantel

Any paneling or formal treatment of the chimney breast over a mantel.

Overscaled

Generously proportioned furniture or patterns of larger than usual size, deliberately scaled or composed for effect.

Overstuffed furniture

Sofas and chairs that achieve a bumper effect because all wooden parts, with the exception of the feet, have been upholstered.

Ovolo

A molding with a convex, semicircular curve like the wide swell of an eggshell, generally painted or carved with the egg-and-dart motif, and found on the edge of table tops, mirror or picture frames and, as a printed design, on a wallpaper border.

OVERDOOR. Photographer: Grigsby.

OVOLO molding.

Late-17th-century **OVERMANTEL** of carved and gilded oak from Holme Lacy, Herefordshire, England. Courtesy The Metropolitan Museum of Art, Rogers Fund, 1916.

OVAL-BACK side chair and armchair.

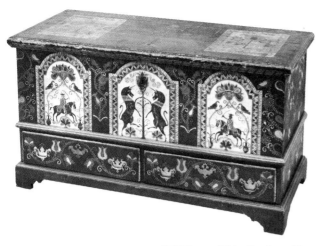

Pennsylvania Dutch **PAINTED CHEST,** c. 1780. Courtesy The Metropolitan Museum of Art, Rogers Fund, 1923.

Pad foot

Termination of a cabriole leg, generally in Queen Anne styles, that resembles a club foot, but without the disk at the bottom.

Pahlmann, William, F.A.I.D.

American interior designer best-known for his expert renditions of the eclectic look in decoration—a harmonious and striking combination of contemporary colors and furniture and objects of many styles and periods.

Painted furniture

A charming decorative conceit that has flourished since the days of the Egyptians and reached its zenith in eighteenth-century Europe. In painted furniture, the natural grain of the wood is completely covered by a colored opaque finish of enamel, lacquer or paint, which is then decorated or left plain. Italian craftsmen, especially the Venetians, excelled in the artifice of the painted finish and their clever copies of French court furniture, even simulating inlays and marble in paint, resulted in a bevy of furniture loosely called Italian Provincial. Interpretations varied from country to country according to the prevailing modes. The French favored delicate pastels. The English style, called japanning, showed the influence of the Orient. Switzerland, Scandinavia and Germany preferred light, bright pieces, and our own Pennsylvania Dutch settlers turned out sturdy chairs and chests with naïve designs expressive of their Swiss and German peasant origin. Oriental lacquer or the brilliant accent pieces of American craftsmen are currently in vogue as an important jolt of color for contemporary rooms.

Paisley

A fabric design in imitation of the woven Cashmere shawls originally made at Paisley, Scotland—hence the name. Today, paisley designs are used in fabric and are also printed on vinyl and wallpaper.

Palampores

Hand-painted or resist-dyed cottons, chintzes and calicoes that predated the invention of block printing. They were modeled on, and took their name from, cottons from India printed with the tree-of-life pattern.

PAISLEY-PATTERN fabric. Courtesy Celanese Corp. Designer: J. Neil Stevens, N.S.I.D.

Palladian

The distinctive style of architecture which was Andrea Palladio's free interpretation of the classic orders, now applied to furniture which has a pleasing symmetry in its formality. England, Ireland and America enjoy the Italian's heritage both in architecture, notably that of the eighteenth century, and furniture designs.

Palladian window

A window design based on the work of Andrea Palladio, widely used in English and American architecture of the eighteenth and nineteenth centuries. The window consists of three parts separated by columns, or pilasters; the outer sections have straight cornices, the taller inner section is arched.

Palladio, Andrea (1518–1580)

Famous Italian architect who applied to houses his own interpretation of the classic orders and directly influenced much of the domestic architecture in England and America, witness the Palladian window so often found in eighteenth-century New England homes.

PALLADIAN WINDOW.

The **PALLADIAN** house of John Huston in Ireland. Photographer: Guerrero.

Paneling

Decorative detail on furniture, walls, doors and ceilings consisting of a rectangular area enclosed in a frame and raised above or sunk below the surrounding surface. Today, walls covered with boards or plywood sheets, with or without moldings, are also described as paneled.

Panetière (*pah-nuh-t'YEHR*)

A type of carved open box for the display of bread, originating in France. Today, it is more often employed as an end table or enclosure for stereo.

Panné (*pahn-AY*)

Fabric in which the pile is pressed back to give a velvety surface and lustrous finish, such as panné satin and panné velvet.

Papier-mâché (*pah-p'yeh-mah-SHAY*)

Paper—molded, glued and then lacquered—formed many articles in the seventeenth and eighteenth centuries. It was popular in Europe and America in the nineteenth century as a material for tables, boxes, side chairs and trays, which were usually black and embellished with inlays of mother-of-pearl in Oriental designs.

Papier-peint (*pah-p'yeh-pan*)

French name for a painted or printed pretense on wallpaper that simulates a painting or mural.

Parcel gilding

A form of gilding practiced in England during the late seventeenth and early eighteenth centuries in which gilt was applied only to the design of carved or flat surfaces, such as mirror frames.

Pargework or pargetry

The lost art of applying stucco or ornamental plaster decoration to a flat surface in relief. Today, many of the original architectural designs of the vanished craftsmen whose work embellished the walls and ceilings of great eighteenth-century houses are being reproduced in anaglypta, a molded rag stock that can be attached with adhesive.

Parian ware

A type of soft-paste ware, generally white, developed in the late nineteenth century by the Copeland factory, primarily for small vases, busts and figurines.

PAPIER-MACHE chairs. Courtesy (1) Victoria and Albert Museum, London. Crown copyright. (2) The Museum of the City of New York.

"Paul et Virginie" PAPIER-PEINT panels. Courtesy Musée des Arts Décoratifs, Paris.

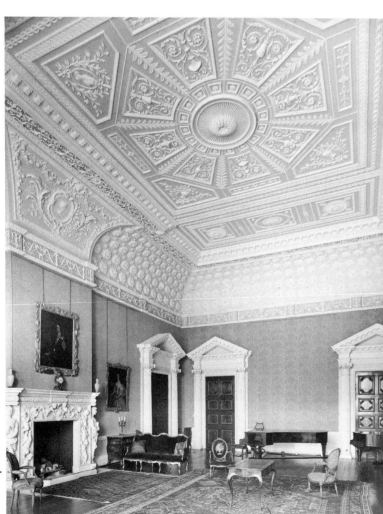

PARGEWORK in the saloon, Claydon House, Bucks, England. Courtesy The National Trust. Photographer: A. F. Kersting.

PARQUET DE VERSAILLES. Courtesy Wood-Mosaic Corp.

Interior design and furniture by **TOMMI PARZINGER.**

Parliament clock

An English pendulum wall clock with a small trunk, large dial and bold numerals, After Pitt's government passed an Act of Parliament in 1797 levying a tax of five shillings a year on all personally owned clocks and watches, these time tellers were installed in public buildings. The law was repealed, but the name remained.

Parlor lamp

Nineteenth-century oil lamp with two glass globes, one on top of the other, and a projecting chimney running through them. The base was usually brass and the glass was often brilliantly colored, with painted, etched or decal decorations. Also known as "Gone with the Wind" lamps, from their lavish use in that movie's sets. Today, they are still in use, modishly electrified.

Parquet *(pahr-KAY)*

Geometric shapes of wood inlaid, mosaic fashion, for flooring and for furniture. Herringbone and other patterns distinguish parquet from marquetry.

Parquet de Versailles

Parquet flooring with a basket-weave design, originally in the Grand Trianon, and now considered handsome enough to top tables as well as to cover floors.

Parsons table

A square or rectangular table with apron and leg widths that measure the same. The design, akin to that of early Chinese tables, originated at and was named for the Parsons School of Design. Versions conceived independently in New York and Paris by Joseph Platt and Jean Michel Franck became the school's mainstay for interiors and an overwhelmingly popular design that can now be found, in a wide range of sizes, in the lines of many furniture manufacturers and in inexpensive unpainted furniture.

Parzinger, Tommi

Designer of modern furniture and accessories whose work is noted for its elegant, timeless quality and unusual wood and lacquer finishes.

Passementerie *(pahss-mahn-TREE)*

French phrase for all the trimmings—from braid, ribbons and tapes to tinsel, gimp and beads.

Passe-partout (*pahs-pahr-TOO*)

A decorative mounting for pictures, used in place of a frame. The picture, mat, backing and glass are held together by gummed tape on all four sides.

Pass-through

An opening in the kitchen wall through which food is passed to a counter in an adjoining room. One of the many American stratagems for self-help in the home.

Pastel

A type of drawing, also called crayon drawing, done with dry pigments or colored chalk. In the eighteenth and nineteenth centuries, portrait heads were often in pastel, and the great masters found it a convenient way to make a quick sketch for a painting. Also, the tint of a color.

Patchwork

The Egyptians were the first to practice this early form of piecework, sewing together scraps of material and then quilting them. By the Middle Ages, velvet patchwork hangings and valances were a standard covering for walls and beds. Patchwork achieved the status of a decorative art in eighteenth- and nineteenth-century America and today is enjoying a revival, both in patchwork fabrics and in patchwork designs, in brilliant colors, printed on fabrics and wallpapers.

Pâte-sur-pâte (*paht-sewr-paht*)

Ceramist's term for a method of applying decoration in low relief by building up layers of slip with a brush, an art developed at Sèvres in the mid-eighteenth century and adopted by all the important potteries, notably Minton, for whom the Sèvres artist Solon later worked.

Patina

Mellowing of surface texture and color produced by age, wear and rubbing. So desirable is it that manufacturers take measures to fabricate the effect.

Patio

Originally, an inner court open to the sky, in the Spanish style, but current usage applies the word to any paved area off a room, enclosed or not. Known in Hawaii as a lanai.

PATIO in California. Designer: Ben Jones. Photographer: Max Eckert.

Peachblow

Nineteenth-century American art glass that supposedly resembled the Chinese peach bloom porcelain. The colors shade from white to rose, light blue to soft pink, greenish-yellow to red.

Peacock chair

Rattan chair from Hong Kong with a high, lacy fan back and a base that swells out like an hourglass. This style has been popular since mid-Victorian times and is often known as the "Saratoga" chair, for the New York State spa where it was much in evidence on hotel porches.

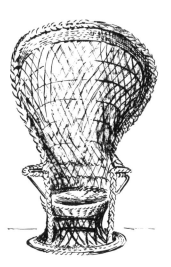

PEACOCK CHAIR.

Pebble weave

A fabric with rough surface texture produced either by a special weave or by the shrinking of twisted yarns while they are wet.

Pecky cypress

A soft wood with a stringy grain which reveals deep gouges and channels when cut into planks. Unsuitable for flooring or furniture, it is a favored paneling for walls because of the "textural interest" it adds to a room. The textured effect is also simulated in printed wallpapers and produced artificially on the surface of other soft woods.

Pedestal

A single—and singular—means of elevating chairs and tables without the support of legs. Architectural in design, the pedestal may divide when it reaches the table top or it may be solid, as if the table were rising like a mushroom from the floor.

Pedestal table

A round or oval table with a central column base, a style derived from the bronze tables of the ancient Romans and found in the late-eighteenth-century designs of Sheraton and Duncan Phyfe. Today, metal mechanisms have been added to the pedestal table, enabling it to be extended.

Pediment

An architectural triangle over a portico, window, door or gable end of a house. The word applies in furniture to the top of a cabinet or high piece, as in Chippendale secretaries, broken or even rounded.

Pekin

Name given to two totally different materials. One is a silk or cotton fabric, patterned with small checks or fine stripes, customarily used to upholster the backs of chairs, such as Louis XV and XVI bergères and fauteuils. The other Pekin is a type of translucent art glass, often cut back like case glass, which was made in the nineteenth and early twentieth centuries in imitation of Chinese porcelains. The colors range from creamy white and yellow to violet and turquoise blues, apple green and sang de boeuf.

Pelmet

A short cornice or valance, usually built in, that covers or conceals the curtain rod.

Pembroke table

A small eighteenth-century table with two drop leaves supported by brackets that pull out from the apron, originally designed by Chippendale as a breakfast table and named by Hepplewhite for the Earl of Pembroke. Pembroke tables usually have a drawer in the apron and four legs, sometimes connected by a saltire, or X-shaped stretcher. Today, they serve as lamp tables or small dining tables.

Pennsylvania Dutch

Name for the early German and Swiss settlers in eastern Pennsylvania (Dutch is a local corruption of Deutsch) and the style of naïve painted decoration, mostly fanciful motifs of fruit and flowers, animals and people, with which they decorated their furniture, utensils and rooms.

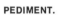

PEDIMENT.

PECKY CYPRESS paneling in a room designed by Mallory-Tillis, A.I.D. Photographer: Tom Leonard.

Percale

A plain, closely woven cotton fabric similar to muslin, but finer. Bleached, dyed or printed percale is commonly used for sheets, slipcovers and curtains.

Pergolesi, Michelangelo

Eighteenth-century Italian artist who worked in England under Robert Adam, painting and decorating ceilings, walls and furniture in the classic style.

Period

Historical stretch of time when a certain style or influence prevailed in furnishings, such as the Louis XV period in the eighteenth century. Styles and periods are not identical, as frequently one style precedes and survives a design period. Or old and new may overlap, producing a transitional style within a period.

Period color scheme

A color scheme taken, with great fidelity, from that of a historical period (French Empire, Regency, Adam, etc.) and applied to a contemporary room. Manufacturers, aided by such painstaking and authentic restorations as Versailles and Williamsburg, have been able to reproduce exactly the colors and patterns of paint, wallpaper and fabric which, together with furniture reproductions, make it easy to reconstruct or reinterpret a room from the past.

Period furniture

Specifically, furniture made during the historical period or school for which it is named. Period design is frequently reproduced in another age, as Louis XVI was made in the nineteenth century.

Petit, Jacob

Nineteenth-century French manufacturer of porcelains in the rococo style, the most collected of which are the *personnages,* ornamental figures of camels and elephants, mandarins, Zouaves and fashionable ladies. Not only his work but his mark—J.P.—has been copied, so the buyer should beware.

Petit point

Fine needlepoint worked in wool or silk on canvas or net, often only as the central part of a design, with the rest in gros point. Petit point has about twenty stitches to the lineal inch; gros point has twelve.

DUNCAN PHYFE armchair.

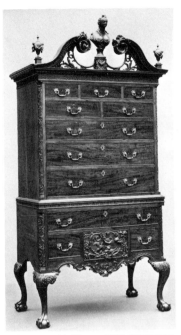

DUNCAN PHYFE flip-top side table with lyre motif.

Mahogany highboy, **PHILADELPHIA STYLE,** c. 1765. Courtesy The Metropolitan Museum of Art, Kennedy Fund, 1918.

Pewter

A dull-gray alloy of lead and tin, originally intended as a substitute for silver, but recognized since the seventeenth century as a decorative metal in its own right and accordingly hallmarked. Paradoxically, antique pewter today often commands a higher price than silver.

Philadelphia style

Eighteenth-century furniture made in Philadelphia, based on Queen Anne and Chippendale, but with strong French and Irish influences, especially in the carving. Highboys, lowboys and chairs are the most notable pieces in this style. Also known as Philadelphia Chippendale.

Phyfe, Duncan (1768–1854)

America's first great furniture designer whose name is synonymous with a style derived in part from the English and French design of the period. His earliest work, done in Albany, New York, was in the manner of Adam and Hepplewhite. Later, when he moved his workshop to New York, around 1790, he developed a trade in custom designs based on English Sheraton and French Directoire which has become known as Federal. Probably the most characteristic of his motifs is the lyre, found in chair backs and table bases. Most of his furniture was mahogany, but later pieces were made of rosewood. *See also* Federal.

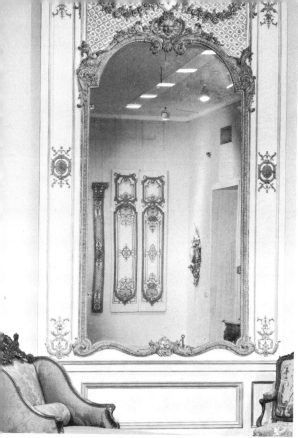

Early Louis XV **PIER GLASS**, c. 1730. The Metropolitan Museum of Art. Gift of J. Pierpont Morgan, 1906.

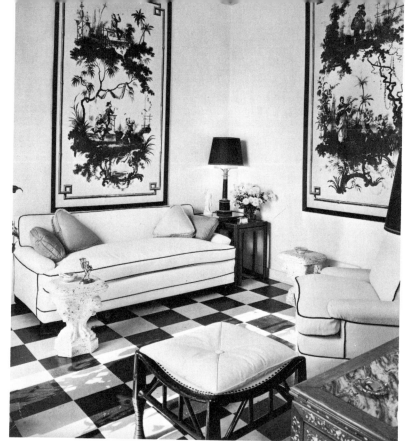

Black-and-white **PILLEMENT** panels in a sitting room designed by William Chidester. Photographer: Julius Shulman.

Picasso, Pablo

Protean artist of many talents—painter, sculptor, engraver, lithographer, draftsman, and designer of ceramics and cartoons for rugs and tapestries. Among the ceramics reproduced from his designs by Susanne and Georges Ramie in their Studio Madoura in Vallauris, France, are tiles decorated with fauns, dishes painted with centaurs, bulls and pigeons, and vases shaped like owls, goats and women.

Pickling

Finish designed to change the complexion of wood. Originally, pickling was done by removing with vinegar the plaster base on painted wood. Now it is achieved by rubbing white paint into the grain of a light wood floor or furniture.

Piece-dyeing

A textile term for a process in which fabric is dyed after weaving instead of before, or yarn-dyed.

Piecrust table

Descriptive name for a small, round eighteenth-century English table with a scalloped edge.

Pied-de-biche (*p'yeh-duh-BISH*)

The delicate cloven hoof, or deer's foot, terminating a slightly curved leg, a forerunner of the cabriole leg.

Pier glass

Tall Victorian wall mirror customarily hung between windows or in a narrow space over a low, marble-topped console. Earlier versions consisted of smaller mirrors over higher tables, or larger mirrors set in boiserie.

Pier table

Any decorative side table, generally placed under a pier mirror, that filled in the window pier. The table-mirror combinations, especially those designed by Adam, usually in pairs and semioval, were an integral part of the architectural symmetry of the eighteenth-century drawing room.

Pierced panels

Stone or wood panels worked in open designs, widely used for windows, doors, screens and balconies in Moorish, Spanish and Oriental architecture. Their present-day revival, indoors and out, is

due primarily to Edward Durell Stone, whose architectural style displays a lavishment of this type of decorative obfuscation.

Pietra dura (*pee-EH-trah DOO-rah*)

A design, often used for table tops, made by setting in mortar fragments of marble or semiprecious stones and then polishing the surface.

Pigment colors

The natural or synthetic materials (raw and burnt sienna, cadmium, viridian, etc.) from which all paint colors are derived.

Pilaster

Half-round or rectangular columns used architecturally to decorate or divide a long wall surface or opening.

Pile

The surface of any fabric or carpet in which the ends of the fibers are upright rather than flat. Pile may be cut or uncut, as in Brussels carpet; made of extra warp yarns, as in velvets or plushes; or of extra filling yarns, as in velveteens and corduroys. Warp pile may also be woven with pile on both sides—as, for example, in terry cloth.

Pile fabrics

Fabric of any fiber that has a pile—i.e., velvet, velour, plush, terry cloth, friezé.

Pillement, Jean (1728–1808)

French painter, engraver and designer for the Gobelins factory, famous for his delicate chinoiserie decorations and patterns.

Pinchbeck

Also known as fool's gold. This poor man's imitation of the real thing, a gold-colored alloy of copper and zinc, was named for its inventor, an English watchmaker called Christopher Pinchbeck. In the eighteenth and nineteenth centuries, inexpensive watchcases and snuff and patch boxes were made of pinchbeck and the name passed into usage as a synonym for an inferior article.

Pineapple motif

The symbol of hospitality, generously distributed around the eighteenth-century houses of Newport, Rhode Island, as a finial in the broken pediment over the front door and at the top of bedposts, and in today's home furnishings, on fabrics and wallpapers and in lamp and table bases.

Piping

A fabric-covered cord trim that finishes and disguises the seams of upholstery, slipcovers, draperies and pillows.

Piqué (*pee-KAY*)

A heavy cotton fabric with a surface texture that appears quilted (the word comes from the French for quilted). Also, an allover decorative inlay of shell, ivory or mother-of-pearl found on small seventeenth- and eighteenth-century objects, such as snuff and jewel boxes.

Piranesi, Giovanni (1720–1778)

Venetian architect, etcher and draftsman. His book of engravings of Roman antiquities, *Diverse Manière,* has been a rich, continuing source for classic ornament, mural decorations, furniture and decorative objects, and his architectural engravings are much reproduced as pictures and on fabrics and wallpapers.

PILASTER used decoratively on a secretary.

Galleria di Statue, Hadrian's Villa, Tivoli. *Views of Rome* by **PIRANESI,** Plate 46. The Metropolitan Museum of Art, Rogers Fund, 1941.

Planter's chair

A low wooden lounge chair upholstered with carpeting, caned, or equipped with canvas slings, common to the West Indies. The arms are very wide and long, presumably so the planter could drape his legs over them and enjoy the cool evening comfort of the trade winds

Plaque

Ornamental medallion of wood, ceramics, metal, glass, stone or other materials which is either applied decoratively to furniture or hung on a wall as a picture. Much of the eighteenth-century furniture was embellished with Wedgwood or Sèvres plaques, later Regency and Empire pieces with ormolu.

Plate

From the Spanish *plata* (silver), a term for dishes, utensils and similar domestic articles made of, or plated with, silver and gold. Eventually, the name was adopted for the dish from which food was eaten at table, be it of metal, wood, glass, porcelain or any similar suitable material.

Plate rail

Dado on a different level, the plate rail is a functional piece of architectural artistry that encourages the display of china above eye level and at a safe remove.

Plate stand

Practical piece of eighteenth-century furniture with a round top and high gallery designed to hold a stack of plates. The stand generally had a tripod base or four turned legs endowed with casters for greater mobility.

Plateau

Footed stand of painted wood, papier-mâché, metal, glass or ceramics that elevates a centerpiece above the level of the dining table.

Ceramic **PLATEAU.** Courtesy Mottahedeh.

Plateresco (*plah-teh-RESS-koh*)

Spanish style of ornamental architecture, current in the fifteenth and sixteenth centuries, which took its name from *platero* (silversmith). The minutely scaled and detailed ornamentation in imitation of the silversmith's work, a probable carry-over from Moorish design, preceded Cortez' discoveries of silver and gold in the Americas, and was adopted in the Spanish colonial cities, such as in Peru, where walls and furniture in private homes were elaborately gilded with Inca gold.

Platt, Joseph (1895–1968)

Designer and decorator credited with originating one version of the famous Parsons table during his years with the Parsons School of Design. His work during the 1930's and 1940's included sets for the movies *Gone with the Wind* and *Rebecca*.

Plinth

Derived from architecture, this term describes a block (square, round or even octagonal) of wood or stone employed as the base of a column or, decoratively, as a pedestal for sculpture.

Plissé (*pliss-SAY*)

A plain-weave fabric with a crinkled surface, either striped or patterned.

Plush

A deep-pile upholstery fabric identified with the opulent interiors of the nineteenth century.

Plywood

A process in which several thicknesses, or plies, of wood are glued together with the grain of one ply at right angles to the grain of an adjacent ply, an alternation of grains that produces a wood of greater strength than a solid wood. Plywood is made in two ways: veneer construction, where several thicknesses of veneer are glued together; lumber core, where thin layers of veneer are glued at right angles to a thick, semiporous core, the veneers being equal in number and thickness on both sides. Although plywood has been known for centuries, it is only in the last two decades that it has been used in quantity. Today most flat areas of furniture are plywood.

Point d'Hongrie (*pwahn dohn-GREE*)

Elegant upholstery fabric of needlepoint flame stitch on silk, a decorating favorite since the seventeenth century.

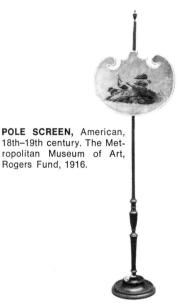

POLE SCREEN, American, 18th–19th century. The Metropolitan Museum of Art, Rogers Fund, 1916.

PLYWOOD-PANELED room designed by Evelyn Jablow. Courtesy U.S. Plywood-Champion.

Pointillism

A style of painting originated by the French Impressionists—notably Georges Seurat—in which the dappled, shimmery effect of light is suggested by tiny points of pure pigment that are blended by the eye of the viewer.

Pole screen

A small fire screen mounted on a pole and a tripod or flat base that adjusted to different heights to shield the sitter from the heat of the fire or, in the eighteenth century, from drafts. The screen was often worked in needlepoint or was hand-painted.

Polish bed

A variation of the eighteenth-century French bed that is set against the wall or out in the room and topped with a canopy ending in a pointed crown.

Polychrome

Literally, many-colored. Generally, a term referring to furniture and objects which are painted and gilded, usually over gesso, to emphasize a design or to embellish a whole area with fantasies.

Polyester fibers

Man-made fabric fibers that when heat-set have excellent durability, stability and "memory"—witness the permanent-pleated fabrics of polyester fibers that both shed wrinkles and retain their built-in creases.

Pongee

Raw silk fabric in natural tones of light tan, originally from China, but today also produced in man-made fibers.

Ponti, Gio

Italian designer of furniture, interiors, silver flatware, etc., whose multifaceted talent and highly individual style have brought him a world-wide following and fame.

Pontil mark

The rough mark left on the bottom of blown glass when the iron rod, or pontil, is removed. Nowadays the mark is usually eliminated by being ground down and then polished.

POLISH BED.

Pontypool

English tole or japanned ware made in Pontypool, Wales, from the late seventeenth century through the nineteenth. The ware, mostly small, utilitarian household objects like tea trays and caddies, tea- and coffeepots and, later, coal buckets, was decorated with scenes of Chinese figures executed in color and gold.

Pop art

Art form of the 1960's which by tongue-in-cheek exaggerations of the most commonplace aspects of present-day living—commercial packaging, comic-strip characters and movie stars—satirizes the superficial, materialistic elements and aspects of our mass-minded culture.

Poplin

A plain, dyed or printed fabric of cotton, wool, silk or synthetic fibers similar to a lightweight rep. An inexpensive choice for curtains, bedspreads or slipcovers.

Porcelain stove

The highly decorative, often fancifully shaped heating device that took the chill off eighteenth- and nineteenth-century rooms in Europe, especially Austria. Today, their presence is valued more than their practicality, for they make an interesting and unusual focal point for a room.

Pot table (*poh tabl'*)

The original night table, tubular in shape, with a door to conceal nighttime necessities and a marble top to hold the bedside oil lamp. Now used decoratively as an end table in a living room or in place of a pedestal to display statuary or sculpture.

Pottery

Objects of nonvitrified earthenware—majolica, faïence, delftware, slipware, etc.—as distinct from stoneware or porcelain.

Poudreuse (*poo-DRUHZ*)

More popularly referred to as a vanity, this is a French powder table. The distinguishing feature is usually a mirror that raises in the midsection.

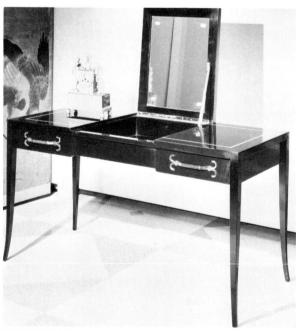

POUDREUSE. Courtesy Parzinger Originals, Inc., New York.

PORCELAIN STOVE in a room designed by Melanie Kahane, F.A.I.D. Photographer: Grigsby.

Pouf

Type of ottoman that is usually round and well upholstered, even button-tufted, to convey a look of comfort.

Powder room

Originally, the closet off the bedroom or entrance hall where ladies and gentlemen powdered their wigs. Now a euphemism for the ladies' rest room or guest lavatory.

Pre-Columbian

Arts and artifacts of the native Indian cultures of Mexico and Central and South America before the discovery of the New World by Columbus.

Pressed glass

Glass shaped by pressure in a mold. Much late-eighteenth-century and nineteenth-century glass was made in this way, and present-day reproductions are taken from the old molds.

PRE-COLUMBIAN POTTERY

Jadeite idol, Mexican. Courtesy The Metropolitan Museum of Art. Gift of Heber R. Bishop, 1902.

Pottery portrait jug, Peru, Mochica Culture, c. 400–1000 A.D. Courtesy The Montreal Museum of Fine Arts.

Prie-dieu (*pree-d'YUH*)

Kneeler, now a chair with high back and low seat, and the additional advantage of a narrow shelf, rail or pad across the top which may be employed as an arm- or headrest.

Primary colors

The three pure colors—red, yellow and blue—that are the genesis of all others in the palette.

Priming colors

The first, or prime, coat of paint which prepares and colors a surface for the final coat. If the final coat is to be pale, the prime coat is white or a light tint of the color. For a dark final coat, the prime coat is a deep value of the same color.

Primitive art

The naïve, untaught art of any people in any period. Often it has been the inspiration for china, fabric and wallpaper designs.

Psychedelics

Bold prints and luminous colors in swirling designs that produce the optical illusion of continuous motion.

Pullman kitchen

The straight line-up of minimum kitchen equipment (stove, sink, cabinets and refrigerator) that is set against the wall or in a shallow recess of a living area in a small house or apartment.

Pull-up chair

A small, lightweight open-arm chair with a firm seat and tapered legs that can be easily moved to the fireside or into a conversation grouping, hence the name. It was developed in the eighteenth century and has been popular ever since. The French fauteuil and the American Martha Washington chair are traditional examples of pull-up chairs.

Putti (*POO-tee*)

Alternate Italian name for the carved, painted or sculptured cupids and cherubs of the Renaissance. *See also* Cherubs.

Carved amethyst **QUARTZ** cup, Ch'ien Lung period, Chinese, 18th century. The Metropolitan Museum of Art. Gift of Mrs. Emma Matthiessen, 1904, in memory of her husband, Francis O. Matthiessen.

Quarry tile

Square or diamond-shaped unglazed paving tile or stone. The word "quarry" derives from quarrel, the short, heavy, diamond-shaped arrow used in crossbows.

Quarter round

A molding with a quarter-circle profile. Generally used, in combination with other types, as a finishing molding.

Quartz

A transparent solid mineral found in hexagonal crystals. The most common, colorless quartz is called rock crystal. Other varieties are rose quartz; false topaz, or citrine, a pale yellow; the bluish-violet amethystine; the banded sardonyx and onyx; the mottled agate; red, opaque jasper; bloodstone and heliotrope; and the brown smoky quartz. The decorative qualities of quartz have been exploited for centuries. The Orientals favored rose quartz; at the courts of Louis XV and XVI rock crystal was preferred, often mounted in bronze doré.

Quatrefoil

A decorative motif originating in Gothic architecture, art and furniture composed of four circular arcs meeting at the cusps, suggestive of a four-leaf clover.

Quattrocento (*kwaht-roh-CHEN-toh*)

Early period of the Italian Renaissance, 1400–1500, a time of transition from Gothic to the classical revival which saw the development of architectural forms and detail in decoration. The furniture, generally of walnut, is dignified, stiff and quite formal. Characteristic pieces are the low sideboard, or credenza; the Savonarola chair, with interlacing curved slats, carved back and arms; the Dante chair, with four curved legs continuing into arms; and the sgabello, a wooden side chair, either three-legged or with carved wood slabs at front and back. A revival of these styles in the late nineteenth and early twentieth centuries accounts for the surprising quantity to be found in secondhand stores.

Queen Anne

A style of period furniture that developed during the reign of Queen Anne of England (1702–1714), easily recognized by its undulating lines and the swelling shape of the cabriole leg. This was an age of amenities and comfort. Furniture makers introduced upholstery in the overstuffed manner and chair backs with a single curved splat, fiddle- or vase-shaped and spooned to fit the back. The craze for tea drinking and china collecting brought into being the small tea table and the glass-doored china closet. Other pieces to appear were the highboy, forerunner of the vertical storage piece, and Windsor and banister-back chairs. Walnut was the favored wood, often lacquered or gilded, with some marquetry. Carving took the shape of the scallop shell, acanthus leaf, broken curve and C-curve. The first furniture to be designed for domestic relaxation, Queen Anne scores high in comfort, scale and simplicity and today is admirably capable of co-existing with modern pieces.

Queen's ware

Off-white earthenware or creamware made for Queen Charlotte, the wife of George III, by Josiah Wedgwood and subsequently copied by other manufacturers. The unusual shapes and simplicity of undecorated queen's ware have assured it a lasting popularity.

Queen-size bed

Bed of regal proportions, though not so large as the king size. The mattress and box spring are sixty inches wide and eighty inches to eighty-four inches long, compared to the conventional plebeian double-bed measurements of fifty-four inches wide by seventy-eight inches long.

Quilted fabric

Double layers of fabric with padding in between, held together by machine stitching in any one of twenty different patterns, such as diamond, square, circular, often combined with outline quilting of flowers.

Quimper (*kam-PAIR*)

French faïence from a factory near Quimper, founded by Bousquet in 1690, later operated by Pierre Paul Caussy of Rouen, and still flourishing today. Most of the faïence, which imitates Rouen, is of the provincial type with peasant scenes on bright-yellow backgrounds.

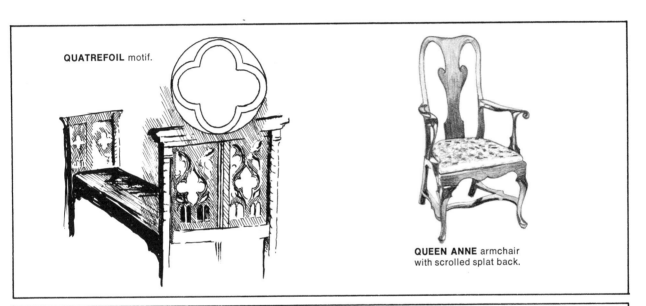

QUATREFOIL motif.

QUEEN ANNE armchair with scrolled splat back.

QUEEN'S WARE. Courtesy Josiah Wedgwood & Sons, Inc.

QUIMPER faïence, 18th–19th century. The Metropolitan Museum of Art. Bequest of Mrs. Mary Mandeville Johnston, 1914.

READING CHAIR.
Courtesy Wood & Hogan, Inc., New York.

Rabbet

In furniture, a step down on a wood section so that another piece may be snugly fitted in. A cabinet door is rabbeted to take a panel, or the side rails of beds to accommodate the box spring and mattress.

Rafraîchissoir (rah-fray-shee-SWAHR)

An elegant ancestor of the bar cart, this Louis XV serving table was primarily intended for chilling wine, and to this end had a top fitted with tole or iron bottle holders. Undershelves held extra dishes and glasses. Today, these practical little walnut or fruitwood tables are mostly used as decorative end tables, and the wells, instead of chilling wine, flaunt plants or flowers.

Ramie

A natural fiber, similar to flax, made from a plant native to China.

Random pattern

An artfully aimless design conceived irregularly rather than as a formal repeat. In wallpaper, a random pattern, scattered instead of spaced in set limitations, may be applied successfully to camouflage jogs and beams on walls and ceilings.

Raphaelesque

Term for the much-copied style of painted decoration executed by Raphael in the Loggia of the Vatican, supposedly inspired by the painted stuccowork in Nero's Golden House.

Rayon

Trade name for a man-made fiber of cellulose, originally created as a substitute for silk, and now one of the most widely used synthetics for upholstery and drapery fabrics, often in combination with natural fibers such as cotton, silk or wool. Rayon is rated high on colorfastness, fair to good on abrasion and durability, and can be flameproofed.

Reading chair

A specially designed eighteenth-century library chair with a pear-shaped seat joined to a narrow back and a horseshoe-shaped crest rail with an adjustable reading stand, sometimes fitted with candleholders. The seat, back and armrest were generally leather-covered. As judges at cockfights sat on these chairs, they became known as cockfight chairs. *See also* Cockfight chair.

Reading table

A small eighteenth-century table with adjustable top to hold a book, probably evolved from the medieval lectern. In the nineteenth century it developed into a pull-up table, high enough to fit over a chair, with an adjustable center section for a book and ends left free for other gear.

Récamier (reh-kah-M'YEH)

French Empire chaise longue that resolves itself in a highly curved end. Derived from a Roman couch, it was named for Madame Récamier, who was immortalized reclining on just such a piece by the painter David.

Receding colors

Cool colors like blue or green which, like sea and sky, seem to escape into the distance and therefore have the effect of making walls retreat.

Redwood

This soft red-brown wood from the Pacific coast has great resistance to decay and insects and weathers well—hence its use for siding on houses and for outdoor furniture. Recently it has also become popular for interior paneling.

Reeding

Raised parallel convex grooves carved to simulate a bunch of reeds, the reverse of concave fluting. An example: the Louis XVI chair with its tapered, reeded leg.

Refectory table

Originally, a long, narrow table built close to the floor and supported by heavy stretchers. When this kind of table was later shortened and fitted underneath with pullout leaves, it became the first self-contained extension table.

Régence

See French Régence.

Regency (1811–1830)

An English style that spanned the years of the late Georgian era when George IV was Prince Regent and continued in favor until the end of his ten-year reign, best exemplified by "Prinny's" beloved Brighton Pavilion, the work of John Nash. Not to be confused with French Régence, English Regency furniture was strongly influenced by French Directoire and Empire, with certain distinctive Egyptian and Chinese motifs, notably bamboo trimming and cane seats and backs. Pieces were often lacquered in black, white or ivory and highlighted with gold trim. Rosewood, mahogany and satinwood were favored, with some exotics like ebony and holly. Simpler in line and smaller in scale than Chippendale, this furniture conveys a special intimate quality and still enjoys a lasting if limited popularity. Some of the smaller pieces have a wittiness that adds an amusing accent to contemporary rooms.

Relief

A form of sculptured decoration in which the design is raised in relief from the flat surface. There are three types: *haut,* or high, relief, where the sculptured portion projects half or more above the surface; *bas,* or low, relief, where the projection is very slight; *mezzo,* or half, where the relief is between high and low. In intaglio, sculpture is cut out below the surface.

RECAMIER chaise longue.

REGENCY drop-leaf mahogany sofa table.

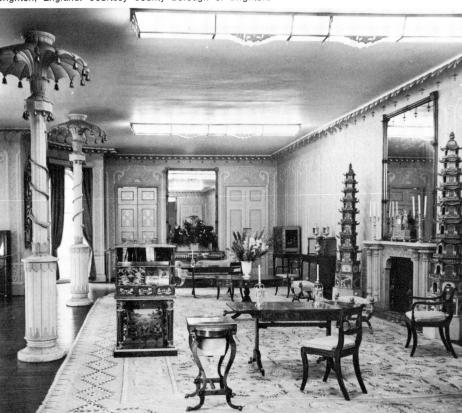

REGENCY STYLE. The North Drawing Room, Royal Pavilion, Brighton, England. Courtesy County Borough of Brighton.

Renaissance (1500–1700)

The earliest of the European styles to reclaim the classic heritage of Greece and Rome and the genesis of decoration as we know it today. Almost all Renaissance pieces, however rudimentary in form and stature, are recognizable ancestors of present-day furniture. In Italy, where the movement had its roots, an architectural feeling predominated in furniture. Later pieces, embellished in line and ornamentation, represent Renaissance style as we know it today. Every country had its own interpretations. In France, the scale of the later Italian Renaissance pieces was resolved to livable proportions. In Spain, where the Moorish influence was rife, Eastern motifs were introduced in inlays and ornate metal mounts and brass studdings. In Flanders, the interpretation resulted in heavy, square and solid proportions with carving often abandoned for turning. In Tudor England, the carving and decoration were more elaborate, the shapes stiff, straight and massive. Oak and walnut were the prevailing woods in all countries.

RENAISSANCE Flemish walnut chair.

RENDERING.

Rendering

Interior designer's hand-drawn illustration of proposed decoration of a room, furnished at the client's request as an aid to visualizing the finished work.

Rent table

Eighteenth-century predecessor of the file cabinet, this round or octagonal pedestal table had drawers marked alphabetically or with the days of the week to aid landlords in collecting rents and keeping their records straight. Today, it assumes a more decorative function as a lamp or library table.

Rep

A corded upholstery and drapery fabric similar to poplin but heavier.

Repoussé (ruh-poos-SAY)

Decorative sheet-metal work. The design is projected in relief on the front through hammerings from the back.

Reproductions

Copies of old pieces, faithful in duplication of all details and even in finish and patina. Today, the word "reproduction" may be applied more loosely to commercial pieces that have some of the flavor, if not the accuracy, of the original because materials and proportions have been changed.

Restoration

Term for furniture, china, rooms, or houses that have been restored to their original condition, with missing or damaged parts replaced or substitutions made. While restored furniture loses much of its intrinsic value, restored rooms or houses are regarded as permissible, for they can re-create the past for the present generation.

Retablo (reh-TAHB-loh)

Eighteenth- and nineteenth-century Spanish and Mexican religious paintings on wood or copper panels depicting the Christian saints, originally hung in churches and chapels.

Reveal

The section between the face of a wall and the frame of a window or door.

RENT TABLE. Courtesy Wood & Hogan, Inc., New York.

RIBBAND back.

RINCEAU.

ROBSJOHN-GIBBINGS chair, Greek adaptation. Courtesy Parzinger Originals, Inc., New York.

Ribband

The ribbon as ornamentation, seen in the Chippendale ribband back—chair splats with elaborate carved arrangements of ribbons and tassels—and in the Louis XVI styles with their profusion of carved ribbons, bows and knots. In our time, mainly a motif for fabrics and wallpapers.

Rickrack

Flat zigzag tape trimming for curtains, pillows, etc.

Rinceau (ran-SOH)

An oblong panel or strip with symmetrical scroll-work flanking a central point or design motif.

Riser

The upright section of a step connecting the two treads.

Robsjohn-Gibbings, Terence Harold

Designer of furniture and interiors in the most elegant and refined modern idiom whose book *Good-bye, Mr. Chippendale* was a plea for emancipation from the bondage of traditional design. His most recent contribution has been the production of classical Greek furniture designs.

Rockingham

Two kinds of English ware produced in the late eighteenth and early nineteenth centuries that have a considerable vogue among decorators and collectors. The simple eighteenth-century Rockingham, pottery with an uneven deep-brown glaze, was the inspiration for American Bennington. In the nineteenth century, the factory progressed to decorative porcelains with brilliant ground colors—dinner, dessert and tea services, large vases, figures, and incense burners shaped like cottages (these were later copied by Staffordshire).

ROCOCO decoration on the South Wall of the North Hall, Claydon House, England. Courtesy The National Trust. Photographer: A. F. Kersting.

Rococo

A style of decoration predominant in eighteenth-century Europe, in particular during the reign of Louis XV, in which rock and shell motifs (*rocailles* and *coquilles*) and similar shapes borrowed from nature were translated into a profusion of carved and painted ornaments. The motifs appeared in interior decoration, applied asymmetrically rather than in the symmetrical balance of the classic styles.

Roller prints

Designs printed on fabrics and wallpapers with engraved metal rollers. Each roller prints one color, but many colors can be printed at great speed. This technique was introduced in late-eighteenth-century England and France with wooden rollers.

Roman shade

A neat variation on the Austrian shade in which the folds of the flat fabric panel are horizontally accordion-pleated rather than being shirred in scallops, giving a much more tailored effect.

Romanesque

A style of art and architecture, chiefly ecclesiastical, that prevailed in Europe roughly from 800 to 1100 A.D., after the collapse of the Roman Empire, and eventually evolved into Gothic. The architecture followed debased Roman concepts, the churches, with their characteristic vaulted roofs and semicircular arches, being modeled after the basilica. The style is stiff and crude, with motifs taken from animal and plant forms and such abstractions as the checkerboard and chevron. Today, many of the motifs have been reinterpreted in rugs, fabrics and wallpapers, their crudeness and vigor blending well with the understated look of contemporary rooms.

Room divider

Improvised partition to separate areas of a room. May be freestanding or built-in—a storage wall, sliding panels, a piece of furniture or as simple a device as a folding screen or curtains on a track.

Rorstrand

Swedish ceramics factory established in 1725 at Rorstrand, near Stockholm, by the Swedish Chamber of Commerce. In addition to tableware, which included fanciful rococo and chinoiserie patterns in *bianco sopra bianco* (white on white) or white on a blue-gray ground, the factory turned out tea trays, stoves and large faïence pieces. Today, Rorstrand makes contemporary porcelain and faïence.

Rosenthal

A china company founded in 1879 in Bavaria, noted for moving with the times. In addition to making porcelains in contemporary shapes, colors and designs, Rosenthal has recently branched out into hand-blown glass, silverware and stainless steel.

Rosette

A disk or button of leaves arranged in the form of a rose, an ornamental motif found on furniture, fabrics, wallpapers and in architecture.

Rosso antico (ROHS-soh ahn-TEE-koh)

Unglazed red stoneware made by Wedgwood.

Roundabout chair

See Corner chair.

Roundel

Any circular form used for ornamentation or in decoration, such as today's translucent roundels of glass or plastic strung together to form mobile room dividers or to take the place of curtains.

Royal Copenhagen

Danish porcelain factory that has been in operation since the late eighteenth century, best-known for its rococo and neoclassic designs, blue-and-white floral patterns, and figurines.

Ruby glass

A type of rich, deep-red glass, often cut or engraved, developed in Germany in the seventeenth century after the discovery of gold chloride, which gave it the distinctive hue. Another type, made in Bohemia in the nineteenth century, had a colorless core and a thin overlay of ruby glass which was cut, engraved and often gilded. The late nineteenth and early twentieth centuries saw the reintroduction and mass production of the ruby-red glass.

Runner

Either the guide strip on the side or bottom of a drawer or the rocker of a rocking chair.

Rush

Woven grass or reed, a traditional material for chair seats and backs since Egyptian times.

ROSETTE motif.

Design for **RUSTIC** chair from *A New Book of Chinese Designs* by Edwards & Darby. 1754. Courtesy Victoria and Albert Museum, London. Crown copyright.

Rustic furniture

Art aped nature in this eighteenth-century garden furniture. Occasionally, real branches formed the legs, arms and backs of chairs or tables; more often the knotty contours of branches and twigs were simulated with paint or cast iron. Chippendale originated many of the designs, a number of which are reproduced today.

Rya rugs

Hand-knotted Scandinavian rugs in abstract or modernized peasant designs. The blurry, shaggy look of the surface is produced by the rya or flossa weave, in which the clipped wool pile alternates with and covers strips of plain tapestry weave, like grasses in a field. The extraordinary colors of rya rugs, as varied as a painting, come from the yarn, a mixture of two hues. Although rya rugs are now emulated by machine, the handmade look still persists, giving them a great affinity for early American furniture as well as contemporary Scandinavian and American styles.

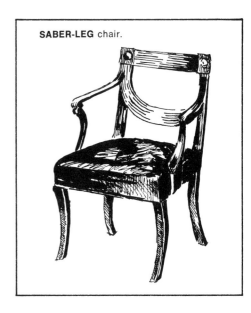
SABER-LEG chair.

Saarinen, Eero (1910–1961)

Architect and designer of the famous mushroom pedestal table and chairs, and the upholstered lounge chair of molded plastic and foam rubber on a base of metal rods, manufactured by Knoll Associates.

Saber leg

A type of simple tapered leg, curved like a scimitar, and found on furniture, mostly chairs, of the Empire, Biedermeier and English Regency periods.

Sailcloth

An inexpensive, strong, firm, plain-weave cotton fabric similar to canvas but lighter in weight. Contemporary sailcloth in bright colors and printed designs is often used for curtains, upholstery, slipcovers and bedspreads.

Mushroom table and pedestal chairs by **EERO SAARINEN.** Photographed at Knoll Associates, Inc. Photographer: Guy Morrison.

Saint Cloud (*san kloo*)

Soft-paste factory established by Pierre Chicanneau in the late seventeenth century. It came under the patronage of Louis XIV between 1702 and 1725, and the early pieces display the Sun King's sunburst emblem.

St. Louis glass (*san loo-ee*)

Crystal and glassware made in the French town of St. Louis since the eighteenth century. First famed for decorative paperweights, now for table glassware.

Salem rocker

Characteristic nineteenth-century New England rocking chair with a scrolled seat, arms and top rail. The back, lower than that of a Boston rocker, has straight, light spindles.

Salem secretary

American name for a type of Sheraton-style secretary-bookcase with a recessed upper section of bookshelves behind two or four glazed doors and a projecting lower section with two or three rows of drawers, and occasionally a fall-front writing flap over the top drawer. The lower portion of the recessed section may also conceal small drawers and pigeonholes.

Salt glaze ware

Stoneware with a glaze made by throwing rock salt into the kiln, a process practically extinct today.

Samovar

Russian tea urn of silver, copper or brass in which water is heated by means of a vertical tube in the center for burning charcoal. The teapot is kept hot on the cup-shaped part on top of the tube. In the United States samovars are mostly converted into lamp bases or used purely for decoration.

Sample length

Sample of fabric, one-third to one-half yard when plain, a full repeat when patterned, purchased or borrowed on memorandum by the interior designer to show to the client. Also called memo sample.

Sampler

When needlework was in flower, in the eighteenth and nineteenth centuries, children and young women fashioned these small, personalized pieces of stitchery to show off their prowess.

Sandwich glass

Pressed glass originally made in Sandwich, Massachusetts, between 1825 and 1888, and currently reproduced from the old molds. The name is often mistakenly given to other types of pressed glass made by other American factories.

Sang de boeuf (*sahng duh buhf*)

French name (in translation, oxblood) for the Chinese porcelain glaze color developed during the K'ang Hsi period (1662–1722). Rich fabrics and porcelains in this distinctive color are once again making the decorative scene.

Staffordshire **SALT-GLAZE** jug, c. 1760. Courtesy D. M. & P. Manheim Antiques Corp., New York.

Sanguine (*sahn-GEEN*)

Drawing executed in red crayon or chalk, originally made from the ground-up bloodstone (sanguine), hence the name.

Santo

Although the Spanish gender is masculine, the word refers to a painted or carved image of any of the Christian saints, or the Virgin Mary, Joseph and the Christ child, made in New Mexico, Puerto Rico, the Philippines or other parts of the world where the Spanish colonial and Catholic influence was dominant.

Saran

A man-made fiber that can be shrunk and then set with heat. Popular as an upholstery fabric, especially for outdoor furniture, as it will not fade or sag, it is washable, quick-drying, flame-resistant, colorfast and resists abrasion. In combination with other yarns, saran can take on a three-dimensional look or raised surface.

Satin

A basic-weave fabric in which the warp yarns are arranged to conceal the filling, giving it a smooth, lustrous surface.

Satin glass

Late-nineteenth-century art glass of the case type. The inner layer is opaque white, the outer layer a transparent color with an acid-etched satiny finish.

Sausage turning

Simple lathe turning of repeated forms resembling a link of small sausages, similar to spool turning and also found on nineteenth-century American furniture.

SANDWICH GLASS celery holders. Courtesy of Mrs. Greer, Middleburg, Virginia.

Folding walnut **SAVONAROLA CHAIR**, Italian, 16th century. Courtesy The Metropolitan Museum of Art. Gift of William H. Riggs, 1913.

Savonarola chair (*sah-voh-neh-ROH-lah*)

The Italian Renaissance X-chair made of curved interlacing slats with a carved wood back. *See also* Quattrocento.

Savonnerie (*sah-vohn-n'REE*)

French rug and tapestry factory that produced hand-woven wool rugs with a high pile in pastel colors and floral and scroll patterns for eighteenth- and nineteenth-century houses and palaces. The originals now bring high prices, but Savonnerie-type rugs can be bought for considerably less.

Modern **SAVONNERIE** rug by Patterson, Flynn & Johnson, Inc.

Sawbuck table

A large wooden table with two X-shaped supports, originally a Gothic design but more often associated with early American interiors. Contemporary versions of sawbucks sport steel or chrome supports, glass or marble tops.

Scagliola (*skah-l'yee-OH-lah*)

Hard plaster surface embedded with small pieces of granite, marble, alabaster and other stones, and highly polished. Used for chest or table tops.

Scalamandrè, Franco

Founder of the Italian firm of Scalamandrè Silks, Inc., famed for its superb reproductions of antique fabrics and authentic copies of old silks.

Scale

Size and proportion of a piece relative to its surroundings and to other pieces in the room. Furniture with slim, low lines earns the term "lightly scaled," whereas that which is large and massive would be considered heavy in scale.

Scale pattern

Ceramist's term for the diaper pattern that resembles the overlapping scales on fish. It occurs on many European porcelains, especially the scale-blue English Worcester. Recently, the pattern has been adapted to fabrics and wallpapers.

Scallop

One of the most constant design motifs, the curved scallop shell crops up in the Renaissance, on Queen Anne and Chippendale furniture, in the Louis XIV, Louis XV and Georgian periods, and in the twentieth century on fabrics, wallpapers and all kinds of decorative objects.

Scandinavian Modern

A style of furniture introduced in the 1930's consisting of simplified versions of the Empire style, usually constructed of walnut or teak with a blond or natural oil finish and a conspicuous absence of applied decoration. Also known as Swedish or Danish Modern.

Scapula, Pierre

Interior designer who works mainly for collectors, skillfully integrating their treasured possessions into rooms that convey a total concept, expressive of the owners' individual taste. His style tends toward the French period idiom, with an occasional modern room in the most luxurious of textures—soft leather and silky fur.

Scenic papers

Wallpaper murals of vistas, panoramas and historical and mythological scenes. Among the famous examples are the early-nineteenth-century *Vues d'Italie* and scenes from Napoleon's Egyptian campaigns. Developed in France during the late eighteenth century, these paper pictures reached a peak of artistry in the nineteenth-century works of Joseph Dufour and Jean Zuber, many of which are still to be found today, either in the originals or in reproduction. Current scenics range from the traditional to the ultramodern.

Sconce

A wall bracket that is decorative and dispenses light, originally in the form of a candle or oil lamp, today electrified for smokeless light. *See also* Applique.

Screen prints

Designs applied with individual screens of silk, nylon, metallic thread or paper. One screen is used for each color in the design and the color is either squeezed or brushed through the cutout portion of the screen onto the fabric or wallpaper. Developed in France in the nineteenth century, this formerly slow hand operation has been mechanized for quick, clear reproduction. *See also* Hand screening; Silk screening.

Screens

An arrangement of one or more hinged panels, covered with leather, fabric, paper, mirror, painted or lacquered. The earliest screens, dating from the second century B.C. in China, were strictly ornamental, being either painted with landscapes or paneled with mica or glass to allow sheltered enjoyment of the outdoors. More practical screens were deployed in castles of the Middle Ages to ward off drafts or the heat from the vast fireplaces. In succeeding periods, screens were decorated according to the prevailing style and taste, and often shelves were added to provide reading or writing space. Among the various types are the cheval screen and the pole screen—both fire screens—the

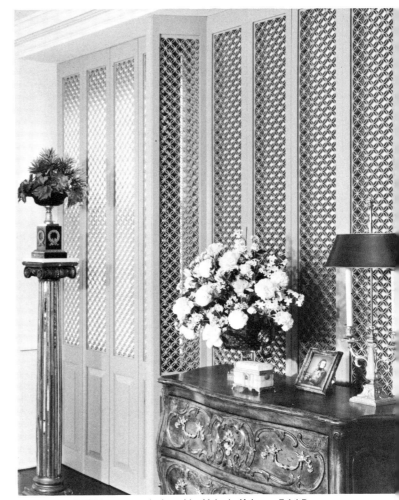

Hinged **SCREENS** in a room designed by Melanie Kahane, F.A.I.D. Photographer: André Kertész.

tall screen, the Coromandel screen and the short three-panel Oriental screens that today are often hung on a wall like a painting.

Scrim

A coarse, loose, open cotton fabric, originally a theatrical material, now popular for sheer glass curtains.

Scroll motif

The scroll or spiral line occurs in decoration as far back as the seventeenth century. Most prevalent types are the Flemish scroll, a double baroque scroll consisting of a lower C-scroll separated from the upper reversed C-scroll by a right angle, found mainly on chair and table legs; the C-scroll, often used in decorative carving; the S-scroll, the swan-neck or double-curved scroll, associated with Queen Anne and Chippendale furniture.

Scroll top

The broken pediment on furniture and mirrors formed by two cyma curves separated by a finial.

Second Empire

The reign of Napoleon III (1852–1870) saw French furnishings that essentially paralleled those of Victorian England, but were interpreted in a more whimsical, less pompous manner. Most familiar and favored today are the papier-mâché and mother-of-pearl furniture and the decorative opaline glass.

Secondary colors

The three that result from mixtures of equal parts of the primaries—orange (red plus yellow), purple (red plus blue) and green (blue plus yellow).

Sectional furniture

Furniture made in units designed to fit together but also to function as single, separate pieces—sofas, bookcases, chests, etc.

Sedan clock

A traveling watch or small clock, about five to seven inches in diameter, that was hung in sedan chairs during the seventeenth and eighteenth centuries. Also available in reproductions.

Selvage

The reinforced outer edges of a fabric; the plain vertical margins on wallpaper rolls or sheets, which generally bear the name of the manufacturer and the design, and instructions for matching repeats, joining, etc.

Semainier *(suh-men-YEH)*

A tall, narrow chest of drawers developed during the reign of Louis XV and so named because it contained seven drawers, one for each day of the week. Modern reproductions of this piece are made today in several versions, some with only six drawers.

Sepia drawing

A drawing executed in a yellow-brown watercolor or ink, one of the earliest of the artist's materials, known in Roman times. Sepia drawings framed with colored mats look effective in wall groupings.

Serpentine front

The sinuous shape of a commode, chest or bureau that curves inward at the ends and outward at the center.

Serving table

A dining-room side table of serving height, fitted with drawers. Many eighteenth-century serving tables had marble rather than wood tops as a protection against hot dishes.

Set off

Decorating tactic to achieve visual definition or distinction, as the use of vinyl tile might set off a dining area from a carpeted living area.

SECOND EMPIRE winter garden of l'Hôtel de la Princesse Mathilde. Courtesy Musée des Arts Décoratifs, Paris.

Settee

Long seat or bench with open arms and back, sometimes upholstered, sometimes caned.

Settle

All-wood settee with solid arms and back, usually built like a box, solid to the floor, with hinged seat. The words "settee" and "settle" are often confused, perhaps because the latter is more pleasing.

Sèvres (*sehvr*)

Porcelain from the factory established by Louis XV under the patronage of Mme. Pompadour, famous for its highly decorated and colorful glazed pieces. Much eighteenth-century furniture is decorated with Sèvres porcelain plaques or tops. A luxury even then, Sèvres is still one of the costliest porcelains.

Sèvres blue

One of the first and most widely copied of the Sèvres enamel ground colors, introduced on the porcelains around 1760 as a replacement for and refinement of the earlier underglaze blue. Other porcelain factories, such as Worcester and Derby, impressed by the smoothness and evenness of the color, soon copied it and the color became incorporated into the decorating palette not only for china, but also for fabrics, wallpapers and carpets.

Sewing table

Domesticated piece of furniture that originated in the seventeenth century and reached its peak of design in the eighteenth-century styles of Sheraton, Hepplewhite and Duncan Phyfe. The traditional versions sport drawers fitted with spool racks, a lid top and often a cloth bag for the sewing gear. Our contemporary types, often of sleek teak, substitute a reed basket for the bag.

Sgabello chair (*sgah-BEHL-loh*)

European provincial chair based on the three-legged stool. Early chairs were simple affairs with three legs wedged into the seat and with a board back. Later, the legs were replaced by scroll-cut slabs at the front and back of the seat, which was sometimes hinged, and the back splat was profusely carved.

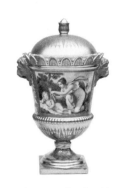

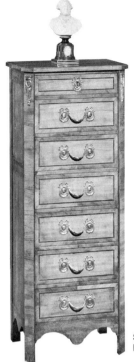

SEVRES sugar bowl with cover, c. 1813. The Metropolitan Museum of Art, Gift of Mr. and Mrs. D. N. Heineman, 1956.

SEMAINIER. Courtesy Baker Furniture, Inc.

SETTEE. Courtesy Wood & Hogan, Inc., New York.

SETTLE.

Italian SGABELLO CHAIR, early 16th century. Courtesy The Metropolitan Museum of Art. Bequest of Annie C. Kane, 1926.

153

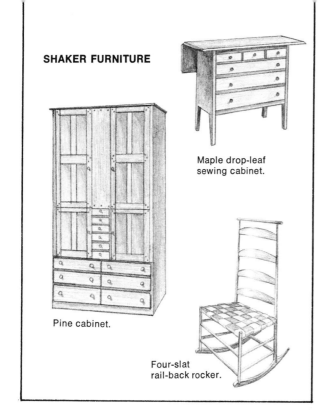

SHAKER FURNITURE

Maple drop-leaf sewing cabinet.

Pine cabinet.

Four-slat rail-back rocker.

SHERATON STYLE

Pembroke table with inlays.

Secretary with Gothic tracery.

Shade

A pure color darkened by the addition of black. Burgundy and maroon are shades, or dark values, of red.

Shaker (1776–1880)

Simple, straightforward furniture, mainly of pine, walnut, maple or fruitwoods, made by the Shakers, a self-sufficient religious sect that came to America from England in the late eighteenth century. The clean-lined functionalism of the Shaker style has sustained it in popularity and its influence is strongly apparent in many of today's furniture designs but, because of its rarity, authentic pieces are now quite expensive.

Shantung

A heavyweight pongee of wild silk, cotton or the two combined, often made into curtains and bedspreads.

Shaving stand

A tripod stand with adjustable mirror at masculine stand-up height that was introduced, as a straightforward piece of of equipment, in the late seventeenth century. In the hands of the Georgian and Victorian furniture makers, it became a more elaborate object.

Sheer

Transparent or translucent fabric, thin and lightweight, frequently selected for curtains to admit diffused light.

Sheffield plate

Serviceable type of eighteenth-century English silver plate made by fusing silver and copper and then shaping the metal into objects—teapots, trays, candle snuffers, etc. Early and well-worn pieces often show the copper through the silver, but no serious collector would dream of having them replated.

Shell motif

A design motif popular since the Renaissance. In its French interpretation, under the name "coquillage," as a scallop shell centered between two acanthus sprays, it was one of the most prevalent of the rococo ornamentations. In eighteenth-century English furniture it appeared on the knee of Queen Anne and Chippendale cabriole legs, and in the form of an inlaid conch shell on chests and tables. Today, shells are still favored in decoration—either as printed designs on fabrics and wallpapers, woven patterns on carpets and upholstery fabrics or, in their own right, as superb examples of nature's art, mounted on stands and displayed as accessories.

Sheraton (1790–1805)

A style of the late Georgian period that took its name from furniture designer Thomas Sheraton. In 1791 he published *The Cabinet-Maker and Upholsterer's Drawing Book,* a compendium of all the known available designs of the time, which were eventually, and mistakenly, attributed to him. Many pieces, then dubbed "harlequin furniture," were early versions of what we would call dual-purpose furniture, and are equally versatile in settings today. Sheraton's later work, based on French Directoire and Empire, was not equal in caliber to the earlier.

Shibui (*shee-BOO-ee*)

Japanese word that implies lasting beauty and an esthetic ideal—essentially simple, understated and subdued. Although the magazine *House Beautiful* adapted some of the principles of shibui to American decorating, this essentially rarefied Eastern philosophy is difficult to apply to our totally different way of life. In decorating, it is interpreted with soft, often neutral colors, natural textures, an overall sense of peaceful harmony and an appreciation of beautiful objects.

Shield back

The popular Hepplewhite shield-shaped chair back with double-curved top rail and splat carved with the Prince of Wales feathers, swags, ribbons or a wheat sheaf.

Shiki (*SHEE-kee*)

A heavy silk or rayon or other synthetic rep fabric made with filling yarns of irregular sizes.

Ship decanter

Bell-bottomed bottle carried on eighteenth-century sailing ships, supposedly designed to keep the spirits from spilling.

Shirring

Fabric gathered or shirred on a rod, cord or thread.

Shoji

Japanese term for wood-framed translucent sliding panels used as room partitioning.

Show wood

Exposed wood parts of an upholstered piece of furniture—a chair or sofa frame, leg, apron.

SHIELD BACK on a chair.

SIDEBOARD with painted finish and panels. Courtesy Baker Furniture, Inc.

Side chair

A chair without arms which varies in height according to its function—as a dining, writing, fireside or ballroom chair. Such chairs may have evolved when a back was added to a stool to make seating more comfortable or by removing the arms of an open-arm chair, the case in the sixteenth and seventeenth centuries when seats had to be widened to accommodate the voluminous hoop skirts of the period.

Sideboard

Sixteenth-century serving table or board that developed through various ages and stages into a chest or cabinet, a hutch, the court cupboard, the two-part dresser, the one-piece buffet with drawers and cabinet combined, and the three-part sideboard, an eighteenth-century elaboration consisting of a table and two pedestals with urns to hold cutlery. Today's version seems to be reverting to the original, simple design of a shelf table sans storage space.

Signed piece

Furniture, porcelain, crystal, bronze, painting, sculpture or any similar object of decorative value signed by the artist or craftsman who made it. A term most often applied to furniture by eighteenth-century cabinetmakers.

Silicone finish

Colorless protective finish that endows the most fragile fabric with an iron constitution, repelling stains, liquids, dirt. Known by brand names like Scotchgard and Syl-mer.

Silk screening

Technique for hand printing designs on fabrics and wallpaper in which color is pressed through a stencil on a fine silk screen stretched on a wood frame. As each color requires a separate stencil and screen, the more screens, the costlier the print. *See also* Hand screening; Screen prints.

Singerie *(san-zheh-REE)*

Lively representation of monkeys, a fashionable motif in decoration during the rococo period. Monkey orchestra figures, monkeys as table bases and reproductions of colored drawings of monkeys in various guises and disguises can be found today by the simian-minded collector.

SINGERIE wallpaper by Piazza Prints.

Sisal

Natural fiber, often woven into rugs, made from the leaves of the agave plant, found in Mexico, the West Indies, Central America and Africa.

Slant-front desk

Popular type of writing desk that was introduced in the early eighteenth century and varied in style according to the period. The slant-front desk section, which tops a lower drawer unit, has drawers, compartments and pigeonholes and a hinged lid that rests on pullout slides, providing a writing surface.

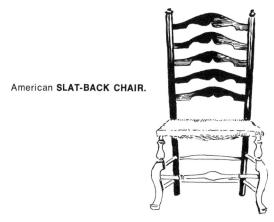

American **SLAT-BACK CHAIR.**

Slat-back chair

A seventeenth-century English turned and carved chair with a high, open back crossed by three slats. It was the forerunner of the later American maple or pine slat or ladder back, which had as many as six slats and a rush seat. Both the English and American ladder backs are simple, functional styles that have remained popular.

Sleepy Hollow chair

Supposedly named for Washington Irving's house on the Hudson, this nineteenth-century American upholstered chair with deep, curved back, hollowed seat, low arms and matching ottoman or footstool is the epitome of masculine lounging comfort.

Sleigh bed

American version of the French Empire bed, named for the high, scrolled ends resembling a sleigh front.

Slip seat

The removable upholstered wood seat that slips into the framework of a chair, enabling it to be easily re-covered.

Slipcover

Practical outgrowth of the fitted, removable cover or "housse" designed during the Louis XV period to protect new upholstery or hide the well worn. In these fickle, fashion-conscious times, slipcovers often substitute for upholstery, and furniture, sold in its plain muslin underwear, may have several slipcover ensembles for seasonal or color changes.

Slipper chair

A low, luxurious little side chair or armchair, upholstered and skirted, designed to take its place in a feminine bedroom or boudoir setting.

Slipware

Pottery decorated on the unfired surface with slip, or clay with the consistency of batter, an early form of simple ornamentation practiced by the Romans, by medieval European potters and by peasants from the sixteenth century on. The techniques consist of tracing the slip on with a quill, painting it on with a brush, marbling or feathering (brushing on a pattern with a feather), or coating the entire surface and then scratching through to reveal the underlying clay color (sgraffito).

Sofa

Indispensable piece of comfort-conscious upholstered furniture which takes its name, appropriately enough, from *suffah,* a divanlike seat of Arabic descent. The French canapé, a small sofa with upholstered back and arms at each end, is modeled along similar lines. The sofas of today assume all shapes and sizes, from the cushiony Chesterfield, Lawson and tuxedo types to those with sleek contemporary contours, and others that lay design claim to periods when upholstered furniture was unknown.

Sofa painting

In decorating, clients' cant for a painting not of but over a sofa. When faced with this phrase, the professional interprets it as meaning a picture sizable enough to occupy the wall space above the Chesterfield, a practice never condoned by lovers of art.

Sofa table

A style of late-eighteenth-century oblong drop-leaf table designed, according to Thomas Sheraton, to go in front of the sofa. In the characteristic Sheraton style, the table is five to six feet long, two feet wide and between twenty-seven and twenty-nine

Modern "Tobacco Leaf" Lowestoft
SOUPIERE by Mottahedeh.

inches high, the drop leaves have rounded corners and are supported on wooden brackets, and there are two frieze drawers on one side of the top and mock drawers on the other. The base was either a turned pedestal with four splayed feet ending in brass casters or paws, or two lyre-form supports connected by a stretcher, popular in American Empire styles. Today, we are apt to place this type of table behind, rather than in front of the sofa, and use it as a desk.

Soffit

The underside of a projecting cornice, beam or wide molding. Often a concealment for lighting.

Soft floor coverings

All-embracing term for carpeting, from wall-to-wall to room size, area and accent rugs.

Soft-paste porcelain

A type of European porcelain, also called *pâte tendre,* made in Europe during the seventeenth and early eighteenth centuries, before kaolin, from which hard-paste porcelain is made, was discovered in Germany. Soft-paste porcelain, which was compounded of fused ground glass and clay, was often more pleasing in color than the true porcelain, but the glaze scratched easily and was not durable.

Soupière (*soo-p'YEHR*)

Soup tureen with cover and platter. In furniture, the soupière in the form of a vase is found in Louis XVI and Empire pieces, pedimented tops of beds, cabinets, chairs and at the intersection of stretchers.

Soutache (*soo-TAHSH*)

Narrow, round braid with a herringbone design for edging or trimming fabric.

Spade foot

A tapering, quadrangular foot seen on Hepplewhite and Sheraton chairs and tables.

Spanish foot

A slightly scrolled ribbed foot, larger at the base, found primarily on seventeenth-century English and nineteenth-century American furniture.

SPANISH FOOT.

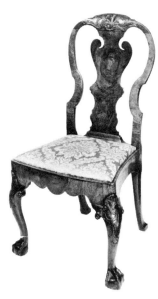

Queen Anne walnut chair with scrolled **SPLAT**, c. 1715. Courtesy Philip Colleck New York.

STACKING CHAIRS designed by Robin Day. Courtesy John Stuart, Inc., New York.

Spatter dash

A textured, flecked effect achieved in painted floor finishes by tapping a paintbrush with a stick or over a block of wood, and reproduced ready-made in vinyl tile.

Spatterware

Earthenware patterned with spatters of blue, green or deep rose, sometimes with reserves painted with fantastic birds. Although originally an inexpensive ware exported from England to America in the early nineteenth century, today it is much collected and brings correspondingly high prices.

Spice chest

A chest of many mini-drawers, developed in eighteenth-century America to keep precious and costly spices under lock and key. Spice chests vary greatly in style, length and height (usually from twenty-seven to fifty-eight inches).

Spider-leg table

A small gate-leg table with eight slender, turned legs, of eighteenth-century vintage.

Spindle back

Chair back in a series of slender, vertical, turned members, most often applied to Windsor chairs, popular since the seventeenth century.

Spinet

A musical instrument with a keyboard and strings, one for each note, very similar to the harpsichord. The early spinet was legless and the wing-shaped case was designed to rest on a table. Today, the word "spinet" is applied to a small apartment-size upright piano.

Splat

The central vertical member of a chair back, the treatment of which is often indicative of a style of furniture, as the scrolled splat of Queen Anne.

Spode

Two types of ware were produced by the Spode factories in England. The earlier was creamware; the later, bone china.

Spool turning

A simple turning for table legs and bed and mirror frames that mushroomed in America during the nineteenth century, after the invention of the power lathe. The name is a literal description of the shape—a continuous bulbous design resembling a vertical line of spools—and was perpetuated in that perennially popular piece of furniture, the spool bed.

Spoon back

A chair that is "spooned," or shaped, to complement the contour of the human body, specifically Queen Anne.

Spoon rack

A wall-hung holder with two rows of slotted rails designed to hold spoons in the Elizabethan era. During the eighteenth century, when it became decorative as well as functional, a box was added beneath for knives. Now the racks usually display a collection of antique silver or pewter spoons.

Squab

Plump, loose cushion added to the inside of a chair or stool frame to form the seat.

Stabile

Abstract sculpture or construction of sheet metal, wire or wood. Unlike a mobile, it stays put.

Stacey, George, A.I.D.

American interior designer with an international reputation and clientele. His taste and touch can be found in such disparate places as the Monaco palace of Prince Rainier and Princess Grace, the Madrid home of Ava Gardner, the Palm Beach house of Dr. and Mrs. Leon Levy and his own hundred-room Château de Neuville in France.

Stacking chairs

Lightweight frame chairs engineered to stack vertically, thus conserving storage space.

Staffordshire

Pottery turned out by the many factories of Staffordshire, England, which did a roaring trade with America in the nineteenth century, exporting earthenware decorated with transfer scenes (many of them American), figurines and pug dogs, perhaps the first example of mass-produced accessories for the home. Staffordshire figures are still reproduced; the originals are collectors' items.

Stained glass

Glass fused, or "stained," with color in the kiln and then made into pictorial, mosaic or other designs delineated by lead strips. This decorative art flourished in the Middle Ages for the greater glory of God and his cathedrals and was adopted by the wealthy to glorify their castles and manor houses. Victorian doors and windows glowed with stained glass, as did Art Nouveau lamps and shades. Today, like so many other materials, stained glass is skillfully and successfully copied in plastic.

Staining

The coloration of wood with a stain. Furniture stains vary according to the century. In seventeenth-century England, a reddish oil containing vegetable dye was the medium. Furniture was stained red and black in the first part of the eighteenth century, light yellow in the latter half, when pale wood finishes were in fashion. With our taste for strong color, furniture, floors and the exteriors of houses are stained in brilliant hues.

Steamboat Gothic

Named for the elaborate trimmings of the Mississippi and Hudson river steamboats, the jigsaw-cut wood "gingerbread"—balls, turnings, finials, gables, etc.—lavished by the Victorians on the inside and outside of their houses and buildings. With the current fad for Victoriana, much of this gingerbread, salvaged from demolished buildings, has been incorporated into wall panels, room dividers and screens.

STEAMBOAT GOTHIC villa on the Hudson. Courtesy The Bettmann Archive.

Directoire **STEEL** bed in a room designed by Louis Bromante.

Modern stainless **STEEL** chair and table designed by Evelyn Jablow.

Steel furniture

The fastidious, functional nature of metal furniture was recognized in the seventeenth and eighteenth centuries, when ironsmiths and gunsmiths fashioned it with great expertise, and at no small cost. Best-known and most popular now are the timeless, elegant designs of the French Directoire and Empire, so successfully revived by interior designers such as Michael Greer and Paul Jones. In our century, the properties of stainless steel have been magnificently exploited by contemporary designer Evelyn Jablow.

Stenciling

Surface decoration simply applied by brushing paint, stain or dye through the cutout openings of a paper pattern. Stenciling on floors and furniture and around walls, windows and doors was the ingenious and inexpensive way our early American ancestors added color and pattern to their plain rooms. Today, the technique is enjoying a revival, in more contemporary colors and designs, and for those too maladroit to cut their own patterns, there are wallpapers, fabrics and window shades printed to resemble stencil motifs.

Step table

A table of steps or a table with a stepped setback on the top to give extra space. The name and design probably derive from the nineteenth-century bed and library steps, which often doubled as tables.

Sterling

Term for silver articles containing, by law, at least 92½ per cent pure silver.

Stippling

A way of duplicating the rough texture of old plaster or stucco by rubbing a brush, piece of burlap or crumpled paper on freshly plastered walls to simulate trowel marks. Now more easily produced by the introduction of an extra-thick stipple paint.

Stone, Edward Durell

American architect and designer whose extensive use of grilles in modern building started a decorative trend to indoor grilles of all types, from room dividers to window screens.

Stoneware

Generic term for all types of nonporous, hard-clay pottery, but not porcelain. The earliest known stoneware was made in China before the seventh century and in Germany in the fifteenth. Gray and red were the common body colors, until an almost-white was introduced in the seventeenth century. Stoneware, being fired to a nonporous state, does not need a glaze, but some were used, especially salt glazing, to give the appearance of porcelain. Today, glazed and unglazed stoneware is made in both classical and modern designs.

Storage wall

A freestanding or built-in assemblage of closets, cabinets, chests or shelves to hold clothing and household paraphernalia. The modern, prefab, freestanding storage walls that can be put together in all manner of ways are either plug-ins, with poles and other components; stacking units; or wall-hung shelves and drawers that fit onto brackets attached to wall strips.

Strap hinge

A hinge with long, leaflike iron straps. The design derives from the Gothic period and is often used today for reproduction furniture and doors.

STRAP HINGE.

Strapwork

A decorative design of curving, interlacing bands, or straps, forming arabesque and rinceau patterns, found in Elizabethan carving and as a motif on fabrics and wallpapers.

Strasbourg faïence

Pottery for the table produced between 1721 and 1780 by a factory founded by the Hannong family in Strasbourg. The painted floral decorations, in light and bright colors, were charmingly executed and did much to influence the style of pottery in other European countries, as well as France. The initials P.H. (for Paul Hannong) can be found on the best of the pottery, made between 1739 and 1760.

Stretch fabrics

Woven or knit fabrics of natural or synthetic yarns, with or without foam backing, used for upholstery or slipcovers on contoured furniture.

Stretcher

The horizontal support that braces and links the legs of chairs and tables. Among the many types of stretchers are the simple H of Windsor chairs and the X, often found on Pembroke tables.

Strié

Woven fabric with streaks of different widths and lengths formed by varying tones in the warp thread, or a fabric printed to simulate this effect.

STENCIL design on window shades by Bishop & Lord, New York. Courtesy Window Shade Manufacturers Association.

STRETCH FABRICS on chairs and loveseat by Pierre Paulin. Interior design by Jack Lenor Larsen. Photographer: John T. Hill.

161

STRIP CARPET. Courtesy Patterson, Flynn & Johnson, Inc. Photographer: Arthur Avedon.

Mirror with **STUMPWORK** border, English, 17th century. Courtesy The Metropolitan Museum of Art. Gift of Mrs. Thomas J. Watson, 1939.

Strip carpet

Name given to twenty-seven-inch-wide Axminster-weave carpeting, commonly used on stairs or, sewn together, for wall-to-wall or large-sized carpets. Another type of strip carpet is the French hand-loomed moquette, a higher-style version with a small repeat pattern (such as the popular imitation-fur and woven-cane designs), made in two kinds of pile: the velouté, or cut pile, and the bouclé, or uncut loop pile.

Striping

Banding on furniture in which paint, rather than wood inlay, supplies the decorative flourish.

Student lamp

The midnight-oil lamp of the nineteenth century, back with us again, but electrified. The shade of tole or glass (usually green lined with white) is balanced by a fuel tank on an adjustable stem set in a brass base, often with a ring on top to make it portable.

Studio couch

A bed-cum-seating-piece consisting of a completely upholstered, armless and backless combination of box spring and mattress, with wedge-shaped bolsters to support the sitter's back. A studio couch may be designed to convert into a double bed or, by means of a second spring-and-mattress set stored underneath, twin beds.

Stumpwork

Silk-embroidered pictures in which the design is padded and stitched to appear in relief, like trapunto, or quilting. This domestic art was very fashionable in Restoration England and nineteenth-century America.

Stylized

Designed according to the rules of style rather than the vagaries of nature. A stylized floral design is characterized by a precise, formal pattern.

Sugi finish

A type of distressed finish for wood originated by the Japanese. The surface is charred, then rubbed with wire brushes to reveal the light wood beneath.

Suite

A complete set of matched furniture, at one time admirably conceived (as in the eighteenth century), but in our time more often an unimaginative and undesirable group of inexpensive furniture.

Sunburst

Adapted from the Egyptian solar disk and identified with Louis XIV, the Sun King, this radiant design motif appears on wallpapers and fabrics, or in the form of clocks, mirrors and plaques.

Sunderland ware

Mottled purple-and-pink Welsh lusterware of the nineteenth century, collected both in the original and reproductions made in Italy.

Supper table

Eighteenth-century circular mahogany tilt-top tripod table, similar to a tea table, but with divisions in the top for cups and saucers.

Surrealism

A twentieth-century school of subjective painters whose paintings explored the realms of fantasy and dreams and expressed, through strange and extravagant symbolisms, the works of the subconscious. Hieronymus Bosch was the fifteenth-century predecessor of present-day surrealists such as Salvador Dali and Giorgio di Chirico.

Surtout de table (*sewr-TOO duh tahbl*)

Table dais for the tureen, a large, raised centerpiece of faïence, porcelain or silver, often elaborately decorated and sometimes fitted with condiment dishes or sockets for candles.

Sutherland table

A nineteenth-century small, oblong table with drop leaves supported by swing-out legs. When the leaves are down, the top is a mere seven or eight inches wide.

Swag

A decoration representing hanging drapery, ribbons or garlands of fruit and flowers. A window may be crowned with a decorative fabric drape caught up at the ends.

Swan chair

A small contoured and upholstered chair designed by Arne Jacobsen with a steel swivel base and flaring swanlike arms.

Swan motif

Graceful, typical Directoire motif often found in chair backs and bedposts in the Italian version of the style and in some of Duncan Phyfe's furniture.

Swastika

An ancient, primitive good-luck symbol shaped like a cross with L-shaped arms of equal length at right angles to each other, all facing in the same direction, either to the right or left. The swastika occurs not only in the classic architecture of Greece and Rome, but also in the arts and crafts of widely separated races, such as rug designs of the Orientals and the American Indians.

Swatch

Decorating term for a small sample of fabric or other material or a paint color.

Swedish Modern

A style of simple modern furniture of the 1930's and early 1940's characterized by light woods, straightforward lines and absence of applied decoration. Much of Swedish Modern was based on Hepplewhite and French Empire pieces. *See also* Scandinavian Modern.

Swing leg

A hinged leg, similar to the gate leg but minus the lower stretcher, that supports the drop leaf of a table.

Swiss

A fine, sheer fabric of cotton (and now also synthetic fibers), plain, embroidered or patterned with dots, first made in Switzerland.

Swiss furniture

A high-style type of painted and carved peasant furniture, basically Alpine German with Italian overtones, much copied in this country during the 1930's and 1940's, especially for children's rooms.

Symmetrical balance

In decorating, there are two types of vertical balance for a wall—symmetrical and asymmetrical. Symmetrical balance is created by one or more subordinate groups of equal weight on either side of a central focal point—for instance, a pair of lamp tables on either side of a sofa or small picture groupings flanking a large oil painting.

SWAG.

SUNBURST motif on a desk.

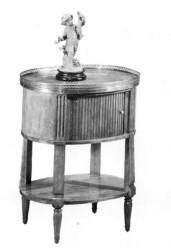

Table with **TAMBOUR** door.
Courtesy Baker Furniture, Inc.

Table à écran *(tahbl ah eh-KRAHN)*

A small writing, work or night table equipped with a framed screen of silk or printed paper that pulls up from a slot at the back, presumably to protect the candle flame from drafts.

Table chair

A sixteenth-century type of dual-purpose furniture that combines the functions of a table and a chair or settee. With the hinged top down, it is a table. When the top is up, it forms the back and the supports become the arms.

Tablet chair

Eighteenth-century American Windsor chair with one wide, flat arm that provides a writing surface, predecessor of the schoolroom chair.

Tabouret *(tah-boo-RAY)*

Drum-shaped stool or seat, without arms or back, used as a stand or end table.

Taffeta

A closely woven fabric of cotton, silk or synthetic fibers, smooth and lustrous on both sides. Mostly used in decorating for draperies, slipcovers, bedspreads and to upholster small chairs.

Taffeta glass

Also called carnival glass. Inexpensive iridescent glassware made to simulate costly Favrile.

Tallboy

English name for the double chest (chest-on-chest) or the single chest on a stand introduced in the seventeenth century. In America, it is called a highboy, from the French *haut bois* (high wood) .

Tall case clock

Generic term for any clock with a tall, narrow case which stands on the floor. Also known as a grandfather or grandmother clock, depending on the size, the grandfather naturally being the taller of the two. Tall case clocks were introduced in the seventeenth century. In the eighteenth century, after the invention of the pendulum, the cases became wider, beautifully paneled, and were embellished by cabinetmakers with elaborate inlays, marquetry and bronze appliqués. Today, copies of many of the eighteenth-century styles are available, as well as simple modern case clocks of brass, steel, wood and plastics.

Tambour

From the French *tambour* (drum) , a term applied to: (1) A round, drum-shaped table on a pedestal base. (2) Voile or muslin curtains embroidered on a round tambour frame. (3) A flexible door made of thin strips of wood glued to linen or duck that works either vertically as one piece or horizontally in pairs and runs in a grooved channel, following any straight, circular or serpentine shape. Tambour fronts are found on Louis XVI and Sheraton furniture and form the roll top of American nineteenth-century desks.

Tanagra figures

Small terra-cotta statuettes of dancing girls, boys at play and other genre figures unearthed in large numbers near Tanagra, Greece, where they had been buried in tombs. They are delicate and artistic and many have painted decorations.

Tapa cloth

A rough-textured cloth made from the bark of the mulberry tree and printed with geometric patterns in earth tones by natives in the islands of the South Pacific. As genuine tapa is not easy to come by, the designs have been copied on cotton prints and wallpapers.

Tapestry

Originally, a hand-woven wool, linen or silk fabric, an all-purpose decorative material that has been used as a wall hanging or for upholstery since the seventeenth century. Since the invention of the Jacquard loom most tapestry fabrics have been machine-made.

Tapestry carpet

Carpeting with a flat, ribbed surface woven by hand or machine on a velvet loom. Similar to but generally coarser than a wall tapestry.

Tatami

Mats of rice straw and rushes bound with cloth tape, measuring approximately three by six feet, the Japanese all-purpose floor and mattress covering, and a convenient unit for estimating the dimensions of a room—a four-tatami room would be twelve-by-twenty-four feet. Tatami are now being made in colors and patterns as well as the traditional neutral, natural tones, a possible concession to or adoption of Western taste.

Tavern table

A low rectangular table with simple square or turned legs, presumably made for dining and drinking in eighteenth- and nineteenth-century taverns, now used as a large end table or table desk.

Taylor, Michael, A.I.D.

San Francisco designer whose distinctive trademark has become his dramatic, often all-white interiors where simple fabrics such as cotton and corduroy and crude white "bean pot" lamps rub shoulders with French furniture and eighteenth-century porcelains.

TAPA CLOTH screen. Interior designer and photographer: Horst.

Modern **TAPESTRY** by Rosetta Larsen. Interior design by Rosamund Fischer, A.I.D. Photographer: Guerrero.

Tazza

A shallow ornamental bowl or dish with a short stem and foot, taken from a classic Greek design.

T-cushion

T-shaped chair or sofa seat cushion; the two projections fill in the space between the ends of the arms and the front edge of the seat.

Tea caddy and tea chest

The caddy was a small eighteenth-century gift box for tea, while the larger tea chest had two or more compartments for teas, a mixing glass and often a drawer for spoon or ladle. Often the tea chest was combined with the teapoy, a low tripod table on which the chest was placed for the mixing ritual. Although the shapes and styles varied with each designer, wood was the favored material and it was variously embellished with inlays or mountings of exotic woods, metals, ivory and mother-of-pearl.

Tea cart

Originally, a small table on casters designed in the seventeenth century to further the service of tea, a newly arrived form of refreshment. In the eighteenth century, the tea cart developed into a tiered cart or trolley, the forerunner of the modern serving cart.

Tea table

The introduction of tea to Europe in the seventeenth century begat a flock of small tables—stands for the teakettle, teapoys for the tea chest or caddy and a single table with pullout leaves to hold the tea service. While the tea ceremony as such is now nonexistent, the tables are still in evidence as occasional tables or latter-day coffee tables.

Tempera

A painting process in which powdered pigments are held together, or tempered, by egg yolks.

Templet

A pattern or contour drawing for a decoration or object, of identical size and shape.

Ten percenter

A trade term describing any decorator—usually not a professional—who works with the client on a basis of cost plus ten per cent.

Tent ceiling

A trompe l'oeil re-creation in fabric or wallpaper of the peaked, draped top of a campaign tent, an effect much in vogue during the French Empire.

Terra cotta

A clay varying in color from light buff to deep red, an ancient and excellent material for urns, figurines, reliefs, floor tiles and garden statuary.

Antique **TEA CADDIES AND CHESTS** in wood and tortoise shell. Courtesy Charles Hall, Inc., New York. Photographers: Taylor & Dull.

TEA TABLE. Courtesy Newcomb's Reproductions.

Terrazzo *(tehr-RAHT-zoh)*

Practical hard-surface material for floors and walls consisting of a mixture of chips of marble and cement, ground and highly polished.

Terry cloth

A lightweight, reversible cotton-pile fabric, either printed or in solid colors, that was once limited to toweling but is now recognized as a pretty, practical material for slipcovers and curtains, especially for beach houses.

Tertiary colors

Those made by mixing the primaries and secondaries. Only some can be mixed. The exceptions are red and green, blue and orange, yellow and purple, which neutralize each other and turn gray.

Tester

The wood canopy that tops a four-poster bed. It may be painted or carved and exposed to view or covered in fabric that matches the hangings.

Tête-à-tête *(tait-ah-tait)*

Polite conversation piece of the nineteenth century, the tête-à-tête is a small love seat for two or three, with seats facing in opposite directions.

Tête de nègre *(tait duh naygr')*

Literally, the head of a Negro, but in decoration, a deep black-brown color with a touch of purple.

Victorian rosewood **TETE-A-TETE**, American, mid-19th century. The Metropolitan Museum of Art. Gift of Mrs. Charles Reginald Leonard, 1957, in memory of Edgar Welch Leonard, Robert Jarvis Leonard and Charles Reginald Leonard.

TENT CEILING in a room designed by David Eugene Bell, A.I.D., of Bloomingdale's. Photographer: Guerrero.

TESTER beds in a room designed by Michael Taylor, A.I.D. Photographer: Fred Lyon.

Textural design

A design produced in the texture of carpets and fabrics by weaving.

Textural interest

Variations in surfaces throughout a room to add interest, particularly when the color scheme is monochromatic. Wood, brick, caning, fieldstone, grass cloth and split bamboo are much used.

Textured fabrics

Those with surface interest produced by the weaving design, mostly used for upholstery. In modern man-made textured fabrics like Banlon, Skyloft, Taslan and Tycora, the effect is engineered by putting the smooth, continuous filament yarns (acetate, nylon and rayon) through different processes—looping, curling, crimping or coiling—that alter their original form and give the fabric bulk and stretch without adding weight.

Thai silks

Silk fabrics from Thailand in a rainbow range of exotic colors, various weights and weaves, and solid colors or patterns—stripes, plaids, etc. Great favorites in home furnishings, either in the lighter weights, for pillow covers, or the heavy, for upholstery.

Theatrical gauze

A transparent, loosely woven cotton or linen fabric, mostly sized to give it body, that progressed from stage sets to interior decoration. Excellent for glass curtains, as it is inexpensive and comes in wide widths and a range of colors.

Thonet, Michael (1796–1871)

Designer who fathered bentwood furniture by perfecting a method of steaming birchwood and molding it into curving, fanciful shapes on rococo lines—the famous, much-copied Thonet rocker, for example.

Thonet furniture (*THO-nay*)

World-famous bentwood furniture—chairs, benches and tables—made by the Thonet family after the invention by Michael Thonet in 1830 of a softening and shaping process for wood. In 1849, Thonet, established as the most famous designer in Austria, began to manufacture inexpensive mass-produced furniture in his small workshop, later opening a factory. Despite the furniture's being widely copied

after the patent lapsed in 1869, the simplicity of the original designs has never lost its appeal and the designs have been adopted wholesale for contemporary interiors by designers and decorators. Genuine Thonet pieces always have the name burned inside the rim of the chair seat or a glued-on paper label that helps to identify them.

Bent-beechwood-and-cane rocking chair designed by Gebrüder **THONET**, 1860. Collection, The Museum of Modern Art, New York. Gift of Café Nicholson. Photographer: George Barrows.

Ticking

A heavy, strong cotton fabric woven in stripes, patterns or plain, and originally used to cover mattresses. Now its sturdiness and hard-wearing qualities have made it popular for wall coverings (applied like paper), slipcovers and curtains.

Tie and dye

A method of hand printing in which small areas of the fabric are tied with thread, then dipped into the various dye colors, thus forming the design. When the knot is tied tightly, the dye does not penetrate and leaves a ring of ground color. When it is tied loosely, the dye penetrates, giving a blurred effect.

Tieback

Cord, fabric bands or ornamental devices for holding straight curtains back at the sides.

Tiffany glass

Fantastically colored iridescent glass produced by Louis Comfort Tiffany at the turn of the century;

also called Favrile, meaning handmade. Recently returned to fashion, the most-collected Tiffany glass pieces are the vases, distinguished by unusual flowerlike forms with surfaces of swirling color; the fancifully designed leaded glass shades and table lamps; and the glass tiles in exotic patterns derived from the Near East.

Three versions of a **TORCHERE.**

Tint

A color that has been mixed with white to produce a light value. All pastel colors are tints.

Toile de Jouy *(twahl duh zhoo-EE)*

Toile is the euphonious French word for a finely woven cotton fabric, and a toile de Jouy is the same fabric printed with classical scenes, usually in one color on a white or off-white ground, from the French town of Jouy. These charming cotton prints were introduced in the eighteenth century and have been favorites ever since.

Toilet mirror

A small, adjustable mirror on a stand, often with a drawer or two below, placed on a chest or table to form a rudimentary kind of dressing table, a device popular since the seventeenth century.

Tole

Shaped and painted tin or other metalware used for decorative objects like lamps, chandeliers, trays, occasional tables, boxes.

Tongue and groove

A type of joint used for flooring, paneled walls and doors. A continuous narrow projection, or tongue, on one board fits into a rabbet or groove, on another. Plywood panels often simulate tongue-and-groove construction.

Topiary

The gardener's art of trimming and training trees and shrubs into unnatural but entertaining shapes —birds, animals, people, geometric forms. This delightful conceit has been practiced since the sixteenth century. Topiary designs printed on fabrics and wallpapers now transplant this fanciful foolery indoors.

Torchère *(tohr-SHEHR)*

A portable stand for lights, originally a stand to hold a great candelabrum in France.

TOILE DE JOUY curtains and shade in a room designed by James H. Granville. Courtesy Window Shade Manufacturers Association.

Tortoise shell

The richly colored and beautifully marked shell from sea turtles, such as the hawksbill, used in decoration as a veneer or inlay material. In Renaissance Italy mirror frames, boxes and tables were covered with tortoise-shell veneers, and the work of André Charles Boulle, cabinetmaker of the Louis XIV period, is noted for exquisite marquetry of tortoise shell and brass. Scarce and expensive today, real tortoise shell has been largely supplanted by imitations in paint, plastic and paper.

Traditional

Comprehensive term for period, rather than modern, design in decoration.

Transfer

See Decalcomania.

Transition

A smooth progression from one thing to another that constitutes an important aspect of decoration because of open planning. An entrance hall may be decorated in a way that provides a transition from the decoration of the living room to that of the dining room.

Transitional furniture

Furniture that blends the elements of two styles, one established, one emerging, as, for instance, French Régence, the design bridge between the massive grandeur of Louis XIV and the more feminine persuasion of Louis XV.

Trapunto

A form of quilting that raises a pattern on a plain fabric, mostly used on the loose back pillows of upholstered furniture. The design is outlined by machine-stitching, then filled in from behind.

Travertine

A light-beige limestone from Italy with a surface furrowed by imperfections, a popular textural material for flooring, walls and table tops. Also reproduced in vinyl versions.

Tray ceiling

A ceiling with symmetrically sloping sides that looks rather like an inverted tray, a device that makes a room look loftier and abets the circulation of air.

Tray stand

Eighteenth-century English small tripod table, less than two feet high, with a circular top notched to take the silver tray for tea and coffee services. Today's tray stands, folding or stationary, are made in many shapes, styles and sizes.

Treen work

Turned and shaped wooden objects, primarily nineteenth century, made either by hand or on a lathe. The roster includes boxes, bowls, urns and epergnes.

Tree-of-life pattern

One of the most ancient and enduring of decorative patterns, a stylized depiction of a spreading tree replete with flowers and fruit, birds and small animals. The design originated in Assyria, was copied by the Persians, traveled to India and from there to Elizabethan England in the painted India cottons, or palampores. These, in turn, were imitated in English crewelwork and left a lasting effect on English textile and wallpaper patterns.

Trefoil

Gothic three-leaf-clover motif usually found in architecture and on furniture relating to that style, also embossed on leather or printed on paper and fabric.

Treillage (tray-YAHZH)

French latticework, no simple garden trellis but artful arrangements of thin, crisscrossed wood slats nailed to a frame that had its finest showing, both indoors and out, in the eighteenth century. We simulate the patterns of treillage in plastic or print them on wallpapers and fabrics.

Trestle table

Early, primitive form of dining table composed of boards or planks laid across trestles, or horses, and removed when not in use. In the Middle Ages, the base was attached to the top and, in this form, the trestle table evolved into a basic piece of dining furniture.

Tricoteuse (tree-koh-TUHZ)

Small French sewing table of the Louis XVI and later periods.

TREILLAGE screens in a room designed by Joan Lerrick. Photographer: Grigsby.

Trictrac table

Dual-purpose piece of seventeenth-century furniture. When the top was removed, a backgammon board, sometimes with a checkerboard on the reverse side, came into play.

Trim

In architecture, the interior woodwork of a room—door and window frames, chair rails, cornices, etc. In decoration, a finishing touch added to upholstery and other furnishings, such as the fringe on a pillow or lamp shade or the rickrack on curtains.

Tripod table

A pedestal table with three legs that flare out at the base. The earliest examples are Greek and Roman, generally of metal. The varied Georgian designs were interpreted in wood and metal. Current versions are made in many styles and materials from crude wrought iron to sleek chrome-plated steel.

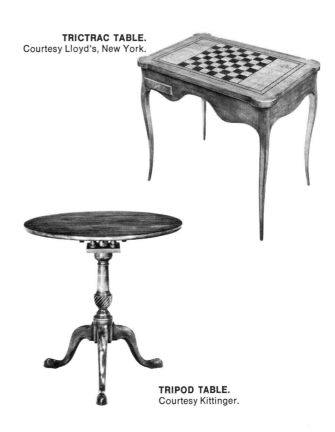

TRICTRAC TABLE.
Courtesy Lloyd's, New York.

TRIPOD TABLE.
Courtesy Kittinger.

171

TROMPE L'OEIL door, painted to simulate a marble niche. Courtesy Judith Garden. Photographer: Hans Van Nes.

TROPHY PANELS on walls of a French alcove, c. 1720–1730. The Metropolitan Museum of Art. Gift of J. Pierpont Morgan, 1907.

Triptych

The three parts implied by the term may refer to a hinged mirror or screen or to paneled altarpieces that came to be used decoratively.

Trivet

A three- or four-legged metal stand or table originally used for warming dishes by the fire, now promoted to plant stand or occasional table.

Trompe l'oeil (*trohmp l'oiy*)

In translation from the French, "to fool the eye," this expression is applied to an ancient art form that does just that—makes things appear other than they are. Paint or paper can simulate dimension, architecture or a view. Today, wallpapers ape marble, wood, tile, paneling and even three-dimensional objects.

Trophy panel

Decorative wall panel sporting painted, carved or inlaid compositions of all manner of symbols of victory and success, from shields, spears and laurel wreaths to musical instruments, fruit and flowers.

Trumeau (*trew-MOH*)

French combination mirror with a painting or carving over it. In the Louis XV and XVI periods, this was built into the overmantel or into the paneling between two windows. Today, it is more often seen as a hanging mirror.

Trundle bed

Early, ingenious form of spacesaving furniture, a low bed on casters designed in the Middle Ages to roll or trundle under a full-sized bed when it was not being used. This was a popular form of sleep-

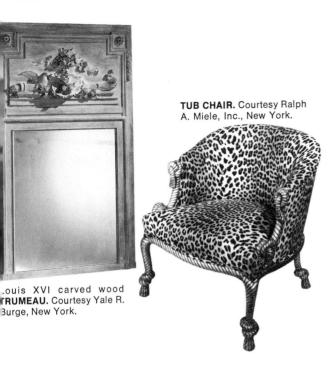

TUB CHAIR. Courtesy Ralph A. Miele, Inc., New York.

Louis XVI carved wood **TRUMEAU.** Courtesy Yale R. Burge, New York.

Tucker

American bone-china imitation of Sèvres, made by European workers in the Philadelphia factory of William Ellis Tucker from 1825 to 1837, and now rare enough to rate as a collectors' item. In addition to the usual flowers and gilding, the decorations included portraits of famous Americans, such as Washington, and monograms and coats of arms.

Tudor rose

Decorative motif of the English Renaissance, designed to symbolize the alliance, through the marriage of Elizabeth of York and Henry of Lancaster, of the warring houses of York and Lancaster, and the end of the War of the Roses. The open five-petaled flower is conventionally treated and centered by a smaller inset rose. Throughout the centuries, English ceilings, tapestries and furniture have displayed the Tudor rose.

ing arrangement in small colonial and early American homes, especially for children. A modern version is the hideaway bed.

Tub chair

An upholstered easy chair of eighteenth-century English origin with a high, round back and wings, similar to the curving contours of a tub.

Tubular furniture

Sleek, linear furniture with continuous tubular-steel framing, a twentieth-century concept introduced in 1925 by Marcel Breuer, who designed an armchair with a chrome-plated tubular-steel frame and two supports instead of the conventional four.

Tufting

In upholstery, an indented surface pattern produced by sewing a series of self-covered buttons into the fabric. In fabrics, stitchery in rounds, squares or diamonds that form a puffed-up design, also called quilting. In floor coverings, carpeting made on a tufting machine with pile, cut or uncut, clipped at different heights to give a sculptured look to the surface.

Turkey work

Handmade fabric that ingeniously imitated, in an inexpensive way, the appearance of Oriental pile rugs. To achieve the effect, worsted yarns were pulled through a coarse cloth, knotted and clipped.

TUFTING on a sofa. Courtesy Kittinger.

173

Turkish influence

Voluptuous trend in decorating epitomized by the Turkish corner of the late nineteenth and early twentieth centuries, a cushiony nook in imitation of the rugs and low divans on which the Turks lolled. Extensions of this fashion were the velour or leather Turkish chairs and sofas, low and luxuriously padded, usually associated with men's clubs. The Joe Colombo "golf sofa" in supple glove leather is a contemporary version of the Turkish look.

Turning

Any wood piece turned and shaped on a lathe—such as a spindle, chair leg, table pedestal or stair balustrade.

Turquoise (tewr-KWAHZ)

A type of backless Louis XV day bed or divan, which takes its name from an old French word for Turkish. The seat is padded with a flat cushion and the two high ends with round bolsters. The turquoise was usually placed lengthwise to the wall.

Tussah silk

The coarse, tough, beige-colored silk produced by the wild Asiatic silkworm, the raw material from which pongee, shantung, shiki silk and nubby, loosely woven tussah are made.

Tuxedo sofa

An American style of sofa with back and arms of the same height, and either completely upholstered or with an exposed wood frame.

Tweed

Initially, a rough wool fabric from Scotland. Now a generic term for wool and synthetic fabrics made in plain, twill or herringbone-twill weaves to resemble the original cloth.

Twin-size bed

The standard size of this single bed is thirty-nine inches wide by seventy-five inches long, but there are many variations in width, from a strait-jacket thirty inches to an opulent forty-five.

Twist carpet

Carpet of uncut pile composed of loops of twisted yarn.

Twist turning

A type of spiral turning used since the seventeenth century in cabinetwork and for decorative columns. The single twist resembles a twisted rope; the double twist, two ropes twined together. Occasionally both were combined on the same piece of furniture.

TURKISH INFLUENCE in the Waldorf-Astoria Hotel, 1902. Courtesy The Bettmann Archive.

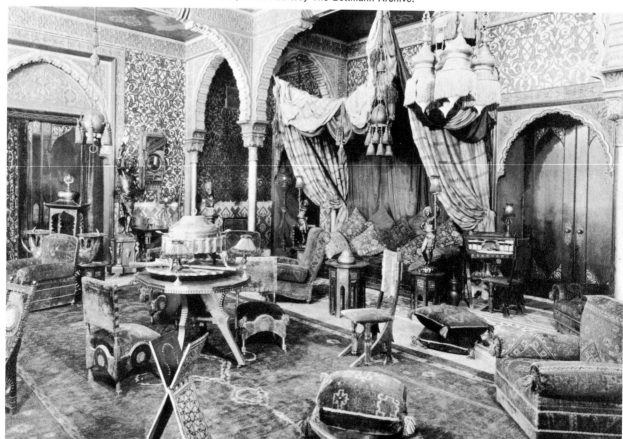

UPHOLSTERED FURNITURE of the 18th century: reproduction of a Louis XV canapé covered in a contemporary fabric. Courtesy Yale R. Burge, New York.

Umber

Earth-brown pigment used in the raw state to "gray" white paint to an antique shade or to "antique" a painted furniture finish. When umber is "burnt," or calcined, it takes on a reddish cast.

Underglaze

China decoration or color applied under the glaze.

Unify

To blend visually disparate or unrelated furnishings in a room through the use of a single color family or fabric.

Upholstered furniture

Covering the bare bones of furniture with stuffing and fabric is a concession to comfort that has been practiced since the seventeenth century, although the materials have varied. When the domestic arts flourished, the covering often took the form of some type of needlework—tapestry, crewel, turkey work. In the eighteenth century, the range of coverings was wide—cut velvet, brocade, damask, silk of all types, chintz and other printed cottons and linens, leather and horsehair—and the stuffings were of down and hair. Today, although the upholstering of furniture has been advanced and improved by synthetic fibers, protective finishes and new types of padding, the basic construction remains the same.

Upstyled

Professional decorator jargon for an old design re-interpreted in contemporary terms and so brought up to date.

Urethane laminates

Fabrics backed with a thin layer of urethane foam, a soft, dense, weightless synthetic that gives body and has excellent insulating and soundproofing qualities. Widely used for wall coverings.

Used furniture

Strictly secondhand furniture. Not to be confused with antiques, even though some self-styled antique dealers have developed a knack for making anything old, if not valuable, look chic.

Utrecht velvet

A mohair upholstery velvet, with a mottled surface created by crushing part of the pile under pressure.

UPSTYLED and overscaled version of flamestitch in fabric. Courtesy Yale R. Burge, New York.

VEUVE PERRIN plate with openwork border, Marseilles; French, c. 1750-1770. The Metropolitan Museum of Art. Gift of Charles A. Dunlap, 1949.

Vaisselier *(vay-seh-l'YEH)*

The French version of the Welsh dresser; a low cabinet topped by open shelves with racks and guardrails for storage and display of china.

Valance

Shaped wood, stamped or pierced metal or draped, gathered or straight fabric used across the top of a drapery treatment or a canopied bed.

Vallauris *(vahl-loh-REE)*

Provencal pottery made in the town of Vallauris since the nineteenth century. Best-known today are the provincial designs of Susanne and Georges Ramie and the colorful vases, tiles and plates designed by Picasso.

Vargueño *(vahr-GAYN-yoh)*

A Spanish drop-front cabinet desk of the sixteenth, seventeenth and eighteenth centuries which was set on a separate base, either a table or chest. The cabinet contains many drawers and has handles on the sides for transporting. The pieces could be used together or independently.

Velour

A general classification covering most upholstery-weight pile fabrics, whether of cotton, linen, silk or synthetic yarns.

Velvet

A general term for all warp pile fabrics except terry cloth; plush and velveteen.

Velvet carpet

A smooth, tightly woven velvetlike pile carpet similar to Wilton.

Veneer

A thin layer of decorative wood applied to solid wood to give it the face value of a fancy grain, or a similar facing of ivory, pearl, tortoise shell or other decorative material.

VAISSELIER. Courtesy Brunovan, Inc., New York.

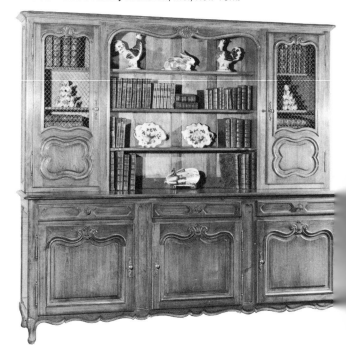

Venetian

An eighteenth-century style developed from the rococo by the Venetians, who had a high regard for the ornamental and created fancifully painted furniture with theatrical profiles.

Venetian blind

One of the earliest—and still one of the most effective—ways to control light at a window. Introduced from the East to Venice by Marco Polo, it was adopted all over the world. Examples can be seen in the Williamsburg restoration. A simple construction of narrow or wide slats of wood, metal or plastic strung on tapes or wires, the blinds can work either horizontally or vertically (the latter are usually known as vertical blinds). Modern versions of the Venetian blind are brilliantly colored or have fabric laminated to the slats.

Venetian glass

Hand-blown Italian glassware noted for its delicacy, decoration and exquisite shapes. It has been made since the thirteenth century, mostly on the island of Murano, near Venice, in a constantly growing range of objects—from chandeliers to goblets and ashtrays—some in designs and shapes that have remained unchanged for centuries, others in contemporary designs and brilliant colors.

VENETIAN two-door encoignure, early 18th century. Courtesy Victoria and Albert Museum, London. Crown copyright.

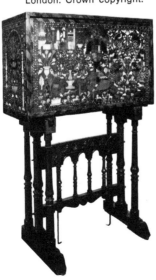

VARGUENO. Courtesy Victoria and Albert Museum, London. Crown copyright.

Venetian velvet

Cut silk velvet with the design in slight relief, originated in Venice during the fourteenth century and still extremely popular.

Vermeil *(vehr-MAY)*

Gilded silver or bronze developed originally as a substitute for solid gold. To replenish their depleted treasuries, the spendthrift kings of France confiscated gold services and objects from their unlucky subjects—hence the demand for vermeil, which reproduced the look of gold at a fraction of the cost without sacrificing quality or detail. Now valued in its own right as an elegant, luxurious step up from silver.

Vernis Martin *(vehr-NEE mahr-TAN)*

A varnish finish of great brilliance and depth, but less durable than lacquer, attributed to the Martin brothers during the reign of Louis XV. Oriental lacquer was the inspiration.

Verrier *(veh-r'YEH)*

A set of open, hanging wall shelves for drinking glasses, now more often used like a whatnot to display small objects. Also the French name for the monteith bowl.

Veuve Perrin *(vuhv per-RAN)*

Eighteenth-century Marseilles faïence bearing the delightful designs and initials (v.p.) of the widow of Claude Perrin. Although some of her decorations were in the manner of Pillement, it is those she conceived herself—fruits and flowers painted on a white or yellow ground with a light insouciance and freedom—that are the most appealing. The work of the Veuve Perrin has been much copied, even to the signature.

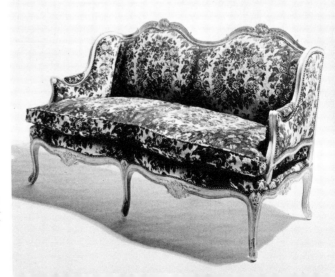

Canapé upholstered in **VENETIAN VELVET.** Courtesy Yale R. Burge, New York.

Victorian

Nineteenth-century mixed-up design period that coincided with—and is named for—the lengthy reign of Queen Victoria of England. The Victorian period was mainly noted for a tendency to come out in a positive rash of styles. Revivals were rampant—everything from Gothic to rococo. Most of the furniture, developed from English and American Empire designs, was heavy in scale and excessively ornamented. Soft curves were combined with straight lines and there was a profusion of exotic carving, turning and inlays of brass, wood and mother-of-pearl. Black walnut and rosewood predominated, with smaller pieces lacquered or made of papier-mâché. Although some of the furniture had a quaint charm, much of it was clumsy and devoid of any design merit. Exceptions are the fine work of Belter in this country and the later, more functional pieces of the English designer William Morris. Because it is now considered amusing and "camp," Victorian is having a considerable revival (and a corresponding increase in value), mainly as accent pieces to add an offbeat quality to a contemporary room. *See also* Belter; Eastlake; Morris, William; Steamboat Gothic; Victorian Cottage; Victorian Gothic; Victorian Jacobean; Victorian Louis XVI; Victorian Oriental; Victorian Renaissance; Victorian Rococo.

Victorian Cottage

The simple turned and painted country-style furniture popular from the 1850's to the 1880's. Most favored was the spool-turned type, based on the Elizabethan spiral turning and dubbed "Jenny Lind," for the famous Swedish Nightingale who happened to be touring the U.S. during its vogue. Mostly, the furniture was plainly constructed of inexpensive softwoods, then painted or enameled in colors, often with stenciling, in the manner of the Hitchcock chair. Among the spool-turned pieces were beds, whatnots, small tables and chairs, washstands and towel racks.

Victorian Gothic

Probably the most distinctive and easily recognized of the Victorian styles, the Gothic revival in furniture followed the architecture of 1830 to 1850. Chair backs, mirrors, hallstands and the head- and footboards of beds displayed the unmistakable shape of the Gothic arch, embellished with quatrefoil and trefoil motifs, rosettes and crockets. Because the Victorian version was less ponderous and massive than its ancestors, it is regarded as perfectly usable today—in moderation.

Victorian Jacobean

A style of simple, angular furniture in walnut and oak with decorative incising drawn from Charles Locke Eastlake's book *Hints on Household Taste*. Parlor, bedroom and dining-room sets ornamented with flowers cut in outline and gingerbread edgings on shelves and aprons were produced en masse from the 1870's until 1900. Much of this furniture has ended up in so-called antique shops selling secondhand discards from American attics, and fetches a much higher price than it did originally.

Victorian Louis XVI

After Victorian Rococo, furniture in the 1860's took a turn for the classical persuasion of Louis XVI, with its more delicate line and sparer ornamentation. The interpretation was unfortunately on the heavy-handed side and today is the least sought after of the Victorian emulations.

Victorian Oriental

A style that shows strong influences of the Far and Near East, popular in the late nineteenth century. Lacquer, Chinese fretwork, bamboo and bamboo-turned wood pieces were much in favor, and Turkish corners, the vogue of the day, were opulently outfitted with deep, tufted, upholstered ottomans and low octagonal tables with Moorish-arched bases. Farfetched enough to be fun, these pieces now bring a touch of Victorian camp to contemporary rooms.

Victorian Renaissance

The most grandiose, massive and unfelicitous of the Victorian styles, based on the heavier, more ornate pieces of the Italian Renaissance and mass-produced from 1855 to 1875. The rebirth of the rectilinear line was seen in the enormous sideboards and the high-rising headboards on beds. The style is characterized also by a profusion of marble tops and carving, classic motifs mixed with flowers and fruit.

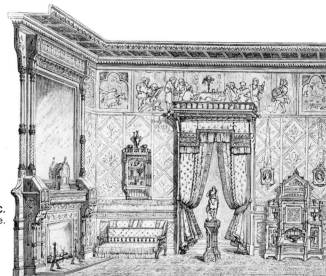

Drawing room in **VICTORIAN GOTHIC.**
Courtesy The Bettmann Archive.

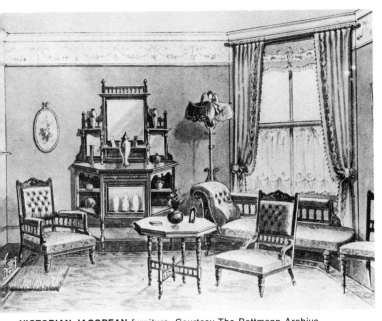

VICTORIAN JACOBEAN furniture. Courtesy The Bettmann Archive.

VICTORIAN RENAISSANCE room, c. 1870.
Courtesy The Bettmann Archive.

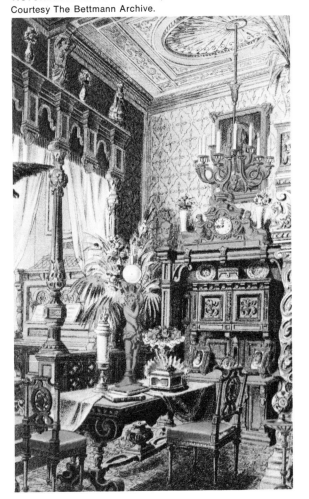

VICTORIAN LOUIS XVI room.
Courtesy The Bettmann Archive.

Morning room in **VICTORIAN ORIENTAL.** Courtesy The Bettmann Archive.

Victorian Rococo

The lightest and most delightful of the Victorian styles, based on Louis XV and displaying the characteristic curves and scrolls and the cabriole leg. During the years it held sway, from about 1840 to 1860, pieces custom-made by such worthy cabinetmakers as John Belter of New York City, Elijah Galusha of Troy and François Seignouret and Prudent Mallard of New Orleans were dispatched all over the country. Among the typical pieces were a seating duo dubbed the husband-and-wife, a pair of chairs with oval backs on which carving was combined with deep finger molding. The feminine version was armless and low-seated for sewing and similar domestic pursuits; the male version had arms and was larger and higher. In today's reappraisal, Victorian Rococo is given the highest rating for value and usability.

Vieux Paris (v'yuh pah-REE)

A heavy nineteenth-century imitation of eighteenth-century porcelains. Despite the crude craftsmanship, it is collected for the decorative quality of its colors, floral patterns and painted scenes.

Vinyl fabrics

Textiles that have been either fused or coated with vinyl plastic to give them greater practicality and possibilities. For instance, printed cottons fused with vinyl make strong, washable window shades and pillow covers. As the coated fabrics are opaque, designs are printed, embossed or stitched on afterward.

Vitrine (vee-TREEN)

A combination display and storage piece for china and objets d'art. The French word describes a cabinet with glass doors and sometimes a glass top and sides as well.

VOLUTE on a Greek column, and a chair back.

Volute

The three-dimensional spiral scroll of the Greek Ionic order, often found in furniture decoration and drawer pulls.

Voyeuse (voh-ah-YUHZ)

A type of eighteenth-century French upholstered back-to-front chair, designed for onlookers at card games and other activities. The narrow flaring back ends in a padded crest rail which the sitter faces and uses as an armrest. Similar to the cockfight chair.

VICTORIAN ROCOCO parlor of 1854. Courtesy The Bettmann Archive.

English **WAINSCOT CHAIR,** 17th century, James I period. The Metropolitan Museum of Art, The Sylmaris Collection. Gift of George Coe Graves, 1923.

Wainscot

Geometrically designed wall paneling that stops short of the ceiling, sometimes terminated by a plate rail. Popular in Tudor and Victorian homes.

Wainscot chair

Panel-back chair common in England, France and America during the sixteenth and seventeenth centuries. The name probably derives from the resemblance of the high, carved or inlaid back to a piece of wainscot paneling. The seat was generally high also, necessitating the use of a footstool.

Wale

The ribs, cord or raised portions in woven fabrics such as corduroy; the successive series of loops running lengthwise in a knitted fabric such as tricot.

Wall bracket

A wall-hung shelf or ledge designed to hold a clock, bust, vase, statue or candlestick. Different versions, in carved and gilded wood, porcelain, faïence, etc., have been current since the seventeenth century. Modern cantilevered brackets with hidden supports often display a prized collection of bronzes or porcelains.

Wall covering

A term that encompasses all the materials other than paper used on walls—tile, grass cloth, adhesive-backed felt, paper-backed fabric, vinyl. Fabric wall coverings come either by the roll or by the yard.

Wall fountain

English name for the French lavabo or wall hand basin, usually made of copper, pewter or pottery and often very decorative. Wall fountains have two sections, a water container with a spigot, and a basin, or catch pan, below. Spanish wall fountains often had their own tiled niche. French lavaboes were hung on the wall or on a tall, narrow cupboard stand in the dining room. Today, they are usually filled with plants or flowers.

Wall grouping

A studied arrangement of pictures and objects over a piece of furniture or a fireplace, or spaced to fill a single wall area.

WALL GROUPING designed by Karl Mann for Bloomingdale's.

Wall pocket

A wall-hung vase of porcelain, faïence, glass, plastic, wood or metal, with one flat side.

Wall treatment

Portmanteau term covering everything designed to enhance a plain wall—paint, paper, fabric, a mural or mirror, or a grouping of accessories, art and objects.

Wallpaper

A decorative artifice developed in seventeenth-century France, partly inspired by the vogue for imported Chinese hand-painted papers and partly as an inexpensive substitute for tapestry, silk and velvet wall hangings. The earliest wallpapers were the illuminated and Domino papers made in sheet form in England and France during the late sixteenth century. By the eighteenth century, French papers were block-printed in patterns to match the hand-painted and printed cotton toiles of the day, and the method was widely adopted throughout Europe and America as a less costly supplement to flock papers, hand-painted papers and silk-screened papers. The nineteenth century ushered in metal roller printing and mass production of wallpapers. Most wallpapers today are priced by the single roll of eight yards, which covers approximately thirty-six square feet, but are sold in double rolls only.

Wardrobe

A portable closet for clothes; an armoire.

Warm colors

The red and yellow half of the spectrum. The sun and flame colors, also known as advancing colors. In decorating, reds, yellows and oranges have an eye-catching quality that can make walls seem closer, space smaller, small objects more noticeable and sunless rooms more inviting.

Warp

Yarns running lengthwise, paralleling the selvage, and interwoven with the woof, or filling, yarns.

Warp print

A fabric, generally cretonne, woven with plain filling on a printed warp that gives the surface a shadowy, watered look.

Washstand

Unplumbed predecessor of the bathroom lavatory, a bedroom cabinet or small table developed during the eighteenth century to hold the basin, ewer and other aids to cleanliness. Today, the marble-topped nineteenth-century American washstands are much in demand as end tables or night stands while the humbler, turned-wood types, which generally had a hole for the basin, are apt to end up as planters.

Waterford

Fine-quality cut glass produced since the eighteenth century in Waterford, Ireland, and world-renowned for exquisite chandeliers, sconces and goblets.

Watteau, Jean-Antoine (1684–1721)

French decorative artist and court painter famous for his delicately amorous pastoral scenes painted on ceilings and wall panels and interpreted in tapestries. Many of his paintings were copied on wallpaper panels, toiles, and Meissen, Sèvres, Berlin and Vienna porcelains.

Webbing

Strips of burlap, linen or plastic interlaced to support the springs and cushions in upholstery construction. In chairs and sofas of the skeletal type, such as outdoor furniture, plastic, nylon or leather webbing is used decoratively to form the exposed seat and back.

Wedgwood

One of the greatest of the English potteries. The name and the fame come from the eighteenth-century genius Josiah Wedgwood. Fired by the discoveries at Pompeii and Herculaneum, Wedgwood took the forms of classical antiquity as his inspiration for pottery that in style and spirit echoed the interior designs and furniture of Robert Adam. Wedgwood's jasper ware, with its beautiful ground colors and classical motifs, appeared not only in decorative objects but also as panels on walls and mantels and as plaques on Sheraton and Hepplewhite furniture. The best-known products of the Wedgwood factory—jasper ware, basaltware and queen's ware—are still made today as table services, lamp bases, urns and vases, cigarette boxes, cups and ashtrays.

Wegner, Hans

Furniture designer best-known for his 1949 classic, unpretentious chair of teak, oak and cane.

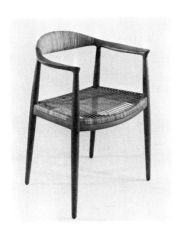

Armchair by **HANS WEGNER,** wood and cane, 1949. Collection, The Museum of Modern Art, New York. Gift of Georg Jensen, Inc. Photographer: George Barrows.

WELSH DRESSER. Courtesy Caledonian, Inc., Winnetka, Illinois.

Welsh dresser

A cabinet that begins as an enclosed storage piece, which is the base, and develops into a set-back upper part composed of open shelves.

Welting

Lengths of cotton cord covered in matching or contrasting material sewn between upholstery and slip-cover seams to give them strength and a more finished appearance. Single welting is generally used on all-upholstered pieces, double on backs and frames of exposed wood pieces. Also called piping.

Wet Look

Decorating innovation of the 1960's based on the current fashion for shiny, slick, reflecting surfaces—foil, patent leather, mirror, glass, chrome, steel, high-gloss lacquer and plastics—carried out in contemporary furniture, fabrics and accessories.

Whatnot

Amusingly dubbed English version of the French étagère, tiers of open shelves supported by turned posts on which curio collectors of the late eighteenth and nineteenth centuries displayed their bibelots and bric-a-brac.

Wheel-back chair

Chair with a circular or oval back resembling a wheel with spokes radiating from a decorative center plaque, or boss. Typical of Adam and Hepplewhite chairs, but also found on Windsors.

Wicker

Generic term for an airy, woven furniture material of various natural or synthetic fibers like willow, reed, rattan or twisted paper.

WICKER furniture. Courtesy The McGuire Company.

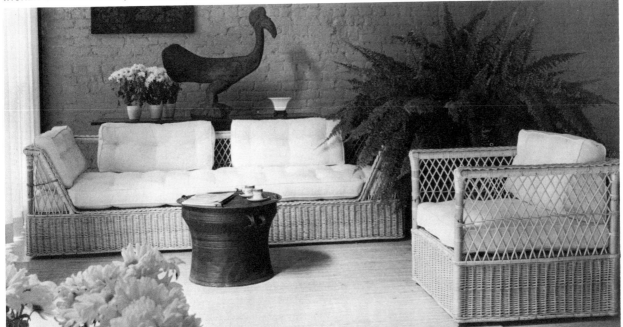

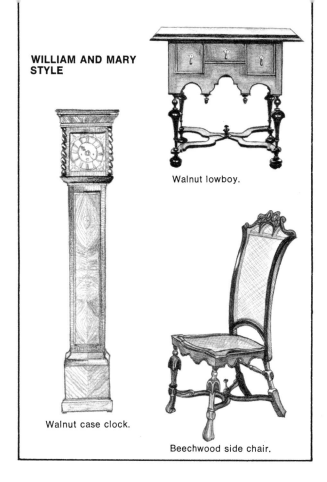

WILLIAM AND MARY STYLE

Walnut lowboy.

Walnut case clock.

Beechwood side chair.

Willard clocks

Case, mantel or wall clocks made, signed and usually dated by any of the three members of the Willard family of Massachusetts—Benjamin, who set up a factory in Grafton in 1765; Aaron, who worked in Boston after 1790; and Simon, who invented and patented the banjo clock in Roxbury around 1802.

William and Mary (1689–1702)

A style and period of English furniture made during the reign of Mary Stuart and her Dutch husband, William of Orange. Cabinetmakers from Flanders, Holland and France were influenced by the baroque richness of Louis XIV, while England's Christopher Wren worked in the more chaste Italian image. The melding of the two schools produced a distinctive type of furniture that gained in comfort what it lacked in grandeur, a lighter, simpler scale and style attuned to the new domesticity of smaller, more intimate rooms. Legs were turned and braced with serpentine stretchers; the Dutch club foot and scroll leg that foreshadowed the Queen Anne cabriole leg was introduced; chairs were padded and often covered with needlepoint. Walnut replaced the sturdy English oak; veneering and marquetry of exotic woods, lacquer and japan-

ning gave a new elegance to the domestic interior. Today, authentic pieces of this style are hard to come by, but many nineteenth-century copies can be found.

Willow pattern

Scenic design derived from the Chinese Canton ware and depicted in every shade of blue on English pottery from the seventeenth century on. The pattern, a profusion of houses, trees, bridges and mandarins "in defiance of all laws of perspective," is still current not only on china imported from Japan but on fabric and wallpaper as well.

Wilton

Carpet of natural or synthetic fibers woven on a Jacquard loom that takes both its name and nature from a fine type of wool carpet made in Wilton, England, in the eighteenth century.

Window seat

Originally, a backless bench with two high ends designed for the window embrasure, now any built-in structure with a cushioned or padded top built into a bay or bow window to serve as a seat and, if necessary, to conceal a radiator or air conditioner or provide storage space.

Window treatment

Any decorative device to cover, accentuate, disguise or improve a window—draperies, glass curtains, ruffled tiebacks, casement or café curtains, roller shades, shutters, screens, shoji panels, Venetian blinds, Roman or Austrian shades, bamboo or woven blinds, grilles—or to top it off—valances, lambrequins, canopies, cornices, pelmets.

Giltwood **WINDOW SEAT,** English, c. 1770–1780. The Metropolitan Museum of Art. Purchase, 1957. Morris Loeb Gift.

Tie-back draperies and glass curtains. Designer: Jack Steinberg, The Unicorn. Photographer: Montgomery-Lisanti, Inc.

Café curtains and matching valance with striped shades. Designer: Mrs. Henry Callahan. Photographer: Alexandre Georges.

WINDOW TREATMENTS

Striped roller shades. Designer: Sue Morris. Courtesy Window Shade Manufacturers Association.

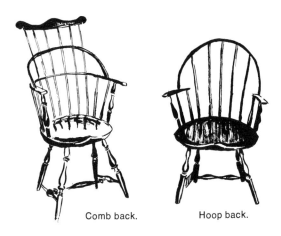

Comb back. Hoop back.

Windsor chair

Named for Windsor Castle in England and introduced during the reign of Queen Anne, Windsor chairs achieved their greatest prominence and most graceful styling in America from 1725 to 1800. The original chairs were made by wheelwrights who laced the bentwood back frames with spindles for support and pegged legs into saddle-shaped seats. Variations in shape include the hoop, the comb, the fan, the bow, the braced and the rocker. Still a favorite style and much reproduced.

Wine cooler

A copper-lined tub, often mounted on a pedestal or legs, originally intended to chill wine, but now more often seen holding house plants.

Wing chair

Sheltering side pieces, or "wings," add to the comfort of this large upholstered chair, which may have evolved from the eighteenth-century French "confessional" or a similar English chair. According to the style, the wings may be upholstered or of wood.

Witch ball

These hollow, colored glass balls were once hung in windows to ward off the evil eye, but are now pure decoration. In small sizes, they are tied to fishermen's nets as floats.

Womb chair

Eero Saarinen's 1946 design for Knoll Associates, an upholstery-covered chair with a molded plastic frame curved to envelop and conform to the body.

Wood tones

The hues of the various woods—teak, walnut, mahogany, etc.—and their matchmates reproduced in stains, paints, plastics and ceramics. Wood tones play such a dominant part in room schemes today that they have come to be regarded as colors in their own right.

Woodcut

A printed impression made with black or colored inks on paper or fabric from a design cut in intaglio or relief on a wood block.

Woof

Also called weft or filling. Yarns running from selvage to selvage at right angles to the warp yarns.

Wool suede

A nonwoven wool fabric made by The Felters Company. Because of its resistance to flame and dirt and its excellent insulating and sound-controlling qualities, it is widely used for draperies, upholstery and as a wall covering.

Worcester

English porcelain similar to Derby and Chelsea, made continuously since 1751, although after the visit of George III in 1788, the factory and the ware were officially designated Royal Worcester. Among the more valuable and notable of the early Worcester patterns are the blue-and-white Dr. Wall and the signed or initialed pieces by Robert Hancock, who introduced transfer printing to the factory in 1757 and decorated his china with portrait heads and copies of Pillement chinoiserie and paintings by Watteau and Boucher. Old designs still in

WOMB CHAIR. Courtesy Knoll International.

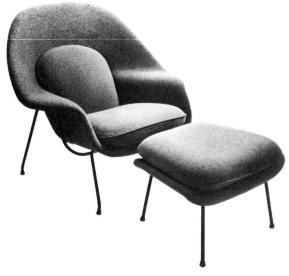

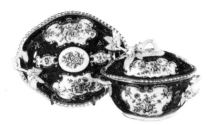

DR. WALL WORCESTER sucrier and stand, c. 1770. Courtesy D. M. & P. Manheim Antiques Corp., New York.

WORCESTER jug, 1751–1783. Courtesy Victoria and Albert Museum, London. Crown copyright.

production include the Worcester "Japans," in the Kakiemon and Imari styles, and the Blind Earl's pattern, made and named for the Earl of Coventry, which has a border of rosebuds and foliage molded in relief. The more elaborate nineteenth-century Worcester pieces, such as those decorated by Thomas Baxter with birds and shells in reserve panels on rich ground colors, are also found in imitations today.

Worcester, Dr. Wall

Blue-and-white china with a blue crescent mark, the earliest of the porcelains made in the Worcester factory during the late eighteenth century, treasured for its delicate beauty.

Worktable

Any small, feminine table outfitted for needlework qualifies as a worktable. Worktables usually have one or two drawers and either a lift-up top that hides a well or bin, as in the Martha Washington type, or a fabric workbag or wicker basket under the drawer section, like the designs recently revived in modern Scandinavian furniture.

Wormley, Edward, F.A.I.D.

Leading designer of interiors and of modern furniture for Dunbar who was largely responsible, in the 1950's, for the reintroduction of Tiffany glass and the Art Nouveau colors associated with it.

Furniture and interior by **EDWARD WORMLEY, F.A.I.D.** Courtesy *House Beautiful.*

Wormy chestnut

A strongly grained wood with multiple wormholes, real or simulated, showing on the surface. Mostly used for provincial furniture, picture frames and wall paneling.

Wreath motif

An early form of self-advertisement, the wreath of Roman laurel leaves enclosing initials or coats of arms was lavished on plaques, china or glassware by the vainglorious—Napoleon Bonaparte being a famous for-instance. The Napoleonic wreath, shorn of its victorious connotations, is still a favored design for fabrics and wallpapers.

Wright, Frank Lloyd (1869–1959)

Pioneering American architect whose highly original structures championed the relationship of building to site. In order to carry through a total design concept, Wright created the interiors and often the furnishings for his houses. His furniture echoed the architectural form of the room (round, square, hexagonal) and was embellished with ornamental detail that repeated the motif of the house. This resulted in designs that, though individual and romantic, were all too often impractical, cumbersome and uncomfortable.

Writing cabinet

A tall, two-part drop-front cabinet introduced in Italy in the fifteenth century that has appeared in successive centuries in widely different versions, ranging from the delicate (Sheraton and Hepplewhite) to the ponderous (French and American Empire). The bottom section may be a simple stand or a cabinet with shelves or drawers; the top part conceals a warren of drawers and compartments behind a drop-front desk top.

Writing table

The French bureau plat, a flat-topped desk with a row of drawers or compartments in the apron and occasionally pullout leaves at the sides.

Interior of a house by **FRANK LLOYD WRIGHT.** Photographer: Guerrero.

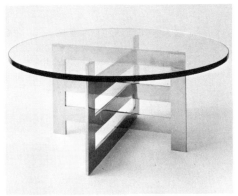

X-BENCH. Courtesy Yale R. Burge, New York.

X-FORM base in stainless steel. Table designed by Evelyn Jablow.

X-bench

The earliest, simplest and most functional form of folding stool. The Egyptians invented it, the Roman curule was taken from it, in the French Empire period it appeared as both a bench and a chair base, and in the twentieth century it crops up in chrome or steel as a bench, chair or cocktail table, looking as fresh and contemporary as ever.

X-form stretcher

In cabinetwork, a stretcher in the form of an X that joins the four legs of a piece of furniture. The most usual is the serpentine X-form, generally with a decorative center knob, or finial, found on William and Mary, Louis XIV and Régence pieces.

YORKSHIRE CHAIR, c. 1670, period of Charles II. The Metropolitan Museum of Art. Gift of Mrs. Russell Sage, 1909.

Yard goods

Literally, fabrics sold by the running yard.

Yarn-dyed

Refers to fabric made from yarns dyed before being woven.

Yorkshire chair

Seventeenth-century English carved side chair with knob-turned legs and scrolled stretchers. It stems from the wainscot chair, but instead of the back being solid it is broken into two arched, carved rails.

Z

ZIGZAG motif on fabric and wallpaper by Howard & Schaffer, New York.

ZWIEBELMUSTER pattern on fabric and wallpaper by Howard & Schaffer, New York.

Zebrawood

A highly decorative wood with bold reddish-brown stripes on a light-yellow ground, primarily used for inlays, bandings and veneers, such as the tops of contemporary coffee and occasional tables.

Ziggurat

Ancient architectural form of Assyria and Babylon, a pyramidal tower composed of a series of setbacks linked by ramps. Inkwells and other small objets were designed in this shape. The modern ziggurat, an offshoot of "brutal" architecture, is exemplified by Marcel Breuer's Whitney Museum in New York and by Montreal's Habitat.

Zigzag

The chevron or herringbone motif of Norman and Gothic architecture, a line of continuous V's. Today, a design for printed fabrics and wallpapers, floorings and decorative borders.

Zoological print

Fabric or wallpaper with an allover print of animals.

Zwiebelmuster (*TSVEE-b'l-moos-tehr*)

German name for the "onion" pattern introduced by the Meissen porcelain factory around 1735, although actually the design has no relation to an onion, either bulb or flower, but is an adaptation of a Chinese floral pattern. *See also* Onion pattern.

ZIGGURAT for today. Habitat, Montreal. Architect: Moshe Safdie.

BIBLIOGRAPHY

Aronson, Joseph, *The Encyclopedia of Furniture*. Crown Publishers, New York, 1938.

Ball, Victoria Kloss, *The Art of Interior Design*. The Macmillan Co., New York, 1960.

Boger, Louise Ade, and Batterson, H., *The Dictionary of Antiques and the Decorative Arts*. Charles Scribner's Sons, New York, 1957.

Briggs, Martin S., *Everyman's Concise Encyclopaedia of Architecture*. E. P. Dutton and Co., New York, 1959.

British *House and Garden*, magazine series, *A Dictionary of Design and Decoration*.

Costantino, Ruth T., *How to Know French Antiques*. Clarkson N. Potter, New York, 1961.

Cox, Warren E., *The Book of Pottery and Porcelain*, Vol. I. Crown Publishers, New York, 1944.

Greer, Michael, *Inside Design*. Doubleday and Co., New York, 1962.

Haggar, Reginald G., *The Concise Encyclopedia of Continental Pottery and Porcelain*. Frederick A. Praeger, Inc., New York, 1960.

Hayward, Helena, ed., *World Furniture*. McGraw-Hill Book Co., New York, 1965.

Huntington, Whitney Clark, C.E., *Building Construction*. John Wiley and Sons, New York, 1929, 1941.

Kornfeld, Albert, *The Doubleday Book of Interior Decorating and Encyclopedia of Styles*. Doubleday and Co., New York, 1965.

Lynes, Russell, *The Tastemakers*. Harper and Brothers, New York, 1954.

Mankowitz, Wolf, and Haggar, Reginald G., *The Concise Encyclopedia of English Pottery and Porcelain*. Hawthorn Books, New York, 1960.

McCall's Decorating Book. Random House, New York, 1964.

O'Brien, George, ed., *The New York Times Book of Interior Design and Decoration*. Farrar, Straus & Giroux, New York, 1965.

Ormsbee, Thomas, *English China and Its Marks*. Deerfield Books, Great Neck, New York, 1959.

Pegler, Martin, *The Dictionary of Interior Design*. Crown Publishers, New York, 1966.

Ramsey, L.G.G., ed., *The Complete Encyclopedia of Antiques*. Hawthorn Books, New York, 1962.

Waugh, Herbert R., and Burbank, Nelson L., *Handbook of Building Terms and Definitions*. Simmons-Boardman Publishing Corp., New York, 1954.

Whiton, Sherrill, *Elements of Interior Design and Decoration*. J. B. Lippincott Co., Philadelphia, 1963.

Wier, Albert E., *Thesaurus of the Arts*. G. P. Putnam's Sons, New York, 1943.

Wilson, José, and Leaman, Arthur, *Decoration U.S.A.* The Macmillan Co., New York, 1965.